WebWorks: Navigation

Edited and with an introduction by Ken Coupland

GLOUCESTER MASSACHUSETTS

>> >>

FUTURE FARMERS

R O C K P O R T
PUBLISHERS

| 13 | 14 | 15 | 16 | 17 | 18 | 19 | 20 | 21 | 22 | 23 | 24 |

First published in the
United States of America by

Rockport Publishers, Inc.
33 Commercial Street
Gloucester, Massachusetts 01930-5089
Telephone: (978) 282-9590
Facsimile: (978) 283-2742

www.rockpub.com

ISBN 1-56496-662-3

10 9 8 7 6 5 4 3

Design: Cathy Kelley Graphic Design

Front cover images (from left to right):
Futurefarmers, M.A.D., BBK

Back cover images (from left to right):
M.A.D., twenty2product, Nomex

Printed in China.

01 02 03 04 05 06 07 08 09 10 11 12

>> >>

>>

01 02 03 04 05 06 07 08 09 10 11 12

Contents

:// HOME

| Reload | Home | Search | Netscape | Images | Print | Security | Shop | Stop |

www.digitas.com/

AS WORLDWIDE ⊹ BOSTON LONDON NEW YORK SALT LAKE CITY SAN FRANCISC

ETHICS CD-Rom Application 1995
Produced for the french publisher Flammarion, "Sink The Warum, A
Tangled Tale Of Ethical Choices" is an exploration of the world of
philosophy though a virtual theatre setting and moral interactivity.

brand new

How do Web designers create a satisfying customer

experience? What are the hurdles they face, and how have they overcome

them? What lessons have they learned ...

One of the great ironies of the World Wide Web's explosive growth is the sheer weight of old-media, dead-tree publishing the Internet has produced. The last few years have seen a spate of books and magazine articles about Web design, all attempting to explain what has become a highly labor-intensive and detail-oriented process. Keeping up with the flood of advice on the subject has not been easy for most designers. On one hand, there are textbooks to trudge through, while on the other are superficial flipbooks loaded with flashy graphic design but no substance. This particular survey of Web navigation provides the best of both worlds: it is intended as both a primer and useful report on the state of the art and as a showcase of smart, effective graphic design.

To compile this anthology, I contacted as many Web-design studios—both large and small—as I could find. In spite of a long familiarity with Web-design issues, extensive research, and plenty of well-informed recommendations, my selection—given the amorphous nature of today's Internet—was necessarily a somewhat hit-or-miss affair. Inevitably, many worthy Web designers were overlooked, while others contacted were simply too successful: their busy schedules didn't leave them time to reply. But the process was also highly selective. While projects that demonstrated visual smarts were favored candidates for inclusion, hard-working Web sites were the most sought after.

Rather than put out a traditional call for entries, I invited individual firms to complete a questionnaire about the work that they submitted. Many of the replies discussed the aesthetic and technical issues involved in creating a successful navigation structure at considerable length—and often in surprising ways. As a result of this process, the projects in this book represent some of the best creative thinking about functional Web design available anywhere.

Each study is prefaced with a description of the studio involved. You'll also notice that a tree diagram is repeated with each project—first as a thumbnail and later in a larger version. The tree describes the structure of the site's navigation in schematic form. Finally, you'll also find the publisher's Web address prominently displayed. From there, you can access all the links to studios and projects featured in this book.

This volume came together over the fall, winter, and spring of 1999–2000. Most of the projects were launched within a year to eighteen months of our publication date, so what you're looking at is relatively current, as Web design goes. Much will have changed about the Web in the intervening months, but one thing remains constant: the Web is an interactive medium and never more so than now. And when it comes to that decisive moment when a Web site either fails or rewards its visitors, proper navigation still rules. ■

– K. C.

What can they tel us about...

Steering a Course to Better Navigation

by Ken Coupland

Once upon a time, in the World Wide Web's halcyon days, the concept of Web navigation sounded thrilling. It was as though you were embarking on a voyage of discovery. The new medium gave "navigation" an almost romantic ring. Taking its visual cues from models that had been developed for earlier interactive media, navigation was seen as little more than a means of providing an opportunity for designers to show off their graphic-design smarts and not as an integral part of Web functionality.

What a difference a few million more Web sites makes—not to mention the billions upon billions of dollars in revenue now moving through e-commerce and business-to-business on-line transactions. Today, navigation is less a warm-and-fuzzy concept and more a do-or-die proposition. It's also a two-way street. As the pace of development on the Web approaches warp speed, a huge audience awaits, an audience whose increasing sophistication and increasingly insistent demands are more than a match for the best navigation strategists. Meanwhile, the typical Web site is looking less like a work of graphic art and more like a product of industrial design. How visitors interact with what's in front of them on-line—and how well they find their way around while they are there—is a critical component of the design mission.

While good graphic design is still an undeniable asset, other factors have intruded on the designer's domain. As a result, the on-line graphic designer now joins a much larger team—of human factors experts, software engineers, and programmers among others—with more job categories constantly being added to the list. The much-touted "user experience," to adopt a phrase that describes the infinitely variable interactions that Web designers must coax the user to perform, draws on all sorts of capabilities. Often fickle and easily frustrated, users who encounter miscues or misdirections will flee in frustration, "abandoning the shopping cart" at the precise moment when the Web site's transactional mechanisms are poised to close the sale. In the brutally efficient feedback loop of Web commerce, it quickly becomes evident what works and what doesn't. Yet the biggest and best-equipped sites continue to disappoint users time after time.

The crux of the situation lies with navigation. Navigation, after all, has been fundamental to the Web's dynamic from its beginnings. And now, more so now than ever. Yet Web sites by their very nature provide few of the graphical and textual cues to navigation that audiences have come to take for granted in older media. Designers familiar with traditional media types need to learn new navigation strategies—and in some cases, unlearn old ones. Sites that reward visitors with ease-of-use and instant gratification will succeed. Sites that frustrate users and send them away will fail. New rules and new solutions are urgently called for.

How do Web designers create a satisfying customer experience? What are the hurdles they face, and how have they overcome them? What lessons have they learned and, perhaps most important, what can they tell us about what's in store down the road for navigation on the Web? In the pages that follow, you'll find as much concern with describing the process by which a navigation structure was derived as with the navigation itself. The journey, in other words, is as important as the destination.

The Discovery Homepage, redesigned, before
(left) and after (right), by the design firm, iXL.

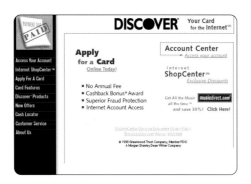

Many of the projects presented herein are redesigns of existing Web sites, which, for one or more good reasons, were due for an overhaul. As the Web has evolved from glorified "brochureware," in which it was enough for a company to announce its presence, to hard-nosed vehicle of commerce, the focus of the experience has shifted, and sites have been retrofitted to reflect the needs of users rather than a company's internal organization.

When they do talk about navigation, designers tend to speak in metaphors: based on botany, such as trees, trunks, limbs, and branches or, less frequently, on genealogy, such as grandparents, parents, and children. Hierarchies of information are either "shallow" or "deep." Generally, the principles of navigation are easy to comprehend.

Implicit in any discussion of navigation on the Web is a set of ground rules—although some may say these have usually been honored more in the breach than the observance. While you'll find any number of variations on the theme in how-to manuals in print and on the Web (see Navigation Resources), the bulk of guidelines for good navigation tend to have a lot in common with each other. Bone up on the basic principles of navigation and dive into the illuminating explanations that follow. And have a pleasant and rewarding journey. ■

>>

What's in store down the road

for navigation on the Web?

Site in a Box
Herman Miller Product Showroom

http://www.hermanmiller.com

>>

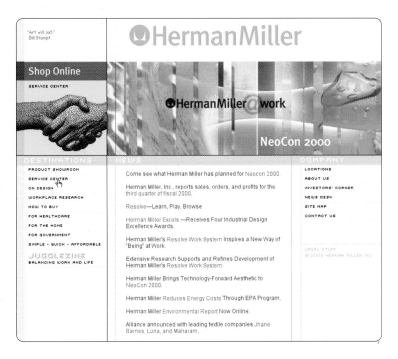

The Product Showroom/International Template navigation is a page template designed for displaying the company's product information through a browser. The project criteria included developing a content-management system by which information can be updated by nontechnical resources through a browser.

The International Template is a kind of "site in a box" designed for Herman Miller's subsidiaries abroad. It too allows for browser-based content management, but unlike the current version of the Product Showroom, it can accept multiple languages and page templates. The tool allows for content managers to create, delete, and update pages, and to customize the appearance of their site. By using the template, the groups can take advantage of preset global navigation and dynamically updated local navigation.

Each page provides both a primary and secondary navigation route. The primary navigation contains graphical headers that represent the site-specific and first-tier category content. The global navigation links to pages that are site specific, including a text-based site map and search features. A "bread-crumb trail" provides text-based links back up the trail through the category front page to the site front page, providing a consistent visual representation of the users location within the site. This constitutes the primary navigation.

To the left of the bread-crumb trail is a tab that, when expanded, provides a vertical listing of first-tier categories. Selecting a category on this list displays secondary listings of pages within that category. Selections here link directly to a particular page. This provides the ability to navigate from any page to any other page on the site, constituting the secondary navigation.

The combination of these two forms of navigation creates both a sense of place within the context of the site and a decentralization of content for return visitors who know where they want to go. The site map becomes a relic for users with newer browsers and nothing stands between users and the content they seek, once they become familiar with the basic navigation logic of the site.

One significant challenge in developing this navigational structure is meeting the technological demands without "fattening" the pages. The pages should average around 30k. To include a full site map of navigation without exceeding this limit requires a way of dynamically loading portions of the page in a manner that does not disrupt overall design of the page. The designers solved this problem through the use of cross-browser dynamic layers as opposed to frames, which are difficult to adequately position within a pixel-perfect design.

Client Herman Miller, Inc. **Team** Kevin Budelmann, creative director; Kevin Budelmann, Michael Carnevale, Yang Kim, Alison Popp, Matt Ryzenga, designers; Leah Weston, Courtney Schramm, producers; Scott Krieger, Von Neel, Jeff Sikkema, programmers **Since** April 1999

Tools BBEdit, Adobe Photoshop, Adobe ImageReady, Anarchie, HP Unix, Apache

Site Map **⊕HermanMillerStore**

▶ Classic Furniture

Eames
Eames Molded Plywood Lounge Chair
Eames Molded Plywood Chair
Eames Molded Plywood Side Chair
Eames Lounge Chair & Ottoman
Eames Molded Plywood Screen
Eames Sofa Compact
Eames Molded Plywood Coffee Table
Eames Elliptical Table
Eames Wire Base Table
Eames Dining Table
Eames Walnut Stools
Eames Hang-It-All
Eames Metal Leg Lounge Chair
Eames Soft Pad Lounge Chair
Eames Soft Pad Ottoman
Eames Aluminum Group Executive Chair
Eames Aluminum Group Management Chair
Eames Soft Pad Management Chair
Eames Three-Seat Sofa
Eames Two-Seat Sofa
Eames Rectangular Dining Table
Eames Aluminum Group Lounge Chair
Eames Aluminum Group Ottoman
Eames Chaise

Nelson
Nelson End Table
Nelson Platform Bench

Noguchi
Noguchi Table

Girard
Girard Pillows
Girard Table Runners
Girard Scrims

Covey
Covey Stool (Model 6)

▶ Office Furniture

Beirise Collection
Beirise Table
Beirise Side Table
Beirise Corner Table
Beirise Corner Table Extension
Beirise Bookcase
Beirise Cabinet
Beirise Cabinet with Doors
Beirise Cabinet with Drawers
Beirise Mobile Storage Unit
Beirise Overhead Bookcase
Beirise Overhead Bookcase with Doors
Beirise Work Organizer
Beirise Display Shelf
Add-On Bookcase Shelf
Beirise Tackboard

TJ Collection
TJ Computer Desk
TJ Table Desk
TJ L-Return
TJ Two-drawer File Cabinet
TJ Mobile Drawer Pedestal
TJ High Desk Organizer
TJ Low Desk Organizer
TJ Overhead Bookcase

Newhouse Collection
Newhouse Desk with Display
Newhouse L-Return
Newhouse Return Bookcase
Newhouse File Storage Bookcase
Newhouse Storage Cabinet
Newhouse Two-Drawer File Cabinet
Newhouse Mobile Drawer Pedestal
Newhouse Corner Wedge

Puzzle
Puzzle Mobile Office

▶ Office Chairs

Aeron
Aeron Highly Adjustable Work Chair
Aeron Side Chair

Equa 2
Equa 2 Adjustable Work Chair
Equa 2 Side Chair

Reaction
Reaction Highly Adjustable Work Chair
Reaction Adjustable Work Chair

Avian
Avian Work Chair
Avian Side Chair

Limerick
Limerick Side Chair

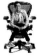

▶ Office Accessories

General
File Drawer Organizer
Utility Tray
Pencil Drawer
Scooter Stand with Plastic Top
Scooter Document Stand
Scooter Stand with Wood Top
Adjustable Keyboard and Mouse Tray
Palm Rest
Ibis Light
Freestanding Task Light
Under-Shelf Task Light
Pavo Task Light
Paper Tray
Diagonal Tray
Foot Pillow
Relay Folding Screen
Beirise Wire Trough
TJ Wire Management Kit
Lapdog
Scooter Palm Rest
Footrest
Horizontal CPU Holder
Overlay Surface
Armature
Document Stand

▶ Gift Ideas

Amenities
Eames House Tour Flip Book
House Construction Flip Book
Toy Trains Flip Book
Lounge Chair Flip Book
Powers of Ten Flip Book
House of Cards Small
House of Cards Medium
Eames House T-Shirt
Lounge Chair T-Shirt
Wire Chairs T-Shirt
Glimpses of the USA T-Shirt
Tanks T-Shirt
Computer House of Cards T-Shirt
DCM T-Shirt

▶ Customer Services

Contact Us
Help & Information
FAQ
What's New
Privacy & Security
Seating Comparison Chart
Copyrights & Trademarks
Warranty Information
Sales & Return Policies

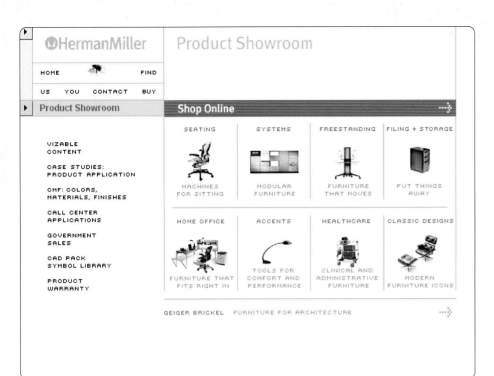

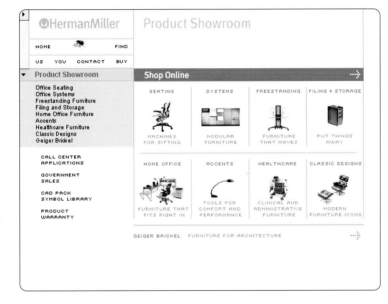

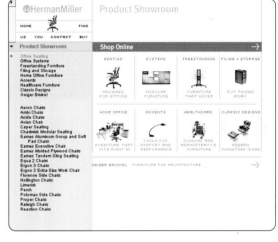

Users can drill down through menus to navigate from one page to another. The result of this path is a bread-crumb trail that can also be used as navigation.

The menu content is pulled dynamically and in real time from a database. The client can add and delete pages, as well as edit content using a Web-based interface. These changes are reflected automatically in the menu.

This kind of interaction allows for non-linear, non-hierarchical navigation through a site. A user can jump from one page directly to another page without having to load index pages.

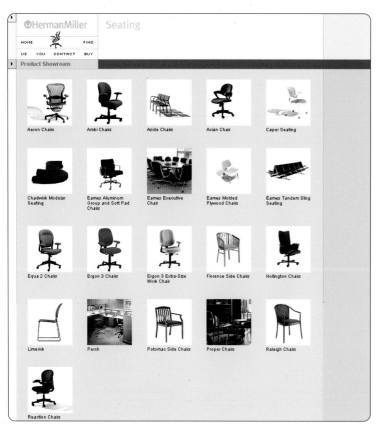

Users can reveal pieces of information, images, and multimedia by selecting from the menu. This kind of interaction allows for an experience less common in Web-based media. In this model, specific pieces of content are loaded on demand rather than jumping from page to page.

The content is pulled dynamically and in real time from a database. The client can add and delete pages as well as edit content using a Web-based interface. These changes are reflected automatically in the menu.

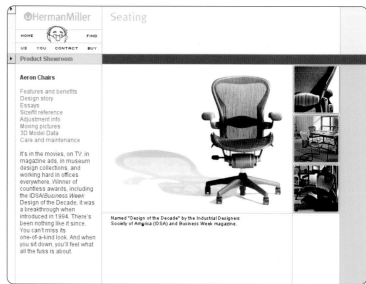

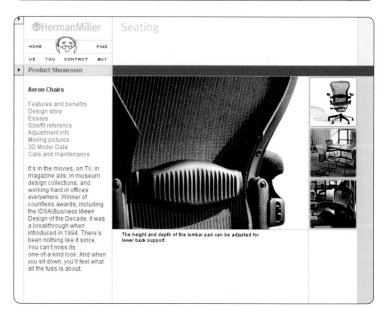

site: www.hermanmiller.com

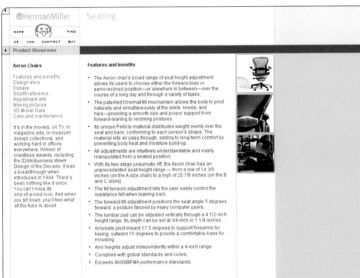

HermanMiller · Seating

HOME | FIND
US | YOU | CONTACT | BUY

▶ Product Showroom

Aeron Chairs

Features and benefits
Design story
Essays
Size/fit reference
Adjustment info
Moving pictures
3D Model Data
Care and maintenance

It's in the movies, on TV, in magazine ads, in museum design collections, and working hard in offices everywhere. Winner of countless awards, including the IDSA/*Business Week* Design of the Decade, it was a breakthrough when introduced in 1994. There's been nothing like it since. You can't miss its one-of-a-kind look. And when you sit down, you'll feel what all the fuss is about.

Features and benefits

- The Aeron chair's broad range of seat height adjustment allows its users to choose either the forward-bias or semi-reclined position—or anywhere in between—over the course of a long day and through a variety of tasks.
- The patented Kinemat tilt mechanism allows the body to pivot naturally and simultaneously at the ankle, knees, and hips—providing a smooth ride and proper support from forward-leaning to reclining postures.
- Its unique Pellicle material distributes weight evenly over the seat and back, conforming to each person's shape. The material lets air pass through, adding to long-term comfort by preventing body heat and moisture build-up.
- All adjustments are intuitively understandable and easily manipulated from a seated position.
- With its two-stage pneumatic lift, the Aeron chair has an unprecedented seat-height range — from a low of 14 3/8 inches (on the A-size chair) to a high of 20 7/8 inches (on the B and C sizes).
- The tilt-tension adjustment lets the user easily control the resistance felt when leaning back.
- The forward-tilt adjustment positions the seat angle 5 degrees forward, a posture favored by many computer users.
- The lumbar pad can be adjusted vertically through a 4 1/2-inch height range. Its depth can be set at 3/4 inch or 1 1/4 inches.
- Armrests pivot inward 17.5 degrees to support forearms for keying, outward 15 degrees to provide a comfortable base for mousing.
- Arm heights adjust independently within a 4-inch range.
- Complies with global standards and codes.
- Exceeds ANSI/BIFMA performance standards.

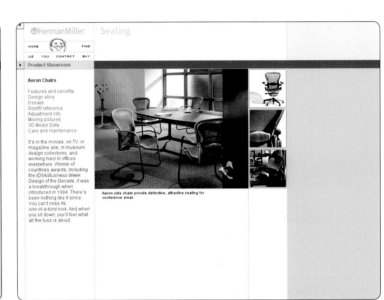

HermanMiller · Seating

HOME | FIND
US | YOU | CONTACT | BUY

▶ Product Showroom

Aeron Chairs

Features and benefits
Design story
Essays
Size/fit reference
Adjustment info
Moving pictures
3D Model Data
Care and maintenance

It's in the movies, on TV, in magazine ads, in museum design collections, and working hard in offices everywhere. Winner of countless awards, including the IDSA/*Business Week* Design of the Decade, it was a breakthrough when introduced in 1994. There's been nothing like it since. You can't miss its one-of-a-kind look. And when you sit down, you'll feel what all the fuss is about.

Aeron side chairs provide distinctive, attractive seating for conference areas.

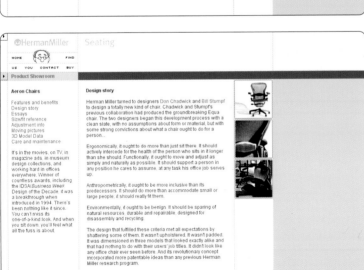

HermanMiller · Seating

HOME | FIND
US | YOU | CONTACT | BUY

▶ Product Showroom

Aeron Chairs

Features and benefits
Design story
Essays
Size/fit reference
Adjustment info
Moving pictures
3D Model Data
Care and maintenance

It's in the movies, on TV, in magazine ads, in museum design collections, and working hard in offices everywhere. Winner of countless awards, including the IDSA/*Business Week* Design of the Decade, it was a breakthrough when introduced in 1994. There's been nothing like it since. You can't miss its one-of-a-kind look. And when you sit down, you'll feel what all the fuss is about.

Design story

Herman Miller turned to designers Don Chadwick and Bill Stumpf to design a totally new kind of chair. Chadwick and Stumpf's previous collaboration had produced the groundbreaking Equa chair. The two designers began this development process with a clean slate, with no assumptions about form or material, but with some strong convictions about what a chair ought to do for a person.

Ergonomically, it ought to do more than just sit there. It should actively intercede for the health of the person who sits in it longer than she should. Functionally, it ought to move and adjust as simply and naturally as possible. It should support a person in any position he cares to assume, at any task his office job serves up.

Anthropometrically, it ought to be more inclusive than its predecessors. It should do more than accommodate small or large people; it should really fit them.

Environmentally, it ought to be benign. It should be sparing of natural resources, durable and repairable, designed for disassembly and recycling.

The design that fulfilled these criteria met all expectations by shattering some of them. It wasn't upholstered. It wasn't padded. It was dimensioned in three models that looked exactly alike and that had nothing to do with their users' job titles. It didn't look like any office chair ever seen before. And its revolutionary concept incorporated more patentable ideas than any previous Herman Miller research program.

The chair was tested for comfort with scores of users, pitting it against the best work chairs available. Leading ergonomists, orthopedic specialists, and physical therapists evaluated the chair's fit and motion, the benefit and ease of its adjustments.

The design team conducted anthropometric studies across the country, using a specially developed instrument to calculate

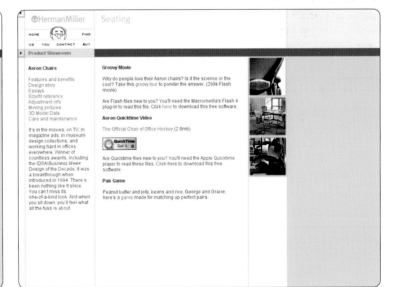

HermanMiller · Seating

HOME | FIND
US | YOU | CONTACT | BUY

▶ Product Showroom

Aeron Chairs

Features and benefits
Design story
Essays
Size/fit reference
Adjustment info
Moving pictures
3D Model Data
Care and maintenance

It's in the movies, on TV, in magazine ads, in museum design collections, and working hard in offices everywhere. Winner of countless awards, including the IDSA/*Business Week* Design of the Decade, it was a breakthrough when introduced in 1994. There's been nothing like it since. You can't miss its one-of-a-kind look. And when you sit down, you'll feel what all the fuss is about.

Groovy Movie

Why do people love their Aeron chairs? Is it the science or the cool? Take this groovy tour to ponder the answer. (299k Flash movie)

Are Flash files new to you? You'll need the Macromedia's Flash 4 plug-in to read this file. Click here to download this free software.

Aeron Quicktime Video

The Official Chair of Office Hockey (2.8mb)

[QuickTime Get 4.]

Are Quicktime files new to you? You'll need the Apple Quicktime player to read these files. Click here to download this free software.

Pair Game

Peanut butter and jelly, beans and rice, George and Gracie, here's a game made for matching up perfect pairs.

>> Each page provides both a primary and secondary
 navigation route. The primary navigation contains
 graphical headers that represent the site-specific
 and first-tier category content. The global navigation
 links to pages that are site specific, including a text-
 based site map and search features.

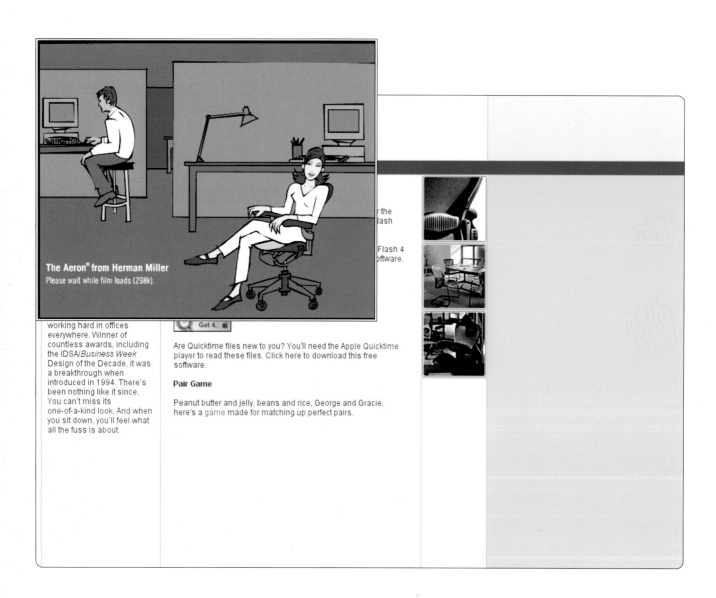

The Aeron® from Herman Miller
Please wait while film loads (298k).

working hard in offices
everywhere. Winner of
countless awards, including
the IDSA/*Business Week*
Design of the Decade, it was
a breakthrough when
introduced in 1994. There's
been nothing like it since.
You can't miss its
one-of-a-kind look. And when
you sit down, you'll feel what
all the fuss is about.

r the
lash

Flash 4
oftware.

Get 4.

Are Quicktime files new to you? You'll need the Apple Quicktime
player to read these files. Click here to download this free
software.

Pair Game

Peanut butter and jelly, beans and rice, George and Gracie,
here's a game made for matching up perfect pairs.

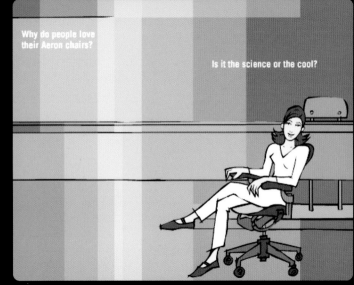

After clicking on "Moving Pictures" on the Aeron chair page, the site asks, "Why do people love their Aeron chairs? Is it the science or the cool?"

Viewers can take this "groovy tour," created in Macromedia Flash, to "ponder the answer."

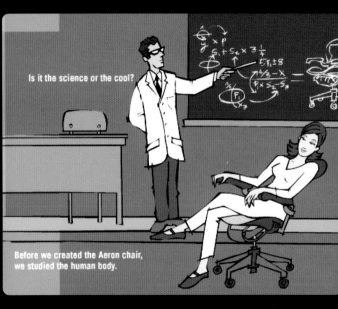

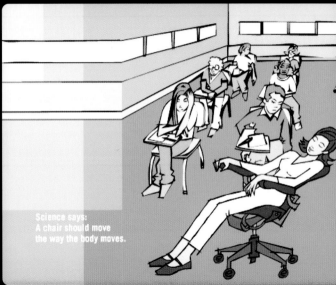

CyberSight Strategic Marketing is one of North America's leading interactive consulting and services firms. The award-winning agency is a pioneer in the development and use of technology to drive integrated marketing solutions. With offices in Portland, Toronto, New York, Los Angeles, and San Francisco, the agency has created new-media projects for companies such as Dole Food, the Dreyfus Corporation, E-Trade Canada, Molson Breweries, Nissan North America, Quaker Oats, and Visa.

Organized into "solution groups," Cybersight's team structure includes strategic services (interactive business, marketing, and technology consulting); a technology group (application development, enterprise integration, database design and development, and Internet-based development); creative services (Web site design, content development, information architecture, copywriting, and interface design); media services (on-line media planning and buying, on-line promotions and sponsorships, and integrated marketing initiative development); production (Internet, CD-ROM, extranet, intranet, and content-management services); and project management (vendor selection and management, usage and analysis, ongoing assessment, and ROI analysis).

Fostering a "Life Moment"
Cap'n Crunch

http://www.capncrunch.com/

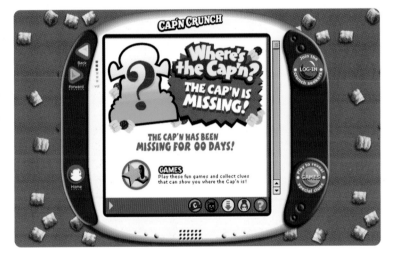

CyberSight developed a strategy to engage a community of kids and revitalize the Cap'n Crunch brand. The Web initiative and its promotion—the largest in Quaker Oats history—aimed to engage a community of kids through an online and real-world search for Cap'n Crunch. The primary objectives were to connect children with the Cap'n Crunch brand; to drive depth of interaction with Cap'n Crunch and foster a "life-moment" experience; and to reinforce equity with the older end of the target audience.

The objective was to communicate a distinct brand that would be relevant to today's digital kids; navigation, design, and content had to contribute and combine to make a memorable experience. Look, feel, and language had to be consistent, kid cool, and painstakingly tuned to engage children. The site invites a difficult-to-reach audience to have fun and be challenged without compromising the positive aim to extend a life-moment brand experience.

The child-friendly interface resembles a portable computer game pad or video game—the result of extensive user-behavior research and an understanding of what kids really like.

Because the designers found that non-linear and traditional table-of-content links were illogical and a distraction for children, they created an interactive experience where the site and the browser are one and the same. The result is a unique and instinctual experience that children find familiar and can engage easily. Created to offer several levels of challenge and populated with wacky characters, the games are intended to deliver hours of fun for hard-to-please young gamers.

Throughout, CyberSight aimed to remain true to its core values while satisfying ambitious branding goals targeted for children. The result is a high-impact site experience that is neither pollutive nor intrusive.

CyberSight adhered to a strict code to ensure a positive and safe environment for children that exceeded the child marketing guidelines of CARU (Children's Advertising Review Unit of the Better Business Bureau) and the FTC rulings on the Children's Privacy Protection Act.

Client Quaker Oats Company **Team** Peter Guagenti, creative director/copywriter; Kelvin Lee, designer; Erik Falat, designer/Web developer; Paul Bjork, Cabel Sasser, designers/multimedia developers; Todd Greco, multimedia developer; Jackie Hockett, producer; Jeff Rosenfield, Marisa Brown, account managers; Amy Boyd, account executive; Daniel Landau, technical director **Since** January 2000 **Target** Boys and girls, ages 5 to 12

Tools HTML coded through BareBones BBEdit 5.0 and Macromedia Dreamweaver; Shockwave features through Macromedia Director, Macromedia Flash, Adobe Photoshop, Adobe Imageready, Adobe Illustrator

13 14 15 16 17 18 19 20 21 22 23 24

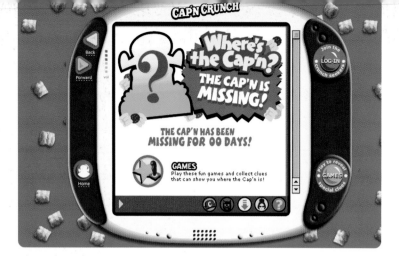

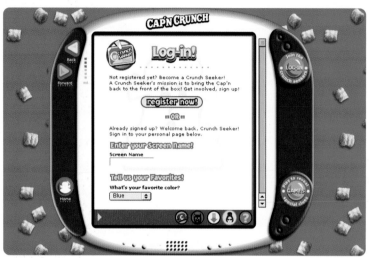

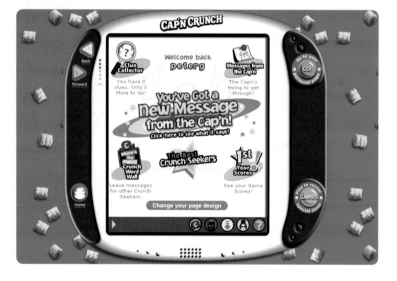

The visitor can select from Games, Sabrina's Search Diary, Messages from Cap'n Crunch, the Word Wall, and Get the Crunch Browser. Icon buttons also appear to allow users to move back, forward, home, and go to games and questions about the site. Also included is a frank note to parents about the motivations of the site.

To become a Crunch Seeker, kids input a screen name and log-in through pull-down menus that request a favorite color, favorite flavor of Cap'n Crunch, and favorite animal (children have a much better chance of remembering their favorites than they do a personal password). Kids then choose a favorite layout from three customized page designs for their Personal Page. While content remains consistent, the look of each page is different. Once one is chosen, the user is instantly sent to his or her Personal Page.

>> The child-friendly interface resembles a portable computer game pad or video game—the result of extensive user-behavior research and an understanding of what kids really like.

site: www.capncrunch.com

(top) A Microsoft Internet Explorer 5.0–based browser enables Crunch Seekers to play Cap'n Crunch games, track clues in their search, receive personal notes from Cap'n Crunch, visit campaign-related links, and travel the World Wide Web.

(middle) A series of quirky, gender-neutral games—Break out of Volcanica, Treasure of Aquatica, Amazonia, and Hunger Attack—help visitors find Cap'n Crunch. The games become more difficult the longer they're played, driving excitement and boosting staying power.

(bottom) Sabrina's Search Diary gives kids a glimpse into weekly diary entries from the title character of the popular TV series. Written narratives revolve around Sabrina's own personal quest to figure out where Cap'n Crunch is. Designed to connect with girls, each entry offers a mix of fun, adventure, whimsy, and humor for all children.

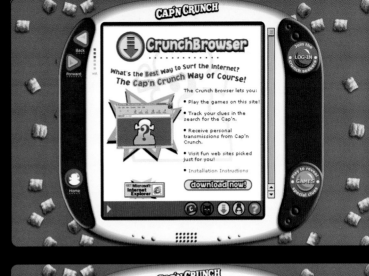

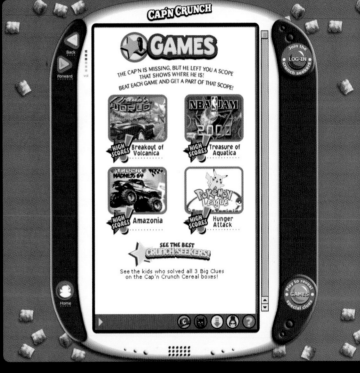

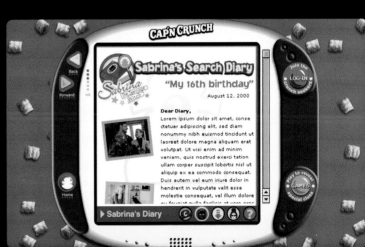

'n Crunch

asked to decode or assemble a series of phrases from Cap'n
ightly cryptic message is arranged, the visitor can listen and
-visual from a mini-TV monitor) to a message from Cap'n Crunch
draw and fresh immediacy, new messages appear weekly.

s a safe and ingenious way to provide the community of Crunch
riendly "graffiti" message board. Visitors are presented with a
zens of words they can arrange into messages for the next visitor
hich he or she can add or respond.

is Search Central, the home for kids involved in the search for
rive, stay current on the search, and register as a Crunch Seeker,
e kids who are actively involved in the search for Cap'n Crunch.
r their search, play games that hone their detective skills, find
registered users, track their successes in the search on their Clue

ch?

s an episodic comic book-style environment that tells the story
gh a fictional news magazine, *Bizarre Mysteries*. The show
Cruncher and Goldie Lishus, two reporters who travel the
characters who are certain they know where the Cap'n is.

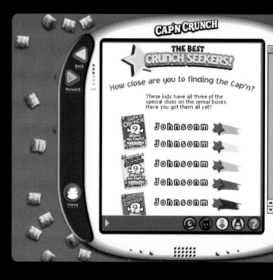

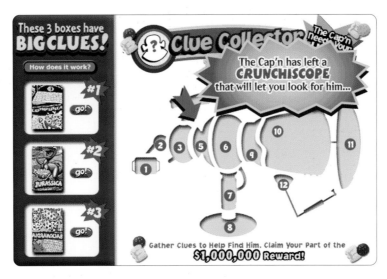

The Clue Collector is the interactive board that stores "clues" for registered site users. By taking part in the four games on the site, users collect four pieces. The remaining eight pieces can be found on the Web and are hidden as special "crunch crumbs" that have settled to the bottom of the page. Using DHTML, the crunch crumbs magically appear; scroll the page and they're still there. Now click on them and see what happens. Once a Crunch Seeker has collected all twelve parts to the Crunchiscope and assembles it, the scope spots Cap'n Crunch.

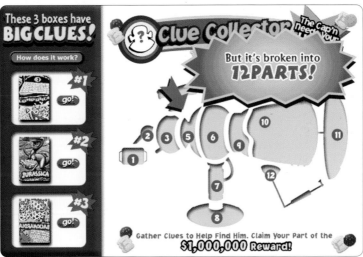

Your score: 0

| Games | Sabrina's Search Diary | Get the Crunch Browser | Messages from the Cap'n | Crunch Word Wall |

Breakout of Volcanica

Treasure of Aquatica

Amazonia

Hunger Attack

site: **www.capncrunch.com**

 ### ReGister
Join fellow Crunch Adventurers for crunchtastic fun!

 ### Games
New sweet games from Crunch Headquarters!

 ### FREE CD-ROM!
Save Volcanica's Crunchium City! Find out how to get your own Crunchling Adventure CD-ROM game!

 ### Picture Maker
Color the scenes of the Capn's great adventure! Or create your own magical art!

 ### CrunchiscOPe
Find the Cap'n with his eye- mazing Crunchiscope!

 ### Riddles
Test your amazing brain power with the Capn's weekly scrambles!

 ### SaBrina's Search Diary
Get the scoop from everyone's favorite teenage witch!

 ### Fun Downloads
The Capn's treasure trove of fun includes games, surfing the 'Net the Crunch way, and more!

 ### word wall
Send cool messages to fellow Crunch Adventurers everywhere!

GAMES CRUNCHLING

Join the LOG-IN Crunch adventurers

http://www.pictor.com

Deepend
[London, England]

Founded in 1994, Deepend offers expertise across the spectrum of digital media design and production. Driven by creative vision and technical innovation, the studio is now one of the leading independent digital media agencies in the United Kingdom and is widely recognized for its creative talent. At Deepend's London office, a team of ninety works across six areas of expertise: Web, multimedia and games development, 3-D visualization and animation, moving image, events production and convergent media. The studio recently opened an office in New York City.

A diverse range of academic backgrounds and interests forms an extremely strong team within the industry. Traditional product and industrial design provide thorough understanding of the spectrum of issues involved in the design process, while graphic, interaction, and new-media design ensure visually compelling, functionally efficient, and effectively communicated media solutions. Marketing, media, business, and communications disciplines provide strategic insight, strong project management, and client-servicing support.

Refined by experience, this resource of knowledge and skills is nurtured by a flexible structure with a minimal hierarchy, where creative involvement in all aspects of the design process is encouraged. The result—an energetic and innovative company culture that consistently produces highly acclaimed work. Clients include Apple Computer, London Design Museum, New Beetle/ Volkswagen UK, British Telecom, Cartoon Network, FT.com, Virgin Radio, Andersen Consulting, Sony, Calvin Klein, Yellow Pages, Shell, Rapido TV, NTL, Telewest, and Pictor.

site: www.deepend.co.uk

Pictor

http://www.pictor.com

Pictor is a stock-image agency. The stock-image industry is already digitized, with a vast majority of players in the market having a Web presence. Global stock-image users now expect to be able to do business over the Internet and those companies that cannot offer this service will not survive.

The site had three main objectives. First, to Support Pictor's repositioning and rebranding. The desire was to move Pictor to a higher creative level through the provision of superior image quality and new forms of digital delivery. The Web site would support this transition to allow Pictor to become a digitally enhanced quality brand. The development of a unified Web brand name across both European and U.S. markets was required.

The second objective was to establish a unique point of difference for the online presence that would make Pictor the image library of choice for the creative industry. Pictor had arrived late in the digital market and needed to use this as an advantage to leapfrog over its competitors. It could not offer just another Web site; a combination of design and functionality had to differentiate Pictor from other stock-image companies.

Lastly, the site had to provide the creative industry with an intuitive environment that would facilitate the search process and differentiate Pictor as a company that truly understands and delivers innovative solutions for creative people. To the consumer, the Web site had to offer the opportunity for a unique and engaging Pictor experience that would stimulate repeat visits and purchases.

After initial analysis of the standard search models used by competitors, Deepend recommended a navigational search tool that was based on intuitive visual selection, rather on the standard tedious Boolean choices. These types of searches, which require mouse-clicking through lists or typing keywords before viewing an image, can lead to a very frustrating experience for the user.

This visual search tool was developed to address the creative mindset of the target audience, who tend to be image focused. They are accustomed to browse catalogs, light boxes, or contact sheets with a magnifier, moving from one image to another as they mentally refine their search.

Deepend's recommendation was to create a more ambitious, visually based search facility to cater to the creative community. Visual searching, with backup from standard keyword and category entry points, would provide a real competitive edge.

Client Pictor International Ltd. (Stephen Kay, chairman, Stephen Harvey Franklin, chief operating officer, Harry Mole, director of e-commerce, Lee Spokes, IT director) **Team** David Streek, creative director; Frances O'Reilly, designer; Andrea Harding, producer; Guillaume Buat-Menard, James Donelly, programmers **Since** January 2000 **Target** Agencies, editors, photographers, students, internal team, and agents worldwide

Tools Adobe Photoshop, Adobe Illustrator, Adobe ImageReady, Allaire HomeSite, HTML, DHTML, JavaScript, PERL, Database (velocis), Pictor's Search Engine

13 14 15 16 17 18 19 20 21 22 23 24

>>

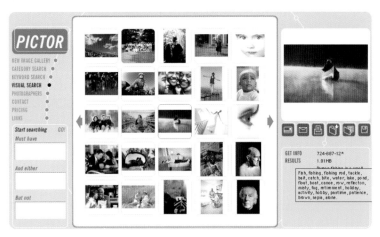

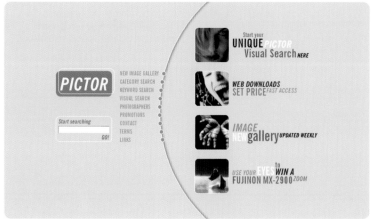

>> Deepend recommended a navigational search tool
that was based on intuitive visual selection, rather
on the standard tedious Boolean choices.

site: **www.pictor.com**

This facility allows the user to visually browse or navigate through a virtual landscape of imagery in an intuitive manner. This virtual landscape is organized into groups of images linked by a common theme or concept. Instead of being divided into "hard" sections, the images are presented in a series of blended transitions between category areas. The user wanders from one area to another with image attributes changing gradually over the terrain.

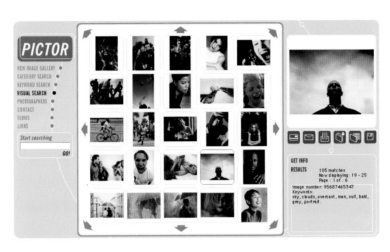

In terms of designing the navigation in the Pictor site, there were two objectives that drove all the brainstorming and rationalizing throughout the entire developmental process: intuitive and user-friendly functionality, and aesthetically strong and compelling interface design. The navigation was designed to satisfy three fundamental requirements:

1) Introducing the site and how to use it most effectively, and providing clear navigation through top-level pages

 New Image Gallery
 Category Search
 Keyword Search
 Visual Search
 Photographers
 Promotions
 Contact
 Terms
 Links

2) Presenting the visual search grid in an easily accessible—download speeds, refreshing, etc.—and user-friendly format. (The minimum thumbnail size that allows a clear image impression was determined at 85 x 85 pixels per inch (ppi). After extensive usability research, the image landscape was limited to twenty-five images within a five-by-five grid.)

3) Presenting the top-level navigation, the Visual Search grid, and selection-specific tools on the same screen in a user-friendly and aesthetic format. The Selection tools include:

 Purchase facility: Buy This Image
 Email this image or folder facility
 Print this image facility
 Add image to Folder
 View Folder
 Download image

The selection of images into My Folder has been designed and developed to be as intuitive as possible with familiar folder names and the drag-and-drop facility. For maximum convenience, the My Folder facility can be used without registration requirements and works with a cookie application that saves and can "remember" the individual user's selections, which may comprise up to fifty images.

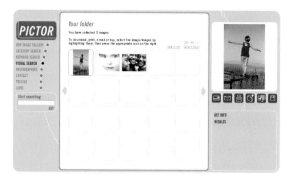

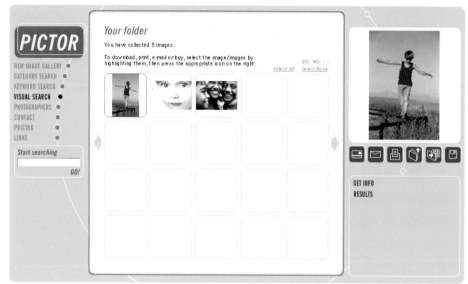

>> Additionally, this area of the navigation includes an image preview window that accommodates a portrait or landscape format with a longest side restriction of 213 pixels per inch, and an image information box that presents keyword definitions and format details on a selection.

Because so much information needed to coexist in the browser window at any one time, the screen automatically resizes to fit any browser window size, although the decision was made to optimize the viewing field for large screen monitors at 1024 x 768 ppi. This was decided because creatives generally work with large-screen monitors.

Also, as the drag-and-drop facility is a standard and much-valued feature of image-based and publishing software applications, it was included as a feature in this image library context. The screen size was therefore deliberately restricted to 920 x 540 ppi to provide a strip of visible desktop to which images can be conveniently dragged.

The navigation layout on the screen follows a logical pattern: The top-level navigation follows a traditional and logical left-hand screen format for easy reference. This is followed by the visual search grid, which occupies a considerable amount of the visual field. Finally the image selections are dragged to folders on the

site: www.pictor.com

right hands side of the screen, which also contains the preview and information windows.

Because the designers wanted to avoid the irritation of multiple windows launching and refreshing after each selection, the decision was taken to take advantage of DHTML, which enables textual content to be served to the information box dynamically, without the need of refreshing. This, of course, limited the browser choice to the latest version, and a "soft landing" or friendly browser-detection facility was written into the splash page to alert users, giving them the option to upgrade their browser if needed.

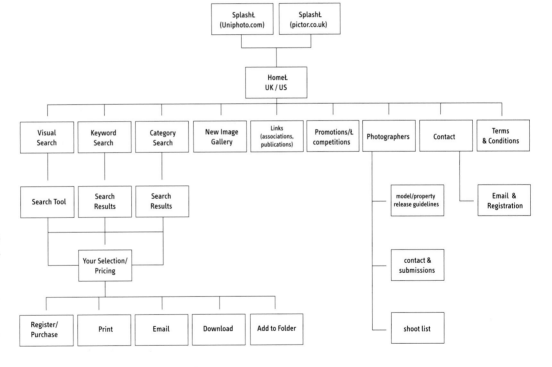

Digitas
[Boston, Massachusetts]

>>

With more than 1,400 professionals working in five offices—Boston, San Francisco, New York, London, and Salt Lake City—Digitas, Inc. supplies services from strategic assessments to media planning and buying, from back-office operations consulting to technical execution, along with world-class creative, including direct marketing and advertising, on-line and off-line.

In 1999, *Adweek* magazine awarded Digitas its President's Award, honoring the firm's "remarkable year" as the best nontraditional agency in the U.S. and placed it among the nation's top ten interactive agencies, based on overall excellence. Digitas also swept the first-ever interactive category for the American Marketing Association's Edison Award for best new products, with Web sites for Kraft Foods, L.L.Bean, and Dove Soap securing the gold, silver, and bronze stars, respectively.

The Digitas client roster includes Allstate, Amazon.com, American Century, American Electric Power, American Express, Aquent, AT&T, AT&T Wireless Services, Bausch & Lomb, BT Cellnet, Charles Schwab & Co., Inc., Delta Air Lines, Federal Express, General Motors, Harcourt General, Industry to Industry, J.C. Penney Database Marketing Services, Johnson & Johnson, L.L. Bean, Morgan Stanley Dean Witter, Neiman Marcus Group, Nicholas Applegate, Saab Cars USA, Seagram Americas, The Gillette Company, Walker Digital, and Xerox Corporation.

Test-Drive
Pontiac/GMC Redesigns

http://www.pontiac.com and http://www.gmc.com

These two projects are redesigns of virtual showrooms to provide information on the product benefits of Pontiac and GMC vehicles. The purpose of the redesign was to improve the availability and delivery of product and pricing information to a customer researching Pontiac and GMC vehicles and to standardize the navigational flow and information hierarchy across the sites.

After usability testing on the existing versions of the Pontiac and GMC sites, it became clear that most visitors were using the site to collect and analyze their purchasing options before going to the dealership. This translated into a need for a site that offered concise and up-front information and pricing in a way that made vehicle-to-vehicle comparisons easier. Also, users requested larger, clearer vehicle imagery and less subjective rhetoric and obvious salesmanship.

Since Digitas had observed that each user perused the site in his or her own way, they wanted to keep the navigation's hierarchy fairly shallow with as many navigational options as possible available on each page. They chose general navigational areas that were relevant to all of the brands and models, both within and across each division of GMC and Pontiac. The result was two sites with very different looks, but consistent navigation.

The content from each previous site was condensed, reorganized, and streamlined to contain the factual information the users requested and to downplay language that the users considered "fluff." At the same time, Digitas provided deeper and more complete information in an easily printable PDF format for those users more interested in every detail of the vehicles.

One of the largest challenges in creating such a structured and consistent site was maintaining a sense of each vehicle's personality while fitting it into strict imagery guidelines. This was achieved with different font and color combinations and a tying in of imagery from print campaigns. The technology hurdle Digitas faced was client and user requests for more and larger imagery. Although users were

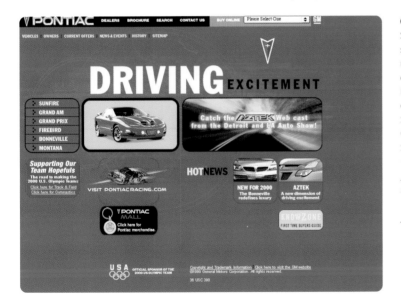

Client General Motors **Team** Dave Rollert, associate creative director; Jim McCarthy, Chuck Seeyle, design directors; Bob Maher, EVP/integrated technology solutions; Todd Alstrom, senior technology manager; Sourena Ansari, Brian O'Connor, Ramesh Sen, senior programmer analysts; Jose Ayala-Rubio, senior technology analyst; Liz Stotler, Tom Diamond, senior designers; Jennifer Querijero, Pat Centrella, Johanna Fogel, Wayne Hui, programmer analysts; Chris Anthony, production designer; Ronda Craig, copywriter; Beth Curran, new-media editor; Amy Gartland, project manager; Dan Beder, vice president/marketing director; David Shulman, vice president/associate marketing director; Wendy Karlyn, new-media manager; Craig Whitmer, Ed Brolin, Ashley Kerr, senior new media analysts; Charlie Fiordalis, Greg Sturcke, new media analysts; Christine Conly, administrative assistant; Anne Sugar, vice president/marketing director; Jennifer Callahan, associate marketing director; Shey O'Grady, Joe Pokaski, media planners; Joanne Hunt, vice president/associate director; Holly Cyr Baker, senior measurement analyst; Don DeMarco, financial analyst **Since** October 1999 **Target** Potential Pontiac/GMC customers

Tools Adobe Photoshop 5, Adobe Illustrator 8, Macromedia Fireworks 2, Adobe Acrobat, Hotmedia, HTML, Javascript **Awards** Outstanding Web site WebAward

13 14 15 16 17 18 19 20 21 22 23 24

>>

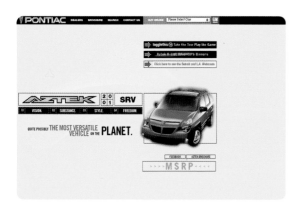

willing to withstand longer download waits for good, clear views of the cars, the team didn't want to make it necessary to download plug-ins. They turned to Hot Media's embedded 360-degree photography. This larger, rotatable image highlighted the car from every angle on a clean white background on each vehicle's home page. The image streamed in, incrementally minimizing the initial download while providing interaction and movement on the page. If the user wanted additional imagery, it could be accessed from the photo gallery. Overall, the designers feel the site answers the user demands for up-front pricing, concise and bulleted information, better imagery, and a strong sense of division and brand personality. The easy navigation and strong structure also make the next round of imagery and enhanced functionality easy to update on the fly.

>> Digitas wanted to keep the navigation's hierarchy fairly shallow, with as many navigational options as possible available on each page.

site: www.pontiac.com and www.gmc.com

>> One of the largest challenges in creating such a
structured and consistent site was maintaining a
sense of each vehicle's personality while fitting it
into strict imagery guidelines.

Gigabuys

http://www.gigabuys.com

Gigabuys.com is an on-line computer supplies store offering more than 40,000 products from dozens of manu- facturers. It is an e-commerce site that enhances Dell Computer's relationship with its customers, while opening up a new base of customers by selling products that Dell does not manufac- ture as well as competitors' computer components and accessories.

Making more than forty thousand computer-related products fit into eight product categories on a visually sparse, but involving, e-commerce Web site that provides each user with a relevant and rewarding experience seemed nearly impossible at first. That's the beauty of this new concept for Dell Computer Corporation, the world's largest direct computer seller. While Dell has clearly been a pioneer in selling its own products to con- sumers over the Web, Gigabuys is its first foray into selling other manufac- turers' products as well. Information architecture took a leading role in get- ting the company there.

As a leader whose successes have bred high standards, Dell demanded that the navigation employed be as elegant as the look and feel of the site.

To that end, user interface experts at Digitas worked closely with the site's team of graphic designers, art direc- tors, and copywriters to assure a posi- tive customer experience.

The process of creating Gigabuys.com reached its first major milestone when the Digitas team suggested the name "Gigabuys." This moniker itself was a solution. It was a clever allusion to the depth of offerings each user can find there. Still, the challenge loomed large: How to organize scanners, games, moni- tors, keyboards, add-ons, storage prod- ucts, modems, digital cameras, audio components, security devices, printers, projectors, laptops, and dozens of other product categories from more than 250 manufacturers, so that ease of use could be attained. To do it in a 600 x 800 reso- lution screen in which each page does not exceed 50K and can be successfully viewed on both old and new versions of Netscape and Internet Explorer was also a challenge.

After conducting some best-in-class research, the team at Digitas discovered that most people preferred a tab navigation system. Tabbing seemed inappropriate for Gigabuys, however, because the inelegant presentation of

Client Dell Computer Corporation **Team** Greg Johnson, EVP/worldwide creative director; Karen Dawson, creative director; Charles Reeves, associate creative director; Matt Belge, user interface; Chuck Seelye, design director; Scott Gieske, art director; George Jenkins, senior new media editor; Sarah Jones, Trevania Henderson, copywriters; Alyson Young, project manager; Alison Kuryla, technology director; Hazel Elgart, Miria Jo, David Ray, technology managers; Martin Mahoney, programmer analyst; Wendy Croft, vice president/associate marketing direc- tor; Mary Graham Weinstein, new media manager; Sharon Bernstein, senior new-media ana- lyst **Since** July 1999 **Target** The broadest spectrum of users **Tools** Adobe Photoshop, Adobe Imageready, Adobe Illustrator, Macromedia Freehand, HTML

>> Instead of tabbing, Digitas created a two-tiered, two-column, left-hand navigation system.

>>

tabs neither melded with the plan to create a visually dynamic and beautiful site, nor lent itself as easily to scalability. Instead of tabbing, Digitas created a two-tiered, two-column, left-hand navigation system. This sat well within the understated design of the site and was extremely easy for customers to use. One of the most elegant aspects of the navigation system is that users who know exactly where they want to go can get there without cumbersome clicking through unnecessary screens. Those who want to browse can immediately arrive in an area that gives them all the product choices they could want. For instance, if users know they want a Zip drive, they can click on that button in the navigation and see the listing of Zip drives available. However, should they be unsure what kind of data-storage product they require, they can access the data storage category and see a more extensive list of product choices that will assist them in locating the best product to suit their needs.

The system is also immediately scalable. As the navigation is dynamically generated and rendered not as a separate graphic but in HTML, new product categories can be added and archaic categories can be removed within the existing template. This

results in ease of maintenance for Dell's technical staff and a consistent use experience for customers.

The key left-hand navigation system is buttressed by a cunning breadcrumb trail that allows the user to see exactly where he or she is within the site and gives each user a fast, simple way to retrace their path. Additionally, special features such as a "how-to" key contained in the Learning Center and a list of "favorites" that is continually updated create the desired service aspect of the on-line store.

Since Gigabuys is a sister site to Dell, access is not only to Dell's products but to its renowned customer service, guarantees, and help functions are readily accessible on every page in the site on Dell's own horizontal navigation bar, which sits above the graphic header.

The Gigabuys user is met with a well-reasoned site that is easy to use but compelling enough to spend time browsing. By making every page— from home to the end of the checkout section—consistent in look and feel, nomenclature, and ease of use, the site has built new bridges to customers, exceeding even Dell's expectations.

The key left-hand navigation system is buttressed by a cunning breadcrumb trail that allows the user to see exactly where he or she is within the site.

Greater Outdoors
L.L. Bean

http://www.llbean.com

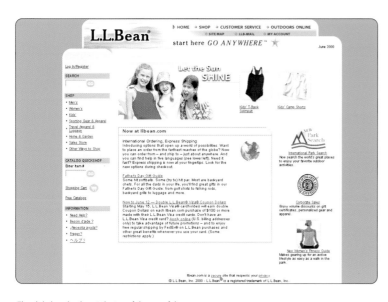

The global navigation at the top of the page follows customers throughout the entire site without changing—a constant in their on-line shopping experience.

The local navigation along the left-hand column provides customers with a clear sense of where they are as they drill down into specific departments or categories.

The L.L. Bean site is an e-commerce site designed to sell outdoor apparel and gear on-line, support and enhance brand recognition, and provide useful activity information. The site offers product images, descriptions, and the ability to order L.L. Bean merchandise on-line. The site also has a robust outdoors section with a variety of helpful information for the outdoor enthusiast, including interactive information on more than fifteen thousand state and national parks.

The rallying cry for the redesign of this site was to simplify. On the Web, new bells and whistles emerge every fifteen seconds. While many of these technologies may make for great public relations, many of them do not actually help consumers.

When Digitas redesigned L.L. Bean's Web site, they wanted to embrace good, clean navigation to help customers find what they wanted faster and easier. As one customer said, "On the Web, simplicity *is* innovation." Digitas's approach to navigation was to provide customers with a constant sense of orientation. Think of it as a "where you are in the mall" kind of compass. The global navigation at the top of the page follows customers throughout the entire site without changing—a constant in their on-line shopping experience. The local navigation along the left-hand column provides customers with a clear sense of where they are as they drill down into specific departments or categories. It's a kind of Hansel-and-Gretel approach to navigation (minus any nasty witches, of course).

These two simple navigation designs alone proved to be a huge boon to e-commerce for L.L. Bean. In usability testing, Digitas watched as user after user grasped the navigation paradigm unaided, then proceeded to navigate around the site using the navigation *not* the back button. This was no small achievement on the Web.

The team also simplified and condensed the shopping experience, starting with providing thumbnail images for all products to help people find their way around by sight rather than words. As another user said, "It's easier to click than to think."

Once users land on the specific item they want to buy, Digitas made it as easy as possible to place an order by collapsing much of the ordering information (size, color) onto one page. In addition, they requested registration information—that way all subsequent shopping can be as easy as ordering with one click.

Client L.L. Bean **Team** Steve Lynch, vice president, creative director; Jay Bernasconi, senior art director; Kristin Cooper, Glenn Matheson, Jason Prince, senior designers; Susan Swartz, designer; Sheri Kaufmann, senior copywriter; Danielle Friedman, copywriter; George Jenkins, senior new-media editor; Jennifer Burgin, vice president, senior technology manager; Jackie Agnew, senior technology analyst; Nadia Belash, vice president, associate marketing director; Mark Gordon, new-media manager; Remy Taylor, Emily Culp, senior new media-analysts; Kathie Skerry, administrative assistant **Since** September 1996 (relaunch October 1999) **Target** Active adults, ages 25 to 54

Tools Adobe Illustrator, Adobe Photoshop, HTML, IBM Net.Commerce, JavaScript **Awards** Silver Star Edison Award, A rating from *Entertainment Weekly* for on-line shopping sites; 1999 Forrester Research commendation, MIMC **Awards** Standard of Excellence WebAward, Casie Award Finalist

>> In usability testing, Digitas watched as user after user grasped the navigation paradigm unaided, then proceeded to navigate around the site using the navigation, *not* the back button.

site: www.llbean.com

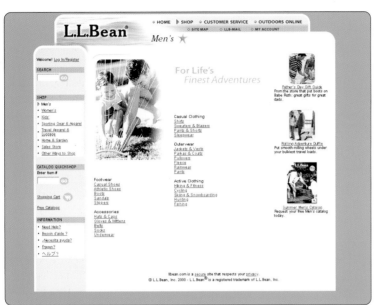

>> Once users land on the specific item they want to buy, Digitas made it as easy as possible to place an order by collapsing much of the ordering information onto one page.

Fork
[Hamburg, Germany]

>>

Fork Unstable Media was founded in 1996. The current partnership consists of Jeremy Tai Abbett, David Linderman, and Manuel Funk. The partners, along with a young team of American and German designers, programmers, and brand experts known for solving communication problems with unusual but effective ideas, round out the Fork team. Much of Fork's inspiration comes from questioning the seriousness of current media programming or propaganda and juxtaposing this seriousness with humor and a healthy lack of respect. Clients include Beiersdorf AG, makers of Nivea skin products; Lufthansa Systems Network, a daughter firm of Lufthansa Systems; Universal and Urban Records Germany; Reemtsma (a tobacco manufacturer), and the Media Academy Cologne, to name a few.

Fork Unstable Media's idiosyncratic vision has been widely recognized by the press, and many projects have been published in books and magazines. The San Francisco Museum of Modern Art has acquired three of Fork's projects for their permanent collection. "The most interesting interaction is that of a baby and its environment," says Jeremy Abbett. "A baby has little experience to base its reactions upon, so multiple attempts are made. This is not unlike the way we like to create a lot of our interfaces for navigation. Users may not understand it at first, but after successive attempts, they will be able to assimilate the meaning. To move ahead we have to keep things fun and frustrating, and at the same time make sure that it is all playful."

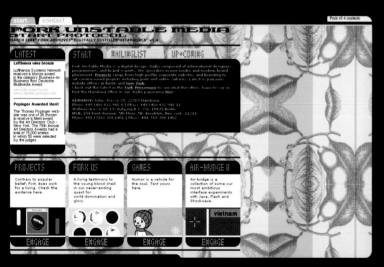

01 02 03 04 **05** 06 07 08 09 10 11 12

site: www.fork.de

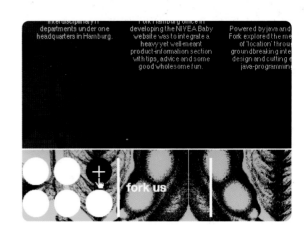

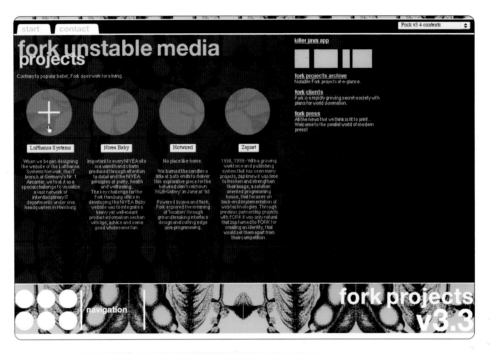

fork unstable media

projects

Contrary to popular belief, Fork does work for a living...

killer java app

fork projects archive
Notable Fork projects at-a-glance.

fork clients
Fork is a rapidly growing secret-society with plans for world domination.

fork press
All the news that we think is fit to print... Welcome to the parallel world of modern press!

Lufthansa Systems

When we began designing the website of the Lufthansa Systems Network, the IT branch of Germany's Nr. 1 Aircarrier, we took it as a special challenge to visualize a vast network of interdisciplinary IT departments under one headquarters in Hamburg.

Nivea Baby

Important to every NIVEA site is a warmth and charm produced through attention to detail and the NIVEA principles of purity, health and wellbeing. The key challenge for the Fork Hamburg office in developing the NIVEA Baby website was to integrate a heavy yet well-meant product-information section with tips, advice and some good wholesome fun.

Hotwired

No place like home.

We burned the candles a little at both ends to deliver this explorative piece for the hot-wired clan's reknown 'RGB-Gallery' in June of '98.

Powered by java and flash, Fork explored the meaning of 'location' through groundbreaking interface design and cutting edge java-programming.

Zapnet

1998, 1999 - With a growing workforce and publishing system that has seen many projects, zap knew it was time to freshen and strengthen their image, a solution oriented programming house, that focuses on back-end implementation of web technologies. Through previous partnership projects with FORK it was only natural that zap turned to FORK for creating an identity, that would set them apart from their competition.

navigation

fork projects
v3.3

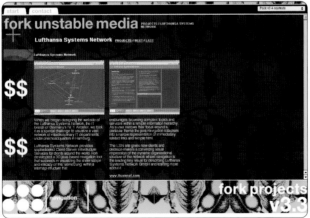

fork unstable media

PROJECTS / LUFTHANSA SYSTEMS NETWORK

Lufthansa Systems Network PROJECTS / NEXT / LAST

Lufthansa Systems Network

$$

$$

When we began designing the website of the Lufthansa Systems Network, the IT branch of Germany's Nr. 1 Aircarrier, we took it as a special challenge to visualize a vast network of interdisciplinary IT departments under one headquarters in Hamburg.

Lufthansa Systems Network provides sophisticated Client-Server infrastructure Services for clients around the world. Fork developed a 3D java-based navigation tool that succeeds in visualizing the sheer scope and intricacy of this 'vernetzung' within a sitemap-structure that

encourages browsing complex topics and services within a simple information hierarchy. As a user moves their focus around a particular theme the java navigation collapses into a narrow representation of immediately related links and simple html.

The LSN site gives new clients and decision-makers a convincing visual impression of the dynamic organisational structure of the network whilst navigation is the leading key visual to describing Lufthansa Systems Network GmbH and learning more about

www.lhsysnet.com

navigation

fork projects
v3.3

Visualizing IT
Lufthansa Systems Network

http://www.lhsysnet.com

When Fork Unstable Media began conceptualizing the site for Lufthansa Systems Network, one of the information technology (IT) agencies of Germany's top airline, the designers took it as a special challenge to visualize a vast network of interdisciplinary IT departments under the company's head office in Hamburg, Germany.

Lufthansa Systems Network provides sophisticated infrastructure IT services for clients around the world. Fork Unstable Media developed a three-dimensional, Java-based navigation tool that succeeds in visualizing

the sheer scope and intricacy of this network. The 3-D navigation encourages browsing complex topics and services within a simple information hierarchy. As the user concentrates on a particular theme, the navigation zooms into a focused representation of immediately related topics. The 3-D model can be manipulated by users, allowing them a feeling of how the various points of the model relate to one another and as a whole. Audio clues are also used, as well as visual clues that respond to the user's actions.

Client Lufthansa Systems Network/ POB **Team** Jeremy Tai Abbett, creative director, designer; Manuel Funk, project manager; Jan-Michael Studt, technologist; Andrea Mittmann, screen designer **Since** March 1999 **Target** Clients and decision makers interested in the IT services Lufthansa Systems Network has to offer

Tools Adobe Photoshop, Adobe Illustrator, Allaire Homesite Builder **Awards** Bronze Award from the German Multimedia Awards in the Business to Business category

site: www.lhsysnet.com

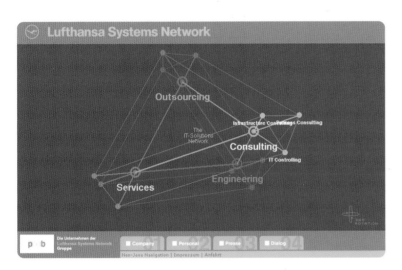

>> As the user concentrates on a particular theme, the navigation zooms into a focused representation of immediately related topics.

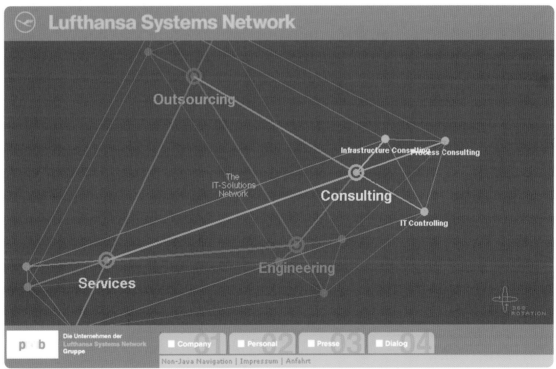

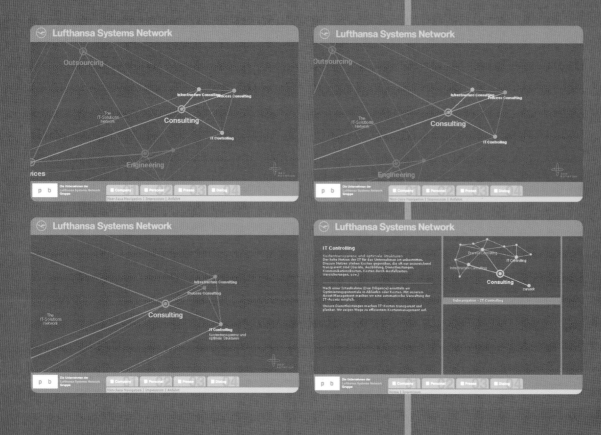

>> "The most interesting interaction is that of a baby and its environment. A baby has little experience to base its reactions upon, so multiple attempts are made. This is not unlike the way we like to create a lot of our interfaces for navigation."
— Jeremy Tai Abbett, partner

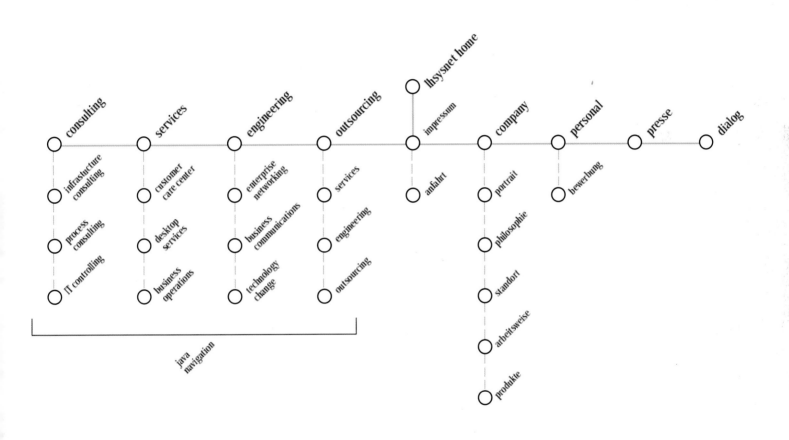

http://www.timm.com

Futurefarmers

[San Francisco, California]

>> Formed in 1995 by Amy Franceschini, Futurefarmers is a self-described "new-media construct" specializing in data visualization via 3-D animation, Web design, interface design, print, games, motion graphics, and environmental design. In its short lifetime, the studio has earned a reputation for a uniquely evocative visual style and fresh approach to interface design. Equally comfortable in new and traditional media, Futurefarmers has completed distinctive print and electronic assignments for major clients including the *New York Times*, G-Shock, Levi's, Autodesk, Nike, NEC, and MSNBC. The studio actively partners with other studios, notably AirKing, SoundDesign, and SAS21, to fully realize their creative capabilities. Prior to founding Futurefarmers, Franceschini was a designer for *Atlas*, an on-line magazine that garnered numerous awards for its dramatic and unorthodox approach to on-line publishing and design. In 1997, the *Atlas* Web site was selected as the first to be included in the permanent collection of the San Francisco Museum of Modern Art. The site has won two Webby awards for Art and Design as well as many other on-line and publication design awards.

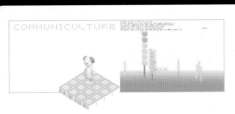

COMMUNICULTURE

We invite you to participate in the development of Communiculture. This is an ongoing development of an on-line community. Please explore this space and offer any suggestions or criticism. Claim a plot, but beware the ground is very fertile, and things may change frequently. Send comments to [_____].

//currently

www.linn.com - Check out air king's ambient soundscape on this prestigious gallery's flash enhanced site.

Bay Area Now 2 @Yerba Buena - air king creator data driven sound design for Amy Franceschini's "Holding Patterns" installation at Yerba Buena Center For The Arts in SF, which ran from 11.19.99 to 02.19.00. Hear an excerpt of the sound from the show....

Nutrishnia @ ResFest 99 - future farmers' record collaborative cd-rom released 9-9-99. Air King scores the Tak Tak game. It's a cool CD and a cool Web site.

New MP3s! - check out our new collection of air king mp3s. Updated weekly.

Hotwired RGB Gallery - air king adds some sounds to Future Farmers' circus of images and ideas about location and transportation called "Destination". Check it out!.

more.......

call us: 415.640.3713
email us: info@airkingsound.com

A Virtual Showroom
Limn Co.

http://www.limn.com

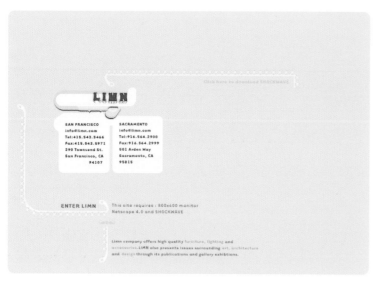

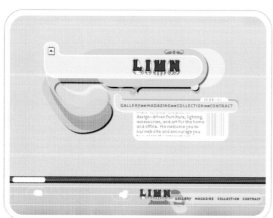

An unusual amalgam of retail and education, San Francisco–based Limn Co. offers high-quality furniture, lighting, and accessories. Limn also presents issues surrounding art, architecture, and design through its publications and gallery exhibitions. The Web site features a broad overview of the Limn experience, as well as sections for the four main activities at Limn: Limn gallery, *Limn* magazine, Limn collection, and the Limn contract department.

With its landmark architecture, art gallery, furniture showroom, and café, Limn provides an unusual experience to visitors to the physical site. Consequently, the Web site had to reflect the idea of a "Limn Experience." The goal was to offer Web users a glimpse of this experience, if only to whet their appetites for an actual visit to Limn Co.'s two showrooms in San Francisco and Sacramento, California.

Because Futurefarmers develops a wide range of design solutions, their goals, methodology, and philosophy are constantly evolving. The navigational environments that they create reflect the interests of the audience and the motivations of the client. The goal is to educate users as they interact, slowly pushing them into more sophisticated and meaningful methods of navigation.

Once Futurefarmers reaches a point in the design process at which they know what the goals and audience for

a Web site will be, they begin to break down the requirements into two categories: the actual content requirements and the functional and technical requirements that are needed to build the site. These two sets of requirements are developed on a parallel track. Ideally, this method of working allows the two sets of requirements to grow off of one another during development. The easiest way to approach the navigation design from this point is from the user's perspective. It is important to provide some consistent navigational elements to give the user comfort and the confidence to delve further into the site. With Limn Co., the team was also working to encourage exploration by incorporating the unexpected. By doing so, the site introduces users to previously unfamiliar types of interaction, expanding their knowledge in preparation for more advanced navigation in the future.

Futurefarmers is known for surprises. The studio approaches navigation differently for every client; for Limn Co. they addressed it much like they would an experimental art experience. The navigation features various unexpected branching and juxtapositions, with the idea that users will discover something new every time they visit the site. There are interactive surprises everywhere—some are easily accessible, while others may simply never be found.

Client Limn Co. **Team** Amy Franceschini, creative director, designer; Keetra Dixon, designer; Joshua Walton, designer and DHTML and Shockwave programmer **Since** January 2000 **Target** High-end users

Tools Adobe Photoshop, Adobe Illustrator, Macromedia Director, Adobe ImageReady, Macromedia Dreamweaver, SoundEdit, HTML, DHTML, BBEdit, Simpletext

site: www.limm.com

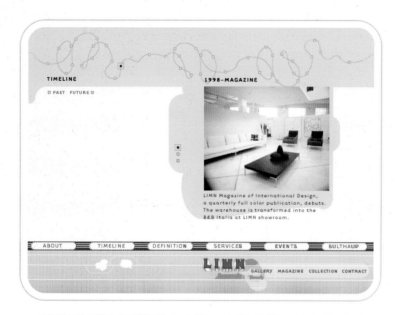

TIMELINE 1998-MAGAZINE

◻ PAST FUTURE ◻

LIMN Magazine of International Design,
a quarterly full color publication, debuts.
The warehouse is transformed into the
B&B Italia at LIMN showroom.

ABOUT TIMELINE DEFINITION SERVICES EVENTS BULTHAUP

LIMN
GALLERY MAGAZINE COLLECTION CONTRACT

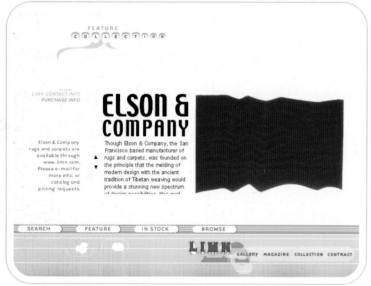

FEATURE
COLLECTION

LIMN CONTACT INFO
PURCHASE INFO

Elson & Company
rugs and carpets are
available through
www.limn.com.
Please e-mail for
more info. or
catalog and
pricing requests.

ELSON & COMPANY

Though Elson & Company, the San
Francisco based manufacturer of
rugs and carpets, was founded on
the principle that the melding of
modern design with the ancient
tradition of Tibetan weaving would
provide a stunning new spectrum
of design possibilities, this goal

SEARCH FEATURE IN STOCK BROWSE

LIMN
GALLERY MAGAZINE COLLECTION CONTRACT

limn:

1) an old English verb meaning
to "draw or illuminate." For
centuries, limners have
embellished and illuminated
the pages of classic texts
with intricate flourishes.

2) the multicolored shimmer
above a body of water that
lasts for only moments
before the sun sets.

LIMN: a San Francisco based,
multi-level resource for design-
driven furniture, lighting,
accessories, and art for the
home and office.

ABOUT TIMELINE DEFINITION SERVICES EVENTS BULTHAUP

LIMN
GALLERY MAGAZINE COLLECTION CONTRACT

CONTRACT

Sales Manager:
Molly Garman

phone:
415-909-0183

fax:
415-543-3500

LINE LIST				
Acerbis	Creative Wood	Herman Miller	Ligne Roset	Steelmobil
Alias	Conde House	for the Home	Matteo Grassi	Tecno
Arco	Dauphin	Heron Parigi	Minotti	Thonet
Artelano	De Pedova	HBF	Magis	Touhy
Artex	Dema	ICF	Molteni & Co	Vitra
B&B Italia	De Sede	Inform	Montis	Vecta
Bright Eyes	De Salto	KI	Mondo	Wittman
B.D. Ediciones	Davis	Kartell	Nola	Wilkhahn
Baleri Italia	Driade	Keilhauer	Nienkamper	W. Coast Industries
Bonacina	Fiam	Knoll Studio	Pallucco Italia	XO
Cappellini	Flo	Lowenstien	Porada	Woodtech
Cassina	Fontana Arte	Leland	Poltrona Frau	Ycami
Classicon	Giorgetti	Label	Ron Rezek	Zanotta

LIMN
GALLERY MAGAZINE COLLECTION CONTRACT

site: www.limm.com

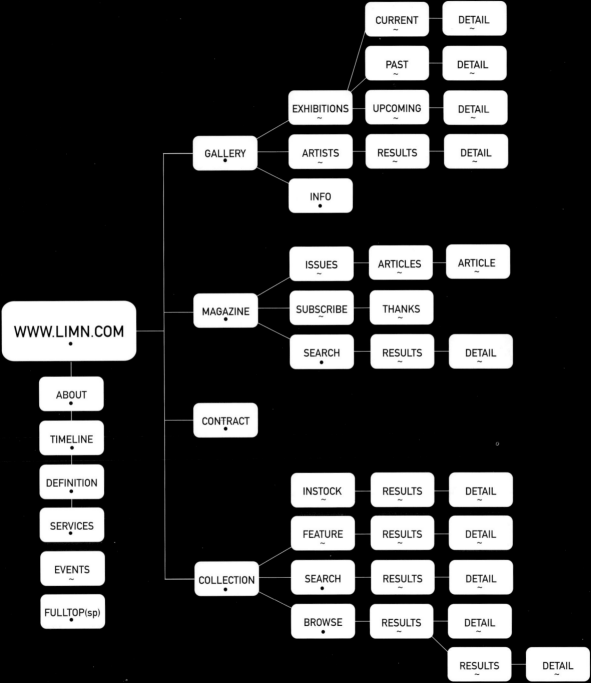

WWW.LIMN.COM

- ABOUT
- TIMELINE
- DEFINITION
- SERVICES
- EVENTS ~
- FULLTOP(sp)

GALLERY
- EXHIBITIONS ~
 - CURRENT ~ → DETAIL ~
 - PAST ~ → DETAIL ~
 - UPCOMING ~ → DETAIL ~
- ARTISTS ~
 - RESULTS ~ → DETAIL ~
- INFO

MAGAZINE
- ISSUES ~ → ARTICLES ~ → ARTICLE ~
- SUBSCRIBE ~ → THANKS ~
- SEARCH → RESULTS ~ → DETAIL ~

CONTRACT

COLLECTION
- INSTOCK ~ → RESULTS ~ → DETAIL ~
- FEATURE ~ → RESULTS ~ → DETAIL ~
- SEARCH ~ → RESULTS ~ → DETAIL ~
- BROWSE → RESULTS ~ → DETAIL ~
 - RESULTS ~ → DETAIL ~

Genex Interactive is a full-service interactive agency with a taste for strategic thinking. "We know how to fuse award-winning design and cutting-edge technology to deliver specific and successful results," their Homepage says. "We take time to understand our clients' business, brand" and bottom line. It makes a difference.

"Each Genex project becomes a customized solution. Our specialty is understanding the big picture. And we do everything from strategic consulting to on-line media planning to e-commerce to networked kiosks. With a highly creative and talented staff, powerful tools, and a lively studio, Genex is committed to doing great work and enjoying the process as well as the results."

Molecular Details
NSXbyAcura.com

http://www.NSXbyAcura.com

For sports-car enthusiasts, the NSX is a thing of beauty and mystique. This eye-catching site was created to showcase the history of the legendary NSX, provide a detailed look into its engineering, and offer a taste of the passion for performance that drove its creation. The site has significant content: stories of NSX development and engineering are revealed here for the first time. The 3-D, interactive navigation system illustrates the molecular level of detail that is now available. Information is presented along two paths—Passion and Technology—so visitors can get both perspectives of relevant topics. The goal of this site was to provide an extended brand experience for NSX owners and enthusiasts, create interest with those who are not currently familiar with the brand, and reflect the impressive technology and craftsmanship of the NSX vehicle.

Though Genex creates a wide variety of sites for a very diverse group of clients, their approach to navigation design tends to be consistent. In general, they prefer that sites not have more than four levels of content, and they try to limit available choices on any given level to a maximum of eight levels. They also like to use hypertext links within copy to emphasize navigation choices particularly relevant to the content on that page, and to help give those choices context. They are particularly resistant to "dead ends" in content architecture, and avoid back buttons "like the plague." Instead, if content elements need to be free-standing or contain unique navigation, they typically open new, smaller windows to house them, allowing users to simply close them when done.

The designers favor multistate, rollover-based navigation schemes to help users discern which elements are

Client Acura Division of American Honda Motor Company **Team** David Glaze, creative director; Chip McCarthy, art director; Jason Harris, art production; Tony Assenza, copywriter; Kevin McManis, producer; Pete Moran, associate producer; Chris McClister, engineer; Franck Leveneur, engineer; Brendan Murphy, programmer **Since** March 1999 **Target** Owners and enthusiasts of Acura NSX vehicles, drivers and prospects of competitive-model sports cars

Tools Adobe Photoshop/ImageReady, Allaire HomeSite, Apple QuickTime, Macromedia Shockwave and Director **Awards** Macromedia Shocked Site of the Day, *Communication Arts* Site of the Week

(left) In addition to the usual welcoming copy and instruction about plug-in requirements, the NSXbyAcura.com site makes navigation elements accessible immediately. Global elements, located in the upper-right corner, are easily recognizable and available throughout the site. These elements address basic and universal topics of interest, including the Gallery and Enthusiasts sections, links to Acura.com and American Honda Finance, an NSX dealer locator, NSX brochure-request form, and a site map.

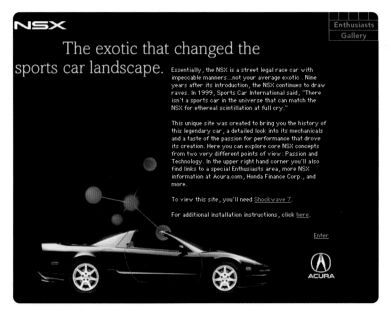

NSX

Enthusiasts
Gallery

The exotic that changed the sports car landscape.

Essentially, the NSX is a street legal race car with impeccable manners...not your average exotic. Nine years after its introduction, the NSX continues to draw raves. In 1999, Sports Car International said, "There isn't a sports car in the universe that can match the NSX for ethereal scintillation at full cry."

This unique site was created to bring you the history of this legendary car, a detailed look into its mechanicals and a taste of the passion for performance that drove its creation. Here you can explore core NSX concepts from two very different points of view: Passion and Technology. In the upper right hand corner you'll also find links to a special Enthusiasts area, more NSX information at Acura.com, Honda Finance Corp., and more.

To view this site, you'll need Shockwave 7.

For additional installation instructions, click here.

Enter

ACURA

>> The site has significant content: stories of NSX development and engineering are revealed here for the first time. The 3-D, interactive navigation system illustrates the molecular level of detail that is now available.

>>

A Mind Meld of Passion and Technology

Begin

Like all great sports cars, the NSX is the product of a small team of dedicated, passionate car enthusiasts. Their approach to building it is take-no-prisoners. Their ambitions for it are way beyond any parameters ever established for an exotic car.

What drives them is passion. And what transforms that passion into aluminum, steel and titanium is technology. Most of it brand new technology, created to make the impossible possible. More than any car in its class, the NSX is a potent elixir poured full strength in equal parts adrenaline, innovation and exquisitely crafted aluminum.

The stories you'll explore in this site reflect this convergence of the emotion behind the NSX's creation and its mechanical brilliance.

From the design perspective, this page was considered the "book cover" because it reinforces the molecule theme and prepares visitors for the site experience. Genex takes an unusual approach to standard automotive information architecture by organizing the content into five sections: speed, control, form, creation, and origin. Each of these sections can be viewed through one of two "filters," Passion or Technology. And in accordance with Genex's standard philosophy of site design and programming, copy and images become immediately available while the ShockWave navigation loads.

active and which have been selected. This type of navigation, coupled with an interface that shows all superior levels of navigation at once, also tends to obviate the need for more formal site maps—"bread-crumb trails"—to orient the user. That said, they still favor the inclusion of site maps, primarily to give users access to a quick "snapshot" of the entire site and its contents. Obviously, there are always exceptions. The NSX site is in fact just such a case.

This site's unusual "molecular" navigation paradigm is a reflection of the project's marketing goals, its target audience, and the type of content to be navigated. Certainly, most navigation systems strive to offer clarity and utility above all else—a logical goal given that visitors to most sites are actively seeking specific information. In contrast, the main NSX navigation is designed to intrigue users, foster exploration, and encourage them to draw their own conclusions, while still keeping them well oriented. The moving interface helps achieve this, as do the somewhat abstract names chosen for the main sections. As the user moves

down through content levels, the naming becomes more self-explanatory.

Engineering the behavior of the 3-D molecular navigation was a challenge, particularly given the file-size constraints of a Web-based application. Not only did the molecule have to turn in space, with all the relevant shifts in element size and focus, each element also had to change state across the vertical equator between Passion and Technology. And this change was not simply visual: as the navigation elements crossed the equator, each also had to target new content.

The more "pragmatic" content in the site is immediately accessible at any time through a set of global links at the top of the page. These elements typically open in a new window, providing users with navigation interfaces that are better suited to the contents of those sections.

The Gallery, accessed through one of the global links, has an interesting navigation of its own. Rather than having to scroll a page of thumbnail images, users simply roll over a grid of small squares. As they do, each square is illuminated and a thumbnail image

site: www.NSXbyAcura.com

associated with that square snaps into view. Clicking on any square brings the image to full size, and a high-resolution version can then be downloaded. As other images are chosen, previously selected squares in the matrix dim to indicate they have already been viewed. This section also showcases a few video and QTVR pieces and these are indicated by a different color in the grid.

Despite the unusual interface, much of the philosophy described has been applied to this site. All navigation elements have multiple rollover states, some even trigger animations. Outbound links and freestanding elements like the Gallery and Enthusiasts section all open in new windows. The navigation is also fully hierarchical—showing all levels of directly superior content at all times.

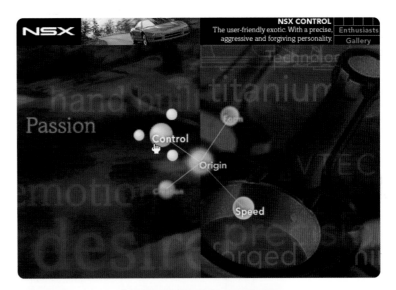

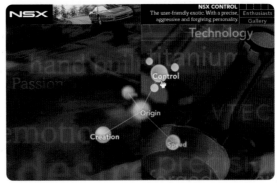

Upon entering the site, visitors have complete control of the 3-D molecular navigation. As the main spheres move across the vertical divide, they offer access to information on NSX Passion or Technology, illustrating the balance of the car's design between advanced technology and exotic design. These three images show the rotation of the molecule and the change in content available as the spheres move to different locations within the rotation.

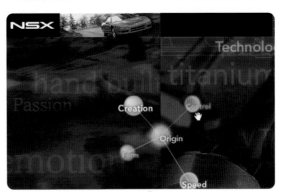

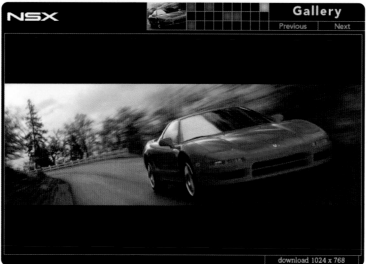

NSX enthusiasts are rewarded for visiting the Gallery with eye-catching, high-resolution images that are rarely downloadable from a single source. To avoid creating a full page of thumbnail images, Genex created a unique navigation solution. The grid enables visitors to see a preview of each image. Clicking on the square brings up a full screen version and a link to a downloadable file. Squares in the grid "burn out" to indicate which images have already been seen and different colors are used to indicate media types. Green squares hold images while purple squares hold QuickTime movies and QTVRs.

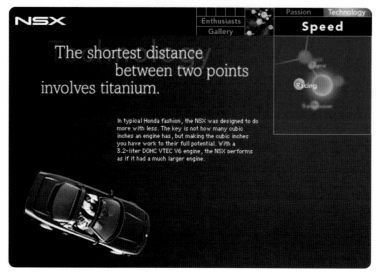

A sample page from the racing section as seen through the Passion filter that shows the technical and engineering information about the Acura NSX sports car. Within the subnavigation molecule, additional information can be seen and is now available.

site: **www.NSXbyAcura.com**

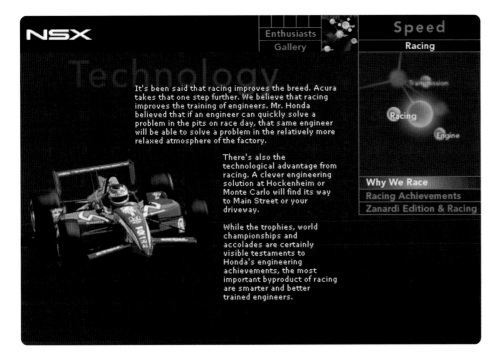

Because it's important to help visitors keep track of their progress and location within a site, visitors use subnavigation, a component of the 3-D molecule, to view content within each section. The primary navigation is available at the top of the screen at all times. Here, visitors can access the Enthusiasts and Gallery sections immediately or they can see where they are within the site via the molecule diagram.

Icon Nicholson

[New York, New York]

>> Founded in 1987, Nicholson NY rapidly became a recognized leader in interactive communications. Early work included some of the first ATMs, kiosks, and interactive installations for museums and exhibitions. Interactive media soon gave way to a new rapidly emerging platform for interactive communications—the Internet. Many of the skills Nicholson had already mastered could be brought to this new environment. In 1994, Nicholson NY began developing award-winning Internet sites for IBM, NBC, *Reader's Digest*, and Condé Nast. The company became recognized experts in information architecture, graphic design, and interactive content. Work also began on the massive four-year interactive exhibit project for the Mashantucket Pequot Museum and Research Center. Later that year, Icon Nicholson invested in a fully staffed engineering department that obviated the need to outsource applications development and systems integration functions.

In December 1999, Nicholson NY joined forces with Icon Medialab, the leading global Internet professional-services firm, to become Icon Nicholson. Icon Nicholson possesses a technology team experienced in all relevant operating platforms, databases, Web servers, Web application technologies, middleware, search engines, e-commerce technologies, personalization/ customization software, custom software development, and legacy systems integration.

 01 02 03 04 05 06 07 **08** 09 10 11 12

site: www.icon-nicholson.com

The Metropolitan Museum of Art

http://www.metmuseum.org

Icon Nicholson's brief in redesigning the Met's Web site was to create an on-line presence to help increase visitor attendance and, at the same time, reach a wider audience of people who couldn't visit the museum in person. Attendant goals were to personalize relationships with art patrons, provide researchers with access to works of art and information about those works, offer a robust environment for learning, educate the public about art, expand the museum store's retail sales through the on-line store, and reach a wider audience.

The result was a new and improved Web site that opens with a splash page that every day features a new object in the collection, and later, images of more than 3,500 works of art from the museum's collection with information on the works. Many of the images are formatted to allow a user to zoom in and see close-ups, examine brushstrokes, or what have you. The My Met Gallery feature allows users to set up their own private collection of their favorite pieces of art. Hundreds of pages of description about the museum's educational programs and resources—libraries, lecture series, films, tours, and lesson plans for teacher, among others—are also included.

Other features include interactive activities that teach about art and art history; an interactive, searchable calendar that displays thousands of events at the museum and allows users to plan visits; a news area for up-to-date information about goings-on at the Met including an archive of press releases for members of the press; an on-line store with art-related products; a membership area that allows users to join the museum on-line using their credit cards; and a secure area of the site for members only that has downloadable screensavers and specials available in the store as well as a special exhibitions area including highlight images and text.

Client The Metropolitan Museum of Art **Team** Lisa Waltuch, creative director; Matt Berninger, art director; Marshall Curry, senior producer; Mayumi Sato, David Morrow, Maya Kopytman, designers; Jason Wurtzel, lead engineer; Colin Rand, Ommerson Constant, Ilya Pivnik, Adam Etline, Oleg Barshay, Ben Abraham, Alex Tween, Zasha Weinberg, Gela Fridman, David Frenkiel, Jim Powers, Venkat Vallurupalli, Anil Nair, engineering team; Marc Borkan, Elizabeth Hure, information architects; Maymui Sato, HTML/art production; Bobby Kim, Jay Soucy, Al Forestier, HTML **Since** January 2000 **Target** Educators, students, scholars, shoppers, artists, tourists, and anyone interested in art

Tools Intel-based PC running Windows NT; Adobe Photoshop, HomeSite, DeBabelizer, MS Siteserver, Visual Interdev, Visual C++

The home page is the "root" of the site and the next level includes: The Collection, Special Exhibitions, Explore & Learn, Calendar, The Met Store, Sign Our Guestbook, Support the Met, Educational Resources, Membership, News from the Met, and Visitor Information. Another part of the studio's navigational philosophy is "multiple access points." So users will reach the information they want, and, in order to accommodate different approaches to the Web, the design provides multiple ways of getting to the same information. From the home page, a user can get to the store from the text link on the left side of the screen, or from the icon link on the right side of the screen. Depending on the type of promotion the Met wants to do, a product could also be featured on the home page, thus allowing three links to the store from the home page. There are many links under these main areas of the site.

1

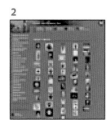

2

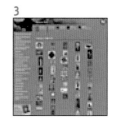

3

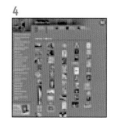

4

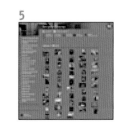

5

4a

5a

4b

5b

5c

Since this Web site is so huge and high-
ly dynamic, there is no tree diagram
that displays the whole site with all its
potential links, results, and personal-
ized pages. Instead, the team made
smaller diagrams for each area in the
earlier phases of their development
process. The site does follow a general
tree model and the relationships are
reinforced by the navigational scheme.

site: **www.metmuseum.org**

>> The design team learned from watching many user tests that visitors
 will be more likely to click the back button on their browsers many
 times than they will be to use the internal navigation of the site.

6

7

6b

>>

The development of Web sites has moved away from putting up static pages—brochureware—to sites that take advantage of technology and are more dynamically driven. As sites continue to evolve this way, the familiar hierarchical tree structure for navigation is less and less relevant.

The goal of any navigation is to make it simple and clear, so users don't feel lost or disoriented at any time. The Met's collections are so vast and their offerings in other areas such as education modules, the store, and the calendar are so engrossing that the designers decided that the navigation should be as simple and intuitive as possible, focusing on the content of the site while still maintaining a sophisticated look and feel associated with an institution such as The Met.

In their statement, the team at Icon Nicholson says, "We believe that a continuum exists in interface design: on one end of the spectrum is the transparent or intuitive interface and on the other end is the entertaining interface. With the Met Web site, our goal was to stay on the transparent end, so users wouldn't have to spend time figuring out how to get the information they wanted, although some of the education modules may deviate from this methodology because their purpose is, in some cases, to entertain the user with games and challenges."

>>

Many times, the division of areas and the names of titles are understandable to an institution internally but fail to communicate well externally. Feeling that by limiting the navigational options the user would be less likely to get lost, the designers divided the various departments into understandable areas from an outside-user perspective and gave them titles that were clear and unequivocal. The team simplified the site-wide navigation to the bare minimum on the level below the home page by only including a link to home. For instance, if a user linked to Membership from the home page, the site-wide navigation at the top only includes home. If he links one level deeper within Membership, his navigation options at the top expand to two, back to the top level of Membership or home.

The design team also learned from watching many user tests that visitors are more likely to click the back button on their browsers many times than they are to use the internal navigation of the site. This happens for two reasons: users are familiar with the navigation associated with their browser because they use it frequently, and they don't use the navigation in individual Web sites as often. They tend toward things they understand and feel comfortable with, but are also likely to reorient themselves from the home page before deciding where they want to go next. Therefore, the designers made the internal navigation easy—one or two navigational buttons at the top-left corner instead of the entire site navigation. This approach served the novice user best. For the expert or frequent user, the team provided site-wide navigation in HTML at the bottom of every page because these users tend to be more comfortable jumping around from section to section within a site and not feeling disoriented or lost.

site: www.metmuseum.org

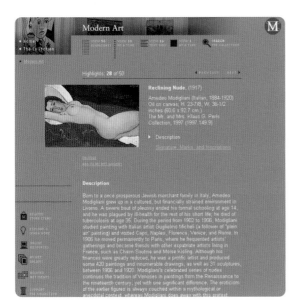

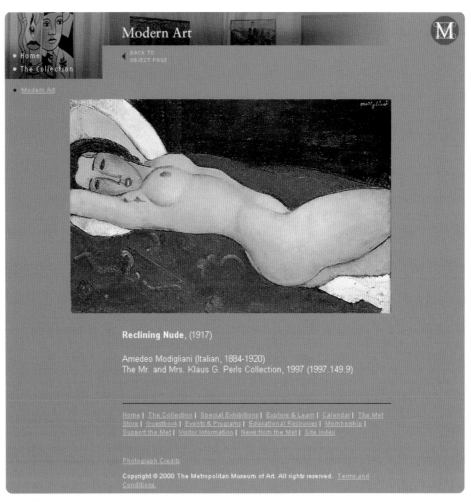

The Met has over twenty different curatorial departments. Some people may be familiar with all of these collections, but many others may think of the collections as only containing paintings and sculptures. The challenge was to serve a novice user, an expert user, someone familiar with the museum, and someone unfamiliar with the museum. In order to accomplish this goal, the designers provided duplicate information on the Collections page. Down the left side is an alphabetical list of all the titles of the collection areas. Down the center of the page, the list is duplicated but with added images and descriptive text of each dept. Users unfamiliar with the museum can browse the list in the center to get a better idea of where to go next. Those who know exactly what they want to see are more likely to choose the easy-access navigation on the left.

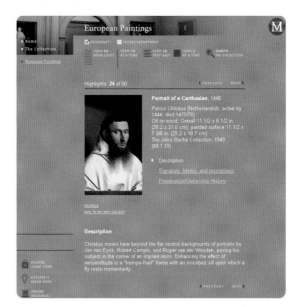

site: www.metmuseum.org

Screen 1 — Asian Art Books

Books

VIEW BASKET | CHECK OUT | BECOME A MEMBER AND SAVE 10%

- Home
- The Met Store

- Books
- Music
- CD-ROMs and Educational Materials
- Videos

- Sculpture
- Limited Editions
- Posters
- Prints

- Jewelry
- Accessories
- Ties
- Scarves

- For the Home
- Stationery and Calendars
- For Kids

- Browse the Met Store
- Special Values
- Gift Guide
- From Our Exhibitions
- Featured Items
- Special Offers for Members

Search the Met Store:

Asian Art Books

Art of Island Southeast Asia: The Fred and Rita Richman Collection
Member Price: $26.95
Non-Member Price: $29.95
ADD TO BASKET

Arts of Korea
Member Price: $45.00
Non-Member Price: $50.00
ADD TO BASKET

Asia
Member Price: $31.50
Non-Member Price: $35.00
ADD TO BASKET

East Asian Lacquer: The Florence and Herbert Irving Collection
Member Price: $17.95
Non-Member Price: $19.95
ADD TO BASKET

The Lotus Transcendent: Indian and Southeast Asian Sculpture from The Samuel Eilenberg Collection
Member Price: $17.95
Non-Member Price: $19.95
ADD TO BASKET

Sacred Visions: Early Paintings from Central Tibet
CHOOSE STYLE/SIZE

Splendors of Imperial China
Member Price: $26.95

Screen 2 — Arts of Korea

Books

VIEW BASKET | CHECK OUT | BECOME A MEMBER AND SAVE 10%

- Home
- The Met Store

- Books
- Music
- CD-ROMs and Educational Materials
- Videos

- Sculpture
- Limited Editions
- Posters
- Prints

- Jewelry
- Accessories
- Ties
- Scarves

- For the Home
- Stationery and Calendars
- For Kids

- Browse the Met Store
- Special Values
- Gift Guide
- From Our Exhibitions
- Featured Items
- Special Offers for Members

Search the Met Store:

PREVIOUS | NEXT

Arts of Korea

ARTS of KOREA

ENLARGE

Edited by Judith G. Smith, with essays by Chung-Yang-mo, Ahn Hwi-joon, Yi Song-mi, Kim Lena, Kim Hongman, Pak Youngsook, and Jonathan W. Best; entries in colorplate section by Hongkyung Anna Suh; 1998

This catalogue highlights one hundred of the finest examples of Korean ceramics, metalwork, and decorative arts, Buddhist sculpture, and painting. One of the few English-language volumes to be published on the subject, Arts of Korea is a comprehensive introduction to an important East Asian cultural and artistic tradition.

512 pages, 350 illustrations (148 in full color). 8 3/4 in. x 12 1/4 in. Cloth.

Arts of Korea, Cloth
E0135
Member Price: $45.00 each
Non-Member Price: $50.00 each

Quantity: 1
ADD TO BASKET

Screen 3 — Calendar

CALENDAR

SEARCH FOR EVENTS | SET MY MET CALENDAR

- Home

Jan ▼ 2000 ▼

S M T W T F S
1
2 3 4 5 6 7 8
9 10 11 12 13 14 15
16 17 18 19 20 21 22
23 24 25 26 27 28 29
30 31

Available ONLINE in the Met Store

Get definitions and general information about the event types at right in Events & Programs.

Subscribe to our Concerts & Lectures series.

Find out how to travel with the Met.

Tuesday: January 11, 2000

ALL EVENTS | MY MET CALENDAR | SPECIAL EXHIBITIONS

EXHIBITION

"Only the Best": Masterpieces of the Calouste Gulbenkian Museum, Lisbon
On display while the Gulbenkian Museum in Lisbon is being renovated are highlights from the collection, including masterpieces by Rubens, Fragonard, Turner, Manet, and Monet.
Special Exhibition Galleries, adjacent to the New Greek Galleries, 1st floor
Through February 27, 2000
REMIND ME | EMAIL A FRIEND

EXHIBITION

Ancient Near East Galleries: Shining New Light on an Assyrian Palace
The Gallery has been renovated and is now illuminated by natural light
Ancient Near Eastern Art, 2nd floor
Through December 31, 2000
REMIND ME | EMAIL A FRIEND

EXHIBITION

Celebrating The American Wing: Notable Acquisitions, 1980–1999
American decorative and fine arts acquired by the museum between 1980 and 1999
The American Wing Galleries
Through November 12, 2000

iXL's formula for success

- Know your audience
- Implement a usability test in the beginning, middle, and final stages of development
- Always offer multiple buying paths
- Provide gratifying experiences

iXL
[Chicago, Illinois]

>> iXL, Inc. is a leading strategic Internet services company that provides on-line strategy consulting and comprehensive Internet-based solutions to Fortune 1000 companies and other corporate users of information technology. iXL helps businesses identify how the Internet can be used to their competitive advantage and uses its expertise in creative design and systems engineering to design, develop, and deploy advanced Internet applications and solutions.

iXL has offices in nineteen cities in four countries: Atlanta, Berlin, Boston, Charlotte, Chicago, Denver, Hamburg, London, Los Angeles, Madrid, Memphis, New York City, Norwalk, Raleigh, Richmond, San Diego, San Francisco, Santa Clara, and Washington, D.C.

01 02 03 04 05 06 07 08 **09** 10 11 12

site: www.ixl.com

Dining On-line
Restaurant

http://www.restaurant.com

This Web destination is designed to help consumers and restaurants create their ideal dining experience, possible through on- and offline business alliances that make up the largest, most searchable database of restaurants on the Web. Restaurants can purchase a Restaurant.com branded microsite that allows them to display their own content (menu, descriptions, photographs) for users who are searching for where to eat. Beyond that, the Web site is also a lifestyle portal for people who love to eat out, since it provides content and functionality that maximizes the dining experience. Users can find current, relevant articles on everything from spices to chef biographies to recipes for innovative cocktails. Functionality allows users to personalize the site with tools that archive each individual's dining preferences (favorite recipe, favorite dishes). In this way, the Web site provides an on-line experience that captures the essence, the variety, and the pleasure of dining out.

The creative team's overarching goal was to build a Web site that combines content, functionality, and brand into a value-rich user experience. The site's business goals were to increase revenue through the sales of microsites and gift certificates, and to build brand equity over time through the strategic development of the company brand identity system. The end-user goals were to be able to easily locate and plan an ideal restaurant experience, according to his or her exact preferences.

One of the challenges of this project was its vast audience—the site targets virtually anyone who uses the Web and enjoys dining out. The large search engine database presented limitations within which the designers had to develop functionality. For example, some restaurants were listed by neighborhood within each region/municipality while others were not, which presented a hurdle in terms of database retrieval.

This, paired with arranging database calls to Mapquest to provide directions

Client Restaurant.com **Team** Mike Hettwer, iXL; Scott Lutwak, RDC, executive sponsors; Bill Fowler, iXL; Scott Lutwak, RDC, project/program directors; Beth Facette, iXL, project manager; Bob Domenz, iXL, creative director; Ajoy Muralidhar, iXL, information architect; Mark Pelletier, iXL; Tim O'Hara, iXL, art directors; Karen Keenan, iXL, content manager; Stuart Stoddard, iXL; Ryan Bond, iXL; Andrew Falconer, iXL, site developers; Steve McAllister, iXL, IT manager **Since** April 2000 **Target** Any Web user

Tools HomeSite, Photoshop (graphics), Adobe Illustrator, ACD See (to view lots of graphics at once), WS FTP, MS Word, QuarkXPress, MS Personal Web Server, MS Visual Source Safe, and others.

to restaurants, made designing the front end of the search function a challenge. Logic and usability were priorities in overcoming this hurdle.

The key ingredients of a great Web site are a solid brand, killer content, and relevant functionality. Following the principles of usability and interface design creates a value-rich user experience. An up-to-date, customized Web site is an invaluable tool, especially since many restaurateurs don't have the time or specialized knowledge to create one for themselves. The Web site has, in effect, given the restaurant community a voice on the Web.

The process of building the site began with building the company brand. If the project was to be successful at all, it required a brand identity system that established a strong on-line presence as well as being applicable to off-line marketing endeavors. After analyzing the marketplace, both

on and off the Web, the creative team developed an innovative identity system that established the integrity of the brand while maximizing the interactive qualities of the Web.

The company's ever-changing logo is comprised of a static typeface with rotating imagery. The photography chosen is clean, elegant, and depicts positive, beautiful aspects of food and the dining experience. The logo uses the interactive quality of the Web to illustrate diversity, choice, and the limitless possibilities of what eating out can entail.

The designers used the foundation of the brand to design a site structure that maximized usability. The market space on the Web was full of sites that lacked this key element, so part of their research and analysis phase was simply trying to order food on-line, which proved to be a harrowing, and more often than not, fruitless endeavor.

In building the site architecture and user interface, usability was the designers' top priority. Starting with potential user scenarios and logical workpaths, they were able to develop strategic navigation and robust search capabilities that allows users to find a restaurant's microsite easily and accurately. From the home page, users can access every page on the site. The content area is organized into logical and relevant topic areas, which are updated weekly with fresh value-added content. The site is incredibly easy to personalize, and is designed to capture user information that can be archived to provide increased customization in later phases.

To solve the problem of outdated information on the site, it was also necessary to develop easy-to-use administration tools for restaurant owners as well as data-entry personnel. This required careful evaluation of how non-Web savvy people process on-line information. The result was a streamlined, password-secured editing tool that allows restaurant owners to update their menus, add their daily specials, and essentially become the content managers of their own micro-sites.

The site architecture of the Web site portrays the structure, if not the flow of the site. It depicts the richness of the search engine, as well as the value-added functionality (for example, e-commerce capability for purchasing restaurant gift certificates and a corporate orders section for office personnel) that enhances the user experience. It also illustrates how many of the pages on the site contain highly updated dynamic content, which is the key to keeping users coming back again and again.

site: www.restaurant.com

The original Discover Card® Web site was one of the first in the industry to offer online applications and statement viewing and sorting. The redesign offers a wide range of services for existing and potential Discover Cardmembers. Members can track, balance and pay their credit card accounts via the Account Center, and receive special discounts and offers through online retailers via the Internet ShopCenter™. There is information about the Card benefits and an online enrollment feature for anyone interested in becoming a new Cardmember.

This site redesign is an instructive before-and-after case study demonstrating how improvements to a Web site's information architecture and interface design can significantly improve navigation and usability.

It is an iXl watchword that usability equals return on investment. A highly usable site allows visitors to easily achieve their goals, thus fulfilling the goals of the business. For example, if users can easily find and purchase products this will lead to an increase in online sales—generating a much faster return on investment than a site that is difficult to purchase from.

Client Discover Financial Services, Inc. (DFS) **Team** Colleen Zambole/DFS; Steve Furman/DFS; Kevin Wick/iXL, project/program directors; Anne Feder/DFS, Cheryl Northcutt/iXL, project managers; Robin Kowalski/DFS, operations manager; Bob Domenz/iXL, Geoff Mark/iXL, creative directors; Linda Gardner/iXL, John Kalagidis/iXL, information architects; Mark Pelletier/iXL, Quentin Maguire/iXL, Jim Santeramo/iXL, designers; Ian Cook/iXL, content manager; Ryan Bond/iXL, Hari Khalsa/iXL, John Hettwer/iXL, site developers; Chris Koehler/DFS, IT manager **Since** October 1999 **Target** Virtually anyone who has a credit card, needs a credit card, or owns a Discover Card

Tools HomeSite, Adobe Photoshop, Adobe Illustrator, ACD See, WS FTP, Dreamweaver, Microsoft Word, QuarkXPress, and others

>> A successful user-interface design requires a thoroughly defined navigation system working hand in hand with a consistent, extendable look and feel.

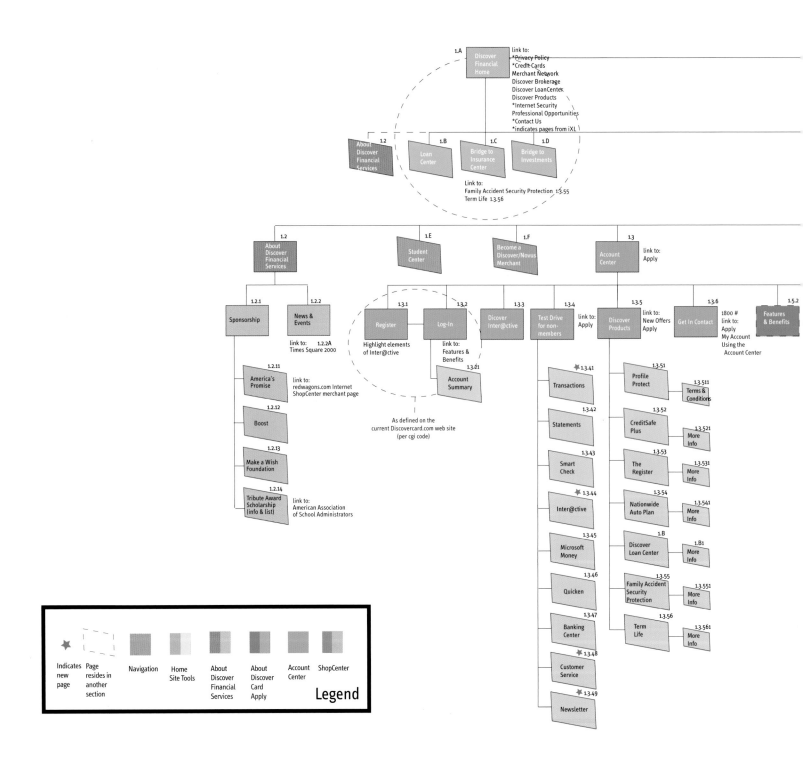

site: www.discovercard.com

- Overarching goal: Increase usability of the site.

- Business goals: Increase online transactions, increase online applications, reduce customer-service inquiries by allowing users to manage their own account.

- End-User goals: Learn about the card, apply for a card, manage credit card finances, use the card to purchase goods and services online, learn about Discover® Card.

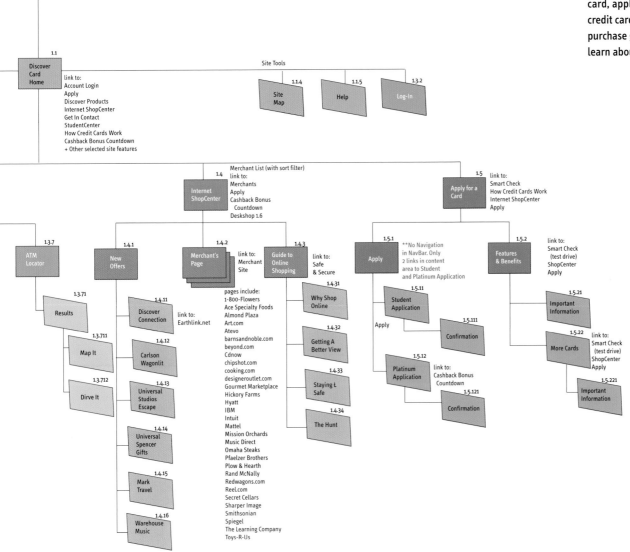

1.1
Discover Card Home
link to:
Account Login
Apply
Discover Products
Internet ShopCenter
Get In Contact
StudentCenter
How Credit Cards Work
Cashback Bonus Countdown
+ Other selected site features

Site Tools

1.1.4 Site Map
1.1.5 Help
1.3.2 Log-In

1.4 Internet ShopCenter
Merchant List (with sort filter)
link to:
Merchants
Apply
Cashback Bonus Countdown
Deskshop 1.6

1.5 Apply for a Card
link to:
Smart Check
How Credit Cards Work
Internet ShopCenter
Apply

1.3.7 ATM Locator

1.4.1 New Offers

1.4.2 Merchant's Page
link to:
Merchant Site

1.4.3 Guide to Online Shopping
link to:
Safe & Secure

1.5.1 Apply
**No Navigation in NavBar. Only 2 links in content area to Student and Platinum Application

1.5.2 Features & Benefits
link to:
Smart Check (test drive)
ShopCenter
Apply

1.3.71 Results

1.4.11 Discover Connection
link to:
Earthlink.net

pages include:
1-800-Flowers
Ace Specialty Foods
Almond Plaza
Art.com
Atevo
barnsandnoble.com
beyond.com
Cdnow
chipshot.com
cooking.com
designeroutlet.com
Gourmet Marketplace
Hickory Farms
Hyatt
IBM
Intuit
Mattel
Mission Orchards
Music Direct
Omaha Steaks
Pfaelzer Brothers
Plow & Hearth
Rand McNally
Redwagons.com
Reel.com
Secret Cellars
Sharper Image
Smithsonian
Spiegel
The Learning Company
Toys-R-Us

1.4.31 Why Shop Online

1.5.11 Student Application
Apply

1.5.111 Confirmation

1.5.21 Important Information

1.3.711 Map It

1.4.12 Carlson Wagonlit

1.4.32 Getting A Better View

1.5.12 Platinum Application
link to:
Cashback Bonus Countdown

1.5.22 More Cards
link to:
Smart Check (test drive)
ShopCenter
Apply

1.3.712 Dirve It

1.4.13 Universal Studios Escape

1.4.33 Staying Safe

1.5.121 Confirmation

1.5.221 Important Information

1.4.14 Universal Spencer Gifts

1.4.34 The Hunt

1.4.15 Mark Travel

1.4.16 Warehouse Music

iXL's process was based in a methodology that includes two fundamental phases prior to actually developing the site in its entirety:

1) Research and Analysis. The team began with an audit and analysis of all existing content, including: navigation, interface design, branding, and functionality. iXL and DFS team members engaged in an intensive series of brainstorming engagements as well as to analyze the current site and profile end-users. They found that the original Web site offered very valuable content and functionality, however the structure and design were inconsistent, not user-centric, and also did not represent the Discover Card brand.

They then evaluated all potential users, creating a profile, mission statement, and specific goals for each major group. Working from the user's point of view, they organized all content into logical groupings and developed appropriate tonality and messaging. This in-depth exploration laid the groundwork for all subsequent information architecture and branding development.

The next step was to examine functional relationships and potential user paths in order to paint a fuller picture of site usage and structure. Again, this was a series of collaborative sessions, and the results created the site architecture—the blueprint for site development and the foundation for navigational design. This map hierarchically organized the entire site into major areas and individual pages, and indicated content organization, functionality, end-user decision-making points, and linked interrelationships.

2) Establishing the user interface. A successful user-interface design requires a thoroughly defined navigation system working with a consistent, extendable look and feel. Believing that design is a key component in navigation, iXL explored navigational approaches and tested usability by creating high-level wireframes—structural story boards that specify all required screen elements. After determining the best navigational system, they created detailed wireframes for key pages and user paths to guide the site's visual design. The visual design process was modeled on the philosophy of Rapid Prototyping: deploying separate design teams on different user paths while exploring the visual design system.

site: www.discovercard.com

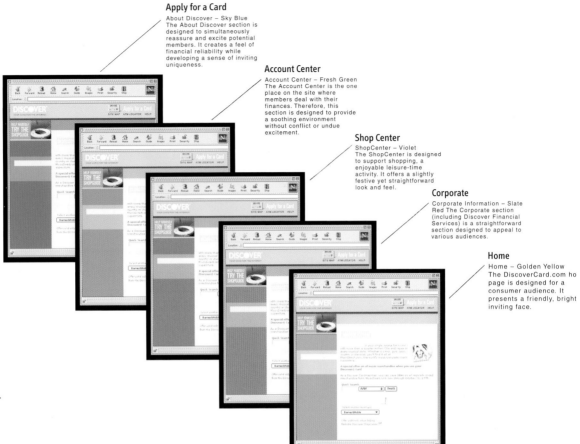

Apply for a Card
About Discover – Sky Blue
The About Discover section is
designed to simultaneously
reassure and excite potential
members. It creates a feel of
financial reliability while
developing a sense of inviting
uniqueness.

Account Center
Account Center – Fresh Green
The Account Center is the one
place on the site where
members deal with their
finances. Therefore, this
section is designed to provide
a soothing environment
without conflict or undue
excitement.

Shop Center
ShopCenter – Violet
The ShopCenter is designed
to support shopping, a
enjoyable leisure-time
activity. It offers a slightly
festive yet straightforward
look and feel.

Corporate
Corporate Information – Slate
Red The Corporate section
(including Discover Financial
Services) is a straightforward
section designed to appeal to
various audiences.

Home
Home – Golden Yellow
The DiscoverCard.com ho
page is designed for a
consumer audience. It
presents a friendly, bright
inviting face.

This approach addresses two partic-
ular issues critical to successful Web
site development.

- It allows designers to further
 refine and resolve structural nav-
 igation and intuitive "flow"
 issues at the user experience
 level.
- It ensures that a consistent
 design system is extended consis-
 tently through all levels of the
 Web site.

iXL's philosophy for this site design
was centered on making the navigation
"transparent" to eliminate the appear-
ance and feeling of jumping from place
to place as the user moves about the
Web site. The final visual solution was
designed to create an intuitive flow
from the home page down to the deep-
est level, keeping the user in the same
environment regardless of the chosen
user path. This avoided the common
problem of a home page that is discon-
nected, both visually and navigational-
ly, from hierarchically deeper pages.
This solution also allows for stream-
lined development of future content,
sections and pages.

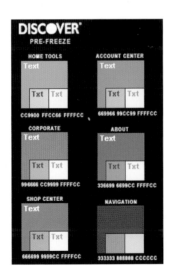

Overall Palette

The DiscoverCard.com site features a
fresh, seasonal color palette designed to
gracefully carry the Pre-Freeze site
through the fall and winter seasons. These
mid-tone colors are variations on primary
and secondary colors. They avoid the
extremes of light pastels and deep satura-
tions, and non-offensively embrace both
masculine and feminine qualities.

One Family, Six Members

A distinct color sheme identifies each of
the six site areas (Home, Account Center,
About Discover, Shopping, Corporate Info
and General Navigation). This makes it
easy for the user to quickly find a section
and always understand his current location.

Together, these schemes comprise a
united family. Each section's unique
color personality makes a strong state-
ment, yet works well as a secondary
color scheme within any other section
(for example, when a ShopCenter promo-
tion appears on a page in the About
Discover section).

Shopping with a Price Tag
Furniture

http://www.furniture.com

Given an existing Web site for the company, iXL's objective was to redesign the existing user interface to facilitate use of the site, provide consistency throughout the site, and get information to customers quickly, thereby enhancing the overall on-line furniture shopping experience.

Furniture.com allows customers to shop according to their shopping style; they can either browse all items in a certain style, or they can look at all designs of a specific piece of furniture. Because the products sold on this site are high-ticket items, the site approaches e-commerce in a unique way. It was necessary for the buying process to encourage repeat visits since most people want to thoroughly think through their decision before purchasing an expensive product. The

My Selections section of the site allows users to store items without having to purchase them in that visit.

The creative team began by examining the existing site, both through inquisitive evaluation methods and user testing. This analysis revealed several problem areas, which helped determine how to formulate a plan for the redesign. By gathering user responses and then prioritizing the problem areas, the designers felt comfortable that the redesign really would meet user needs in terms of features. They then drafted a site structure and created both paper and HTML prototypes. Participants were again brought in to assess the prototypes and the team used that feedback to make final changes before launch.

Client Furniture.com; Carl Prindle, executive producer **Team** Michelle Fonvielle, information architect; Michelle McDonagh, manager, information architecture; Dave Berke, project manager; Abby Ackerman, director, project management; Caroline McMurtrie Barnes, art director; Jill Donohoe, account director; Scott Janousek, senior software engineer; Brian Sullivan, software engineer **Since** Fall 1999 **Target** Anybody who wants to buy mid- to high-price quality furniture on-line

Tools Visio, Allaire HomeSite, Adobe Photoshop **Traffic** Client reports a tremendous increase in revenue since the redesign **Awards** Ranked #1 Home Furnishing Site by Gomez Advisors, Awarded an "A" for User Experience by the *Wall Street Journal*, favorable mention by MSNBC

site: www.furniture.com

The Brand

Usability Testing

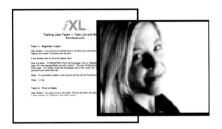

Site Structure

Live Site

Creative Comps

The project is structured to allow users to quickly and easily find the perfect piece of furniture from over fifty thousand items offered on the Web site. Users can browse the furniture selections from a "piece" perspective as well as from a "style" perspective to accommodate all shopping methods. Once a user has found the perfect pieces of furniture, the design enables a quick and simple buying process.

From any point in the site, users always have direct access to Help, including FAQs, company policies, Web site security, and delivery information. To make the buying experience even more comfortable and secure, the site also allows users to educate themselves about the furniture they are buying, as well as to get expert advice from design consultants accessible by phone or live chat.

GLAMOUR
Wardrobe
Wrap-Up

Feel-Good Proposition

Keds

http://www.keds.com

The tag line for the Keds brand is straightforward: Keds feel good. iXL designed the company's on-line presence to convey this strong branding throughout the entire site, and to make shopping for Keds "feel good." iXL's objectives were to reinforce the Keds brand meaning, communicate the breadth of product line, enable on-line transactions, and gather actionable market data. iXL also wanted to define the easiest, most efficient, well-branded access to information and products for users.

This simple on-line catalog accommodates the user with no time to spend shopping, as well as the user who enjoys the browsing experience. The user who has to get in and out quickly can use the quick search feature to look for Keds in a certain size,

material, or style. Users who enjoy browsing can easily look through the on-line catalog as they would a printed catalog. Regardless of the selection method, the buying process is quick and simple, but still allows for extras such as multiple shipping addresses and gift wrapping. The design also enhances the shopping experience by offering "fun" activities such as being able to send electronic postcards or find a good book to read based on recommendations found on the Web site. The design is easy to use, fun, and makes shopping for Keds feel good.

The site offers easy-to-use navigation for two kinds of shoppers: those who have time and like to browse, and those who need to make their purchases quickly.

Client Keds, Mary Obano, executive producer **Team** Matthew Winitzer, software engineer; Michelle McDonagh, manager, information architecture; Naomi Katagai, software engineer; Jeff Schneller, senior software engineer; Dave Berke, project manager; Damien Roskill, technical teamleader **Since** March 1999 **Target** Women age 24–45, kids age 5–9

Tools Adobe Illustrator, Visio, Microsoft PowerPoint, Allaire HomeSite, MS Siteserver e-Commerce Edition, Visual Basic, Taxware

site: www.keds.com

The Brand

Site Structure/Schematics

Features

Concepts

Live Site

iXL's philosophy for this site was to represent the user throughout the process by involving him or her and constantly utilizing scenarios of their interactions to validate decisions made in the development process as well as to work with the creative and technology departments to create multiple means of access for different users. As people navigate sites differently, and the designers needed to provide different shopping options for them. The quick searches allow customers to obtain information quickly. The site reflects how well the Creative, Information Architecture, and Technology teams worked together to build a great site.

In order to build an e-commerce site for a brand with such a strong customer base, iXL determined it was best to start simple and be loyal to the brand. Their other goal—to show the breadth and depth of the Keds line—conflicted with the necessary simplicity of this e-commerce site, but they ultimately opted to focus on introducing e-commerce, rather than showing every style of shoe on the site.

LiveArea is a Web design and development company based in New York City. Company founder Peter Comitini defines LiveArea's mission: "The Web provides new opportunities to express and build relationships with the public," he says. "LiveArea manages the process of transforming data into information and information into understanding. This is the most competitive communications environment ever, with about 360 new sites being launched each hour. Helping our clients achieve a truly distinctive presence is what our development process is all about. Intelligent content creation, design, and navigation make the critical difference in a Web site's success or failure."

LiveArea has its roots in Peter Comitini Design, a strategic design practice for clients that included Nickelodeon Online and Discovery Communications. No stranger to creating a dialogue with a worldwide audience, Peter Comitini sharpened his editorial and design skills as cover art director of *Newsweek* magazine during the first half of the 1990s. His work was included in the Mixing Messages show in 1996 at the Cooper-Hewitt National Museum of Design in New York City, and has been recognized over the years in every major awards competition including the AIGA, Society of Publication Designers, NY Art Directors Club, *PRINT*, and *Communication Arts*.

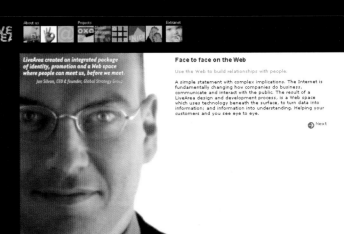

Ergonomically Correct
OXO

OXO International's Good Grips products could be said to have reinvented the housewares category. But research showed that consumers did not easily associate the OXO brand name with the products, so making the brand name more memorable was a key objective. Since local retailers don't always carry the entire product line, making the complete OXO product catalog available for sale everywhere was an important second goal. Telling the OXO story and providing recipes, a search tool, and links to Web resources, rounded out LiveArea's design mission.

OXO products follow the principals of universal design, and as a result they are more comfortable for everyone. They are simultaneously chic and playful—beautiful objects to hold and behold. These qualities set the standard for the site design and navigation. From the moment you enter the OXO site, the design—with its simple, fresh graphic approach—has a sense of both purpose and playfulness. For example, an intuitive connection between the brand name OXO and the classic children's game of tic-tac-toe becomes a permeating feature of the site's design—a navigational metaphor, organizational trait, and an actual interactive game developed in Shockwave.

Client OXO International **Team** Peter Comitini, creative director, interface designer, designer; Andrea Pinto, designer; Susan Saunders, Michelle Sohn, Evelyn Krasnow, writers; Dino Karl, Craig Wolman, Tavis Jeffries, programmers; Mathew Siee, Rebecca Johnson, graphic production; David Wagner, Jeff Lederman, digital video producers; MYK, photographer (catalog); Alan Donaghey, 3-D animator **Since** March 1999 **Target** The general public; anyone who cooks or uses a hand tool of any kind is a potential user

Tools Cold Fusion, BBEdit, HTML, JavaScript, Java, Microsoft Active Server Pages (ASP), Microsoft Sequel Server (SQL), Adobe Photoshop, Adobe Illustrator, Macromedia Director, SoundEdit, GifBuilder, Apple QuickTime. Developed on the Macintosh and Windows NT platforms. Hosted on a dedicated Compaq Pro-liant running Windows NT **Traffic** 2,000 hits per day and up **Awards** *Communication Arts*, Interactive Design Competition 5

13 14 15 16 17 18 19 20 21 22 23 24

>>

LiveArea **87**

The black strip running across the top of each screen contains the global site navigation icons. Users can link to any of the nine main sections from any section's page by using the top navigation bar. The top bar serves navigation by providing a way around the site and feedback on one's current location. The logo appears in this area on every screen of the site, assuring that a link to the site from anywhere on the Web will carry the brand identity. Clicking on it links back to the home screen.

The navigable destinations operate much as they do on the home screen, with mouse-over responses and a verbal explanation of their destinations. Graphic text and a static icon in red identify the current section. The current window's title bar also identifies the location of a user. The designers also provided a redundant, static, icon system for browsers that do not support the JavaScript, which enables the mouse-over animations.

Section navigation menu
Each main section has a linear structure. A red navigation bar runs down the left of each page. It contains a menu specific to navigating only the current section. The links in this menu can be used to jump to a specific item of interest within the section. The menus change to reveal more detailed content as one drills down into a section.

For example, at the topmost level of Chef's Choice, the menu contains a list of the chefs whose recipes appear in the section. Clicking into a particular chef's section, it contains a selection of recipes. In this way, the section menus give section location feedback and links within the current content area.

Content page
Content screens are broken down into logical components, and users can scroll down to view longer pages. Oversized graphic arrows and in-page text links are used throughout.

Special media and features
Pop-up windows are invoked for QuickTime movies and the OXO Search Tool features. These smaller windows launch over the current one. The OXO Search Tool in particular uses multiple windows to query different search engines. LiveArea implemented JavaScript that continually pushes the window containing the search tool interface to the front, which lessened the possibility that users might lose their place behind multiple open windows.

Dynamic sections
Developing and distributing a growing line of products is at the core of OXO's business. LiveArea developed a database-driven publishing solution that can grow with OXO's product lines and business. The OXOnline shop, Just Out, and the intermittent Sneak Preview sections are dynamically generated site areas programmed in Microsoft Active Server Pages (ASP). This technology permits images and text to be called out of a database, written into an HTML page layout, and served over the Internet to a user's browser on the fly.

>> An intuitive connection between the brand name OXO and the classic children's game of tic-tac-toe becomes a permeating feature of the site's design.

site: www.oxo.com

A unique user experience is what has made OXO's products so popular. Besides working flawlessly, they look and feel different. It was important that OXO translate these same qualities to their Web space. The tactile and visual experience of the home screen's interface design intuitively reflects the qualities of OXO's products. This screen is not only a table of contents, but an interactive poster for the brand as well. LiveArea created a group of navigation icons that become the defining site design statement. The icons create a sense of place that OXO "owns" on the World Wide Web. They serve as an interactive table of contents upon entry and then as a navigational palette and location signpost as one journeys deeper into the site. The OXO home page introduces the nine interactive icons with an engaging, gamelike quality. Each icon responds to user actions by changing color and animating when a mouse rolls over it. Each mouse-over also invokes a verbal description of the section it links to.

Giving users a consistent and intuitive system to browse a site supports usability and, when done right, feels seamless. The basic site page structure places navigational interface elements into well-planned and graphically distinct page areas. Each supports a different way of helping users to navigate and access the site's content.

The Online Shop

Interface design is a highly visual browsing and shopping experience that follows the same basic page structure conventions used throughout the site. Its structured system of pull-down menus permits users to browse freely. A search field enables users to find specific items using keywords relating to tasks, foods, or products. LiveArea art directed the photography and optimized the images to assure fast delivery over the Web, enabling an extensive use of multiple and large product shots to be used. The studio created a browseable and searchable system of pull-down menus, thumbnails, and large product shots. Shopping cart and on-line ordering is supported, plus a custom database-administration tool permits the adding and editing of products, categories, and keywords. The Just Out section operates in a similar fashion for newly introduced housewares not yet available in stores.

site: www.oxo.com

>> The navigational challenge is not just within a site but across the entire World Wide Web. There is little sense of owning a visually unique Web property.

The browser window title: **Netscape: OXO International [Swivel Peeler]**

Tools that make everyday living easier

OXO International is dedicated to providing innovative consumer products that make everyday living easier. From cooking and cleaning to baking, barbecuing and gardening, OXO's easy-to-use products are designed with an emphasis on comfort, quality and value. From our signature Good Grips collection to our Basics and Softworks product lines, consumers around the world — of all ages and abilities — delight in OXO's award-winning and revolutionary designs.

What Makes OXO Products So Good? All OXO products are manufactured using the highest quality materials, measured against the most stringent standards in the business. We've taken every step to ensure that the best possible products are available to consumers in all markets. Ergonomic designs and ground-breaking innovations are based on comprehensive research and extensive interviews. Add that all together and it's simple: OXO products feel great, look great and perform with excellence.

Good Grips products feature soft, flexible handles made out of Santoprene, a processed rubber, to ensure a comfortable grip. Embedded 'fins' on handle sides flex under pressure and conform to individual finger grips. The fins also give users control even when the handle is wet or slippery. Our large handles are proportionately designed to fit easily in the palm. And all OXO products contain over-sized holes for easy hanging.

continue

Java Video
Java capable browser required

Quicktime Video
Quicktime Plug-in required

Select a Video

Awards

site: www.oxo.com

| | search engine ▲▼ | ☑ see results in a new window |

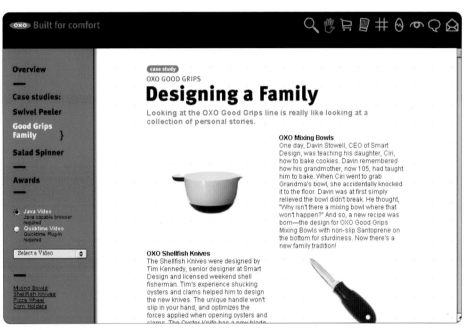

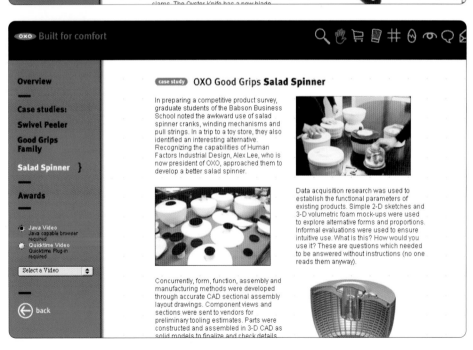

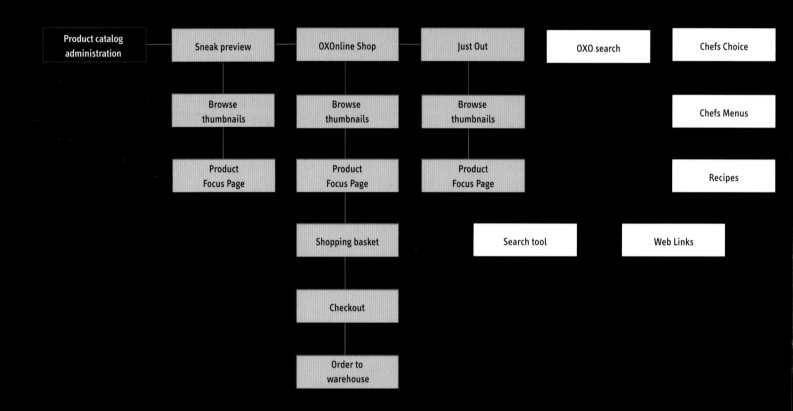

| Product catalog administration | Sneak preview | OXOnline Shop | Just Out | OXO search | Chefs Choice |

Browse thumbnails — Browse thumbnails — Browse thumbnails — Chefs Menus

Product Focus Page — Product Focus Page — Product Focus Page — Recipes

Shopping basket — Search tool — Web Links

Checkout

Order to warehouse

site: www.oxo.com

```
                                        ┌─────────────────┐
                                        │   Database      │
                                        │ Administration  │
                                        └─────────────────┘

┌─────────────────┐                     ┌─────────────────┐
│  Splash Screen  │                     │   Dynamically   │
│                 │                     │    published    │
└─────────────────┘                     └─────────────────┘

┌─────────────────┐                     ┌─────────────────┐
│   Homescreen    │                     │    Web page      │
│                 │                     │                 │
└─────────────────┘                     └─────────────────┘

┌───────────┐  ┌──────────────────┐  ┌──────────┐  ┌──────────┐  ┌──────────────┐
│Family Fun │  │ Built for comfort│  │Eye on OXO│  │   Help   │  │ Contact OXO  │
└───────────┘  └──────────────────┘  └──────────┘  └──────────┘  └──────────────┘

┌───────────────┐                     ┌──────────┐  ┌──────────┐  ┌──────────────┐
│ OXO Tic-Tac-Toe│                    │Philosophy│  │ Site Map │  │ Submit form  │
└───────────────┘                     └──────────┘  └──────────┘  └──────────────┘

                                       ┌──────────┐  ┌──────────┐
                                       │ History  │  │Search Tool│
                                       └──────────┘  └──────────┘

┌───────────────┐  ┌──────────────┐   ┌──────────┐  ┌──────────┐
│ On-line Videos│  │ Case studies │   │  Awards  │  │Tic-Tac-Toe│
└───────────────┘  └──────────────┘   └──────────┘  └──────────┘

                   ┌──────────────┐   ┌──────────┐  ┌──────────┐
                   │    Awards    │   │ Credits  │  │ Plug-ins │
                   └──────────────┘   └──────────┘  └──────────┘
```

>> The basic site-page structure places navigational
interface elements into well-planned and graphi-
cally distinct page areas. Each supports a different
way of helping users to navigate and access the
site's content.

Sneak Preview section

A special case arose when OXO wanted to promote a couple of new product categories for the hardware and automotive markets. LiveArea provided development of a new dynamically published section called Sneak Preview. This area is designed as a special promotional section to introduce new lines of business before they come to market. LiveArea wanted to create a different sense of location here; apart from the main site, the screen designs in this section intentionally break the rules set up on the rest of the site. The section navigation bar appears in a steel boilerplate pattern, and the top navigation bar carries a promotional message instead of icons. Users can move out of the section by clicking on the home button. There is a balance of the familiar and the new. Users "get" that they are in the same neighborhood but on a block they have never seen—much like the transition of OXO's featured products, going from peelers and garlic presses to screwdrivers and wrenches. Because of the promotional nature of the section, it needed to be available only during new product introductions, as opposed to being a permanent site feature. Instead of creating another site section, the designers created a database-driven feature that could be turned on and off via an administration tool. When the feature is enabled, users logging onto the home screen accept a pop-up window containing an invitation to preview the new products. They click through to a special hidden section of the site. Here, they can browse through the new products and return to the home page.

Creating a sense of location

Implied in any conversation about navigation is the idea that you are going somewhere. Yet, so many of today's Web sites look alike. They are uninspired reflections of the database technologies driving content to the screen. They have no sense of being unique places, no matter how useful or special their offerings may be. The navigational challenge is not just within a site, but across the entire World Wide Web. There is little sense of owning a visually unique Web property. Sure, the usability research guys will say things like "tabs provide an easily understood metaphor" (translation: we are dealing with a pretty dumb audience). By encouraging conformity, they are underestimating users and robbing content providers of their strongest strategic asset—to build a richer and more unique user experience. In fact, many of these companies must rely on huge advertising budgets to build their brands. Just think of the real value that they would gain by designing their on-line products to impart a real sense of location. As the Web continues to grow and mature, the public perception of who's who will become increasingly important. It's not just about a creative use of technology. The on-line industry is starting to understand the need to differentiate their services using strong ideas, expressed through design. Content providers with the talent to create unique environments have a bright future in this world.

M.A.D.
[Sausalito, California]

>> Since 1989, M.A.D. has produced high-impact conceptual design and illustration for a wide variety of companies and organizations. Some of M.A.D.'s most visible work has been the studio's editorial introduction spreads for *Wired* magazine, as well as projects for Wired Digital, where M.A.D. cofounder Erik Adigard recently concluded two years as design director. While experimenting with new media prototypes, he also worked on the creation of Web products such as WiredNews, the Wired Channel on Pointcast, LiveWired and the '98 Wired Digital redesign. Related activities range from video and installations to fashion graphics and journalism. Both LiveWired and Funnel, M.A.D.'s experimental Web site, were among the first Internet works to be included in the permanent collection of the San Francisco Museum of Modern Art.

Recent projects include user-interface design and 3-D illustration for Lotus, Inc., concept and graphic identity for the San Francisco Stop AIDS Project, editorial graphics for *Mother Jones* and *Wired* magazines, and the advertising campaign and Web site for the 1999 International Design Conference in Aspen. M.A.D. was chosen for the 1998 Chrysler Award for Innovation in Design and is frequently featured in publications worldwide.

01 02 03 04 05 06 07 08 09 10 **11** 12

site: www.madxs.com

A Seamless Environment

M.A.D.

www.madxs.com

In late 1997, to update their showcase for design and illustration work, M.A.D. undertook a redesign of the studio Web site that was conceived as an experiment with what at the time were the novel possibilities of DHTML. The designers wanted to work on a redefinition of the Web space, getting away from a scrolling page to a Web window, like a form of low-bandwidth television. To do so, they created an immersive viewing experience: the Web site fills the entire monitor area, blocking out desktop clutter, and continues to run as an ambient screensaver when left alone.

The site presents a seamless environment of scrolling art, animated graphics, and an automatic slide show. Layers allow for the use of animated elements displayed on top of static imagery. A boldly rendered "millenni-um countdown" is presented while the site is building in the background.

The M.A.D. Web site is conceived as a stand-alone artwork constructed from examples of award-winning design and illustration for clients such as ABC/Disney, Macromedia, Microsoft, and *Wired*, as well as for arts and non-profit groups such as the San Francisco Stop AIDS Project; Computers, Freedom, and Privacy (CFP); and the San Francisco Museum of Modern Art.

M.A.D.'s portfolio is easily accessible from many levels via the site's invisible, multitiered architectural design. A drop-down custom menu system allows instant access to any part of the Web site. Clearly designed interface controls lead to consecutive portfolio pieces in the slide show.

The scrolling billboard of miniature artwork at the bottom of the Web

Client M.A.D. **Team** Erik Adigard, creative director; Patricia McShane, producer; Erik Adigard, Patricia McShane, designers/illustrators; Dave Granvold, designer/programmer
Since December 1997 **Target** World Wide Web users

Tools Adobe Photoshop, Macromedia Director, SoundEdit, BBEdit, GifBuilder, DeBabelizer, QuickTime, DHTML, JavaScript

A splash screen loops while the first site components are being downloaded.

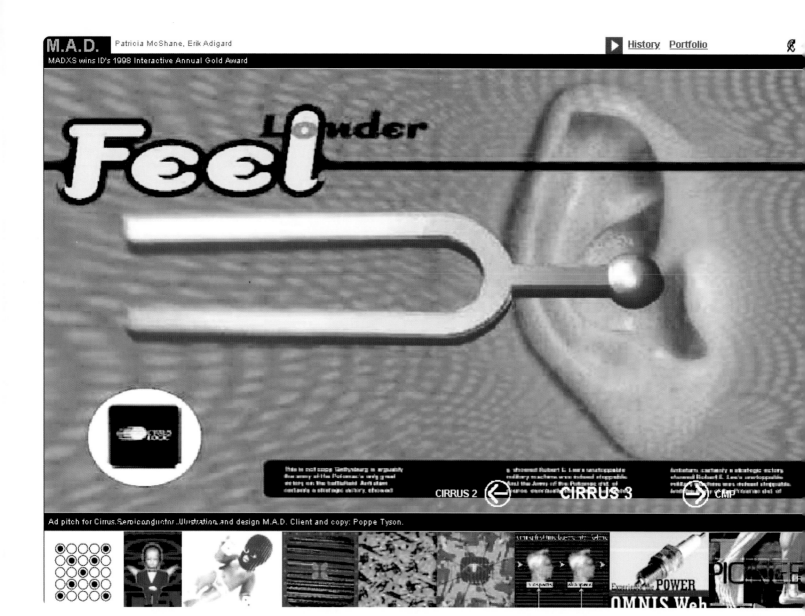

site: www.madxs.com

window can also be used to jump to specific works. Captions are dynamically shown with moving rollovers as the user moves the pointer over the art. The interface is updated to accurately reflect where the user is, based on access according to any of these methods. The site continually runs in an automatic slide-show format, presenting the portfolio in a seamless loop. Precise timing is determined by when the artwork is fully loaded from the server, so that the presentation is smooth and well-timed whether run via modem, ISDN, or T1 connection.

The designers tried to focus equally on all aspects of the site but especially on the user interface. Attention was given to consistent and clean use of typography, hierarchy of design elements, continuity, simplicity of control, and cleanliness of structure. The single-view design, content "on-demand," multithreaded access, and consistent interface behavior all contribute to the presentation experience.

A complete history of M.A.D. is found in the custom-integrated menus, which also provide lists of clients, exhibitions, publications, awards,

notes on the site structure, and M.A.D. biographies. Scrolling messages can easily be changed and presented on a daily basis. A small animation area is the playground for highlighted work.

The site has the following features:
- no plug-ins required
- runs or NS4 and IE4
- dynamically opens to full screen
- pixel-level positioning
- time-based presentation
- automated slide show presentation
- random event processing
- transparent layering
- dynamic layer presentation
- on-demand loading of site elements
- scrolling animated images
- moving dynamic rollovers
- custom integrated menus
- single-window interaction
- style sheet usage
- daily message updating

The site presents a seamless environment of scrolling art, animated graphics, and an automatic slide show.

M.A.D. Patricia McShane, Erik Adigard
MADXS wins ID's 1998 Interactive Annual Gold Award
History Portfolio

98

EXHIBITS

AIGA, Denver	*Dolly*, *ICONTROL*, July, 1998 (EYE-CONS invitational poster show)
SFMOMA	*Funnel*, May - Sep 1998 (from the permanent collection of Architecture & Design)
SFMOMA	*Wired Magazine*, Dec 97 - Mar 98 (from the permanent collection of Architecture & Desig

FEATURES

Calmann & King	*Color-3rd Edition*, (for Wired Oct 1997 Intro:*Innertube*). 1998
Duncan Baird	*Coolsites 98*, (for *Funnel*). 1998
HOW	Multimedia Introduction by Patricia McShane, *Self-Promotion Annual*. October 1998
CNNfn	*Digital Jam* (TV show feature on madxs). July 1998
ID	*Interactive Media Design Review*, *Gold Awards*. June, 1998
Etapes Graphiques, FR	M.A.D. feature, *Total Media*, by Erik Adigard. June, 1998
CA	M.A.D. feature, *Technology: M.A.D.*, by Julie Prendiville Roux. Illustration Annual. June 19
Critique	M.A.D. co-feature, *A Wider Window on the Web*, by Ken Coupland. Spring, 1998
Publish	*10th Annual Design Awards, 1st Place*. May 1998
HOW	*International Design Annual, Microsoft College Recruitment Campaign*. April 1998

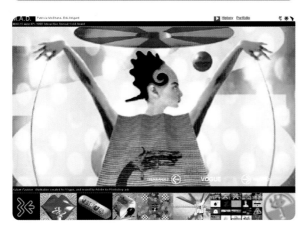

Typical screens showing the automated streaming of imagery. The scrolling thumbs at the base of the site allow users to open up specific images.

As viewers mouse down, History or Portfolio menus open and allow the user to further seek out specific content. Above, is an example of a typical database screen.

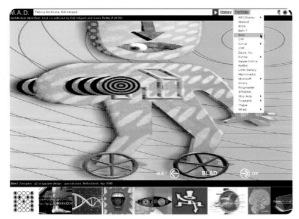

site: www.madxs.com

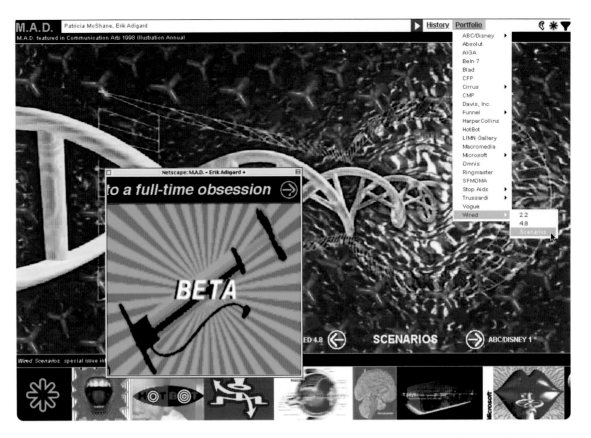

This floating window is opened by clicking on the asterisk at the top right of the screen.

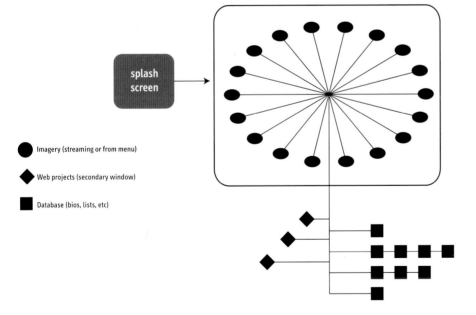

Imagery (streaming or from menu)

Web projects (secondary window)

Database (bios, lists, etc)

splash screen

MeTV

[Waterford, Connecticut]

>>

MeTV delivers broadband streamed movies on demand over the Internet. MeTV Network, Inc. has in-house creative and technology teams comprising top professionals in marketing, graphic, and Web design, audio-visual editing, copywriting, applications, and database development. This team was brought together to produce and maintain MeTV.com's phase one and two sites. "One of our goals is to keep both our phase one and two sites simple enough that even those consumers with little or no Web experience can enjoy our service with ease," says Lizann Michaud, MeTV Network, Inc.'s creative director. "The design must also be flexible enough to expand as we add to our services. As our Web site evolves, and the back end becomes increasingly complex, we strive to maintain this simple, appealing, and expandable user interface."

Movies by Mouse
MeTV

metv.com

The purpose of MeTV.com is to build 56k and broadband (375k and above) membership, prove the MeTV concept, and form strategic partnerships. During phase one, MeTV is building its movie library and membership. MeTV's encoded movie library had over one hundred movies available to its broadband (375k and above) members in early 2000, with 150 more on the way. Movies are currently streamed for free, and can be viewed full-screen on members' PCs. As quality and quantity of movies, music, and TV programming improve, a pay-per-view model will be implemented.

The main site is dedicated to the consumer. Besides movies, the site contains information about MeTV's present service versus what MeTV will offer late in 2000. It also has a high-speed Movie Facts database and on-line shopping for books, music, and video merchandise. The main site also has a link to the MeTV Corporate Connection site, a site designed to give advertisers, investors, and the media background information about the company as well as contacts for their specific areas.

The MeTV site was designed for average people, including those with little experience with Web navigation. The in-house design team strove to keep guesswork out of the picture. The graphics are appealing, simple, and come up quickly.

Navigation is obvious. The MeTV navigation bar is always present and gives the user access to all areas of the site at all times. The site uses color-coded sections for additional orientation. A shallow site is much more pleasant and easy to use than a deep one. In most areas of the MeTV site, it's not necessary to go beyond three clicks deep to get to any piece of information. The areas with more than three clicks are those that go in a straight line. The design guides the user through these areas in an intuitive way, presenting choices only as needed.

MeTV will soon be adding pay-per-view to the site, and that will mean more straight-line sections for transactions. Again, the viewer is pulled through the process without being lost or disoriented. Each screen will be simple, presenting only the necessary information and exits. As MeTV adds to the site, visitors' ease-of-use continues to be a top priority. When appealing to a large demographic, designers must consider the least computer-literate of this target group in their plans. A user who does not experience confusion, frustration, or long waits is more likely

Client MeTV Network, Inc. **Team** Lizann Michaud, creative director; Sheri Cifaldi, Lizann Michaud, Donavon Young, Web design and development; Ernst W. Renner, vice president, information technology; Robert Nocera, senior applications architect; Stephen Garabedian, George Michel, Lawrence Truett, Zhenyu Yang, application developers; Debra Nelis, database administrator; Jennifer Yee, video encoding coordinator **Since** July 1999 **Target** lower- to middle-class Americans, age 18 to 55 **Traffic** 7,000 visitors/190,000 screen hits per day

Tools Oracle 8i, Windows Media Player, Adobe Photoshop, Adobe Illustrator, Image Ready, HTML, Macromedia Flash, Dreamweaver

Level 1

The MeTV home page presents a friendly image, makes a focused announcement, and shows the simple navigation bar that is with the user throughout the site

Level 2

MeTV's Corporate Connections home page is accessed through the main site's home page. The link to this page was downplayed on the main site to maintain emphasis on the consumer

Level 2

This area of the site, coded by its blue background, describes the MeTV service as it is today and as it will be late in 2000. It also contains a straight-line demonstration of how the movies play.

Level 3

One click into the Corporate Connection site brings the user to a simple Pressroom interface, where press is divided by media. Clicking on one of the media icons calls a pop-up window with the news stories that appeared in that media

site: www.metv.com

>> The MeTV site was designed for average people,
including those with little experience with Web
navigation.

Level 2

From the main page, this Movie Facts searchable
database is one click in. It was programmed and
positioned for top-speed results.

Level 2

Members log-in on this Movies page.
Nonmembers are directed to the Join page.

Level 4

Once the member has selected a category, movie covers, titles, and ratings appear. The member clicks on More—or on the movie graphic for a full movie description.

Level 5

A detailed description of a movie has a link to watch the movie or to go back.

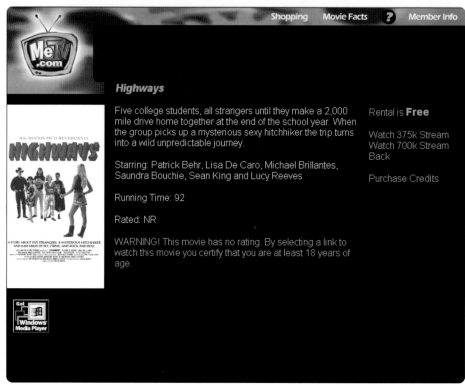

site: www.metv.com

>> The MeTV navigation bar is always present and
gives the user access to all areas of the site at
all times. The site uses color-coded sections for
additional orientation.

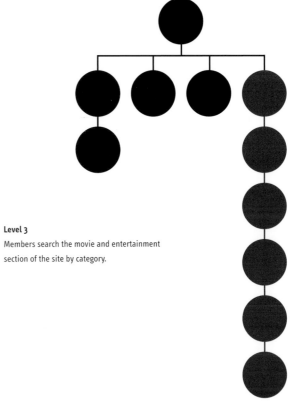

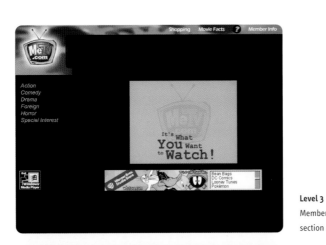

Level 3
Members search the movie and entertainment
section of the site by category.

Level 6
The imbedded Windows Media Player screen
includes statistics, full Movie Player controls, and
the option to watch the movie in full-screen mode.

Minneapolis College of Art and Design

[Minneapolis, Minnesota]

>> Designed by an internal team at the university, the primary purpose of the Web site for
the Minneapolis College of Art and Design (MCAD) is to supply prospective students and their parents with
the information about MCAD they need to make an informed decision about their college choice. Visitors can
obtain information about MCAD's programs, including the application process and financial-aid options.
Students can view the current catalog on-line via PDF files or request a hard copy through an on-line form.
Visitors can also read about the latest MCAD news and events, view student portfolios, and obtain
general institutional information.

 01 02 03 04 05 06 07 08 09 10 11 12

site: www.mcad.edu

Campus Recruiter
MCAD

www.mcad.edu

The project was to be no more than a visual redesign of the existing MCAD site. With that aim, a new visual design was created that focused on the concepts of thought and interpretation. Each visitor who entered the site would see a word that was juxtaposed against a series of randomly combined images, resulting in a new narrative with each visit. The new visual design was independent of the structure, which proved to be a blessing as the project progressed.

As the team began to apply the design, they realized the structure had seriously degenerated over the life of the original site. Content had been added by many different people, the file names were inconsistent, and the navigational structure and system was no longer accurate or usable. So before the team could implement the new look, they needed to address some structural issues. They started by documenting the existing site content and after analyzing the diagrams, noticed that the site had been organized primarily by the internal institutional structure (due to maintenance and logistical issues) rather than around

users' needs. They had to clearly define the target audiences and goals of the site, as well as the tasks that users would want to accomplish.

The MCAD team then created a new architecture, using a user-centered approach, that met the needs and objectives they had defined. Once they reached a consensus on the structure (see flowcharts), they began organizing, editing, and writing new content to support it. To keep the process manageable, a file-naming convention was established and the content of the entire site was compiled into a detailed design document that outlined the navigational elements and contents of each page. Hardcopies were distributed to all the content owners and the approval process began. While the site contents where being finalized, the team focused their attention on the interface. Site category labels where created, page layouts where designed, and an HTML prototype was created. Once the content and interface prototype where both approved, they went into final production. The site continues to be updated and expanded weekly.

Client Minneapolis College of Art and Design **Team** Sean McKay/faculty, information and interface design; Piotr Szyhalski/faculty, design style; Nicole Dotin/MFA graduate student, HTML and graphic production; Michelle Ollie/staff/faculty, marketing **Since** March 1999 **Target** Prospective students and parents and the art and design community **Traffic** Monthly averages are 17,000 visitors, 75,000 page requests, 170,000 total requests (hits)

Tools Adobe Photoshop, BBEdit, JavaScript, NetCloak, NetForms

13 14 15 16 17 18 19 20 21 22 23 24

>>

By using frames, the designers were able to accomplish their first three navigational goals. Although frames are usually considered to create more problems than they solve, the team decided that they were very appropriate and effective in this situation. The main navigation options are always available at the bottom of the composition, the "nav" bar expands and adjusts with the browser window, and only refreshes when moving laterally between top level choices. This allows users' eyes to focus on the content frame or "content space," which helps the user stay oriented.

The last two goals were accomplished through keeping things technically simple. Since the designers knew that the site contents would continue to evolve and expand (a lesson learned from the original site), they used hypertext links for a majority of the site navigation. By minimizing amount of navigational graphics, they increased flexibility and performance.

The random images that are sprinkled throughout the content pages add visual and conceptual interest, but created an interface challenge. Normally sites use icons and images to visually "mark" each section, giving the user visual reference points for maintaining orientation. But in this case, the designers had to use variations in the visual structure of each page to keep users oriented between the various levels and areas. The content pages have significant layout differences from the subsection menus and also repeat the subsection navigation choices; highlighting the appropriate textual navigational elements. Since they chose to use frames, the designers needed to account for the inherent bookmarking problems. To do this, they created individual frame sets for each main section and any significant content.

site: www.mcad.edu

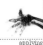

(REQUEST A CATALOG)

applying
visiting our campus
financing your education
careers
>>request a catalog

Download a copy of MCAD's catalog in PDF form:

- Entire Catalog 4.3mb

- BFA Majors and BS Visualization 437k
- Portfolio of Student Work 1.8mb
- MFA Visual Studies and Post Baccalaureate Programs 152k
- Course Descriptions 855k
- Information and Faculty/Staff 1mb
- Admissions 339k
- Application 152k

To view and print PDF files you need Acrobat Reader. Download it for free.

Or, request the print version:

First Name:

Minneapolis **College of Art and Design** about MCAD degree programs continuing studies search admissions
news & events /portfolios catalog ©1999

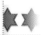

(CONTINUING STUDIES)

Winter/Spring 2000:
computer design
design
fine arts
interactive media
photography

youth programs

faculty
registration/tuition
campus info

MCAD's Continuing Studies program advances the College's mission to the larger community. Through a diverse range of classes, workshops and special events, Continuing Studies offers creative exploration and technical training in the Visual Arts to the general public.

Catalogs for the Winter/Spring 2000 will be available in mid-December. Registration begins by fax, e-mail and mail January 6 and by phone and in-person January 13. The Winter/Spring 2000 session runs February 7-April 15.

Minneapolis **College of Art and Design** about MCAD degree programs continuing studies search admissions
news & events /portfolios catalog ©1999

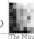

(DEGREE PROGRAMS)

bachelor of fine arts
bachelor of science
post baccalaureate
master of fine arts

The Minneapolis College of Art and Design welcomes applications from candidates interested in obtaining a Bachelor of Fine Arts (BFA) degree in the visual arts, Post Baccalaureate degree, Master of Fine Arts (MFA) degree in Visual Studies or Bachelor of Science (BS) Visualization.

Minneapolis **College of Art and Design** about MCAD degree programs continuing studies search admissions
news & events /portfolios catalog ©1999

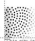

(/PORTFOLIOS)

student work

WebSites
student
faculty/staff
alumni

This site is a center for students/faculty/alumni to display their art and design. It offers a chance for students to expand their audience of viewers beyond campus exhibits and events to the global community. Alumni stay connected to the college offering students a professional national/international network of successful artists and designers and often provide Internships/Externship/Independent Study for students. Our students are immersed in acquiring skills of the studio and engaged in critiques. We welcome you to explore, critique, and communicate.

The offices of Alumni Relations and Career Services welcome those interested in partnering

Minneapolis **College of Art and Design** about MCAD degree programs continuing studies search admissions
news & events /portfolios catalog ©1999

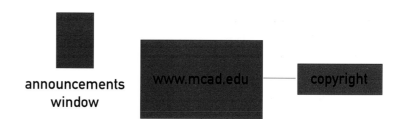

announcements
window

www.mcad.edu

copyright

about
MCAD

A

degree
programs

B

continuing
studies

C

admissions

D

news &
events

news

events

exhibitions

calendar

academic calendar

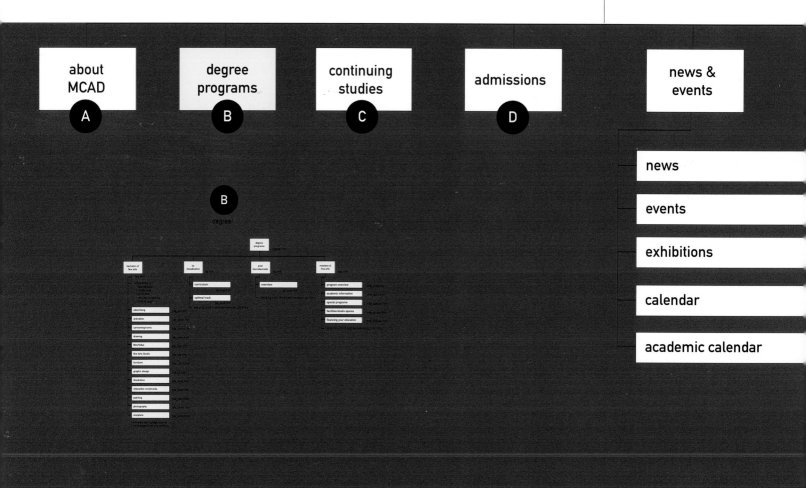

B

degree/

degree
programs

degree htm

| bachelor of
fine arts | | ba
visualization | | post
baccalaureate | | masters of
fine arts | |
bfa.htm			ba.htm					mfa.htm	
•		curriculum		overview		program overview		mfa_overview.htm	
•		optimal track				academic information		mfa_acin.htm	
•						special programs		mfa_special.htm	
						facilities/studio spaces		mfa_studio.htm	
advertising						financing your education		mfa_finance.htm	
animation									
cartooning/comic									
drawing									
film/video									
fine Arts Studio									
furniture									
graphic design									
illustration									
interactive multimedia									
painting									
photography									
sculpture									

site: www.mcad.edu

The MCAD site contains a broad spectrum of information and is meant to serve a variety of users and user levels, so the designers wanted to build a navigational system/interface that would:

• Give users continuous access to top-level navigation, so they could explore the breadth of the site quickly and easily.

• Create a consistent content space, so users would maintain orientation.

• Maintain the compositional integrity of the design within the various browser window sizes and versions.

• Allow for easy expandability, so the content could be added easily within each area.

• Perform well within the wide range of user connection speeds.

Icons, seen below, are used throughout the MCAD site.

portfolios

search

catalog
(link into admissions)

student work

web sites:

student

faculty/staff

alumni

Nofrontiere
[Vienna, Austria]

>> Nofrontiere Design GmbH is a design platform for creative people from around the world. The identity of the agency is plastic and shifts according to the particular collection of "Nofrontierans" in the place at any given moment. Communication is central. Nofrontiere develops standardized hybrid languages to mediate various disciplines, languages, and cultures. These hybrids allow the studio's creatives to have new perceptions and to make innovative design solutions. The nature of each [co]operating system is project based; it is a chemical balancing act, performed through flexible configurations of particular Nofrontierans. The idea of a [co]operating system is informed by the perception of design as a coordinating tool. It is closely allied to the concept of a *gesamtkunstwerk*, where different disciplines, as in the Viennese Secession or the Bauhaus, would be integrated to produce a totally unified polysensory work.

With Nofrontiere on the brink of fifty people, the system has become more complex than a family circus of autonomous performers. A mental map of the larger system could be imagined through an idea of blobs. These blobs are virtual operative units consisting of design, consulting, conceptual, research, project management, and IT, among others, which overlap to form a floating system linked by common goals and interests in the international context of the design world. Clients include Deutsche Bank, Bank Austria, ORF ON, BMW, Philips, Procter & Gamble, Lego, Swatch, Connect Austria, and UNYSIS.

site: www.nofrontiere.com

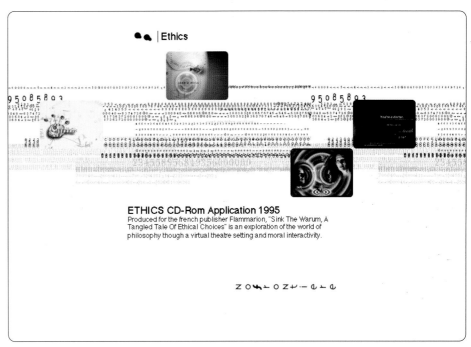

ETHICS CD-Rom Application 1995
Produced for the french publisher Flammarion, "Sink The Warum, A Tangled Tale Of Ethical Choices" is an exploration of the world of philosophy though a virtual theatre setting and moral interactivity.

"*You die young when you know too much.*"

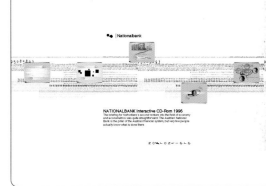

●● | Nationalbank

NATIONALBANK Interactive CD-Rom 1996
The briefing for Nofrontiere's second venture into the field of economy and econometrics was quite straightforward. The Austrian National Bank is the pillar of the Austrian financial system, but very few people actually know what is done there.

A Virtual Theme Park
Swarovski Crystal Worlds

http://www.swarovski-crystalworld.com

The official Web site of the Swarovski Kristallwelten at Wattens in Tyrol, Austria, offers visitors complete information about one of Austria's most visited tourist attractions: how to get there, opening hours, an interactive Shockwave tour through the Chambers of Wonders showcase, special product presentation, press information including a picture archive, and an on-line form to make reservations for upcoming events.

The designers' intention was to translate the incomparable experience of architecture, visions, and sound of the Swarovski Kristallwelten at Wattens, a popular industrial theme park, into a sophisticated virtual environment. Various interactive features invite the user to enter the gateway to fantasy and encounter a unique spectacle in the "magic kaleidoscope of wonder."

The voyage of discovery into the Swarovski Crystal Worlds leads users into a new dimension: the crystal interface generates a truly intuitive interactive experience. On the other hand, the Web site also offers complete information about the theme park, special product presentations, and press material, and allows on-line reservations for upcoming events.

The client's main interest was to provide on-line information for tourists, journalists, and Swarovski crystal collectors. Nofrontiere proposed to reflect the audiovisual impressions that visitors to the Wunderkammern Wattens in Tyrol encounter in a state-of-the-art, on-line application. Therefore, Nofrontiere created a crystal interface focusing on the "kaleidoscope of wonder" as a central navigation tool. The designers furthermore developed a special language, based on Swarkovski founder André Heller's individual approach to words and texts, to support an emotional setting: the world of magic.

Client The Swarovski Kristallwelten **Team** Fritz Magistris, concept; Nicki Mayrhofer, art direction, design; Oskar Habermaier, Nick Meinhart, copywriter; Pedro Lopez, translation; Raimund Schatz, Martin Seiter, Wolfgang Schreder, programming; Anna Weidinger, project manager **Since** August 1999 **Target** Tourists worldwide, collectors of Swarovski products, journalists, event managers, designers, and artists

Tools Adobe Photoshop, Macromedia Director, SoundEdit, GifBuilder, DeBabelizer, QuickTime, HTML, Shockwave **Award** Best of the European Web 1999

The Web site of Swarovski Crystal Worlds became a symbiosis of an interactive journey and first-hand information. The main navigation follows a spatial and thematic separation between interactive experience (the wonder world) and information level. The Web site offers three spheres: the Kaleidoscope of Wonder, an illustrative tour, and the information level. To follow the intuitive, playful navigation through the kaleidoscope is a unique adventure by itself. Within the tour, a shallow navigation was implemented to guide the visitor through the organic Chambers of Wonder.

To put all information content on one level, the designers used a shallow navigation with a broad entry using rollovers to optimize space restrictions. In concert with the client, special attention was paid to the definition of titles for the information menu bar. One of the problems they encountered was to fit all eleven equally important "chapters" into a clearly structured main menu that can easily be activated from all parts of the journey.

One major technical hurdle was to divide the screen carefully into the different sections to jump between the Shockwave application and HTML to implement two versions of the kaleidoscope for those users who are unable to use plug-ins.

The standard browser navigation was intentionally enabled to channel all moves of the user within the content frame. To highlight the site's exclusivity, no standard interfaces were used. The user can choose among different ways of navigation: icons, or word or picture links.

>> The voyage of discovery leads users into a new
 dimension: the crystal interface generates a truly
 intuitive interactive experience.

>>

The most significant idea within the whole concept was to tempt the user into the Swarovski Crystal Worlds. Crystals have many characteristics: they create reflections, they sparkle, they have facets. These attributes are reflected in the diverse and comprehensive offerings of this Web site. The Shockwave version of a kaleidoscope is equipped with a "handle" that provides full functionality, just like a real kaleidoscope. This is an experience, the designers believe, that is unique to the Web.

Nomex

[Montreal, Canada]

>>
Nomex Inc. is a full turnkey Web solutions provider using the latest in information technology to serve up complete products to a variety of clientele. The consultancy offers three tiers of services: Web marketing, solutions development, and integration. Marketing services includes strategic market planning as well as all Web design, development, and electronic marketing (search engines and banners etc.). The company's solutions division provides high-end publishing tools, intranets, extranets, and e-commerce applications for their clients. Once Nomex delivers a solution, they back it up with complete installation, training, and support services

01 02 03 04 05 06 07 08 09 10 11 12

site: www.nomex.net

Paper Chase
Creative Toolkit

http://www.creativetoolkit.com

Domtar, a major paper supplier, wanted to become more involved in their marketplace. Nomex proposed that they offer a new on-line resource for designers, specifically print designers. The site is designed as a complete resource for the print designer and includes all the latest news and articles on more recent events and products. Designers can also use the site to download plug-ins and software that can aid them in their day-to-day operations. Contests and discussions encourage participation by designers, creating an environment for them to "hang out" in. The toolkit section of the site will continue to evolve with the addition of new features such as a photo and illustration search mechanism, a project-management tool, and many other features arriving each month.

The client's mandate was: "Help us become more active in the graphic design market place." The creative team's first step was to review all of Domtar's competitors on-line and see what, if anything, they are doing to attract the market to their sites. Nothing of value was found. Most of the Web work done by Domtar's chief rivals amounted to simple, brochure-type sites.

The team's next step was to find what the market was doing on-line. Luckily there was much written on the Web activities of graphic designers and they easily found that the download of software and content was high on graphic designers' list, along with searching for inspiration and finding photos for production. This is where bells started to chime. The team then listed out all sites that offered answers to these few needs at one place. They found only three such sites that were done well enough and with enough content to be of use to designers. More importantly, none of the sites focused on print design. This was key. Were Domtar to develop a print-oriented design resource, they would instantly be the only one out there.

Once Nomex had identified the goal of creating the ultimate resource for print design, they brought in six graphic designers and began a two-day brainstorming session. The goal was to define the site they wished to build and all possible features. Once they had defined the features of the site, they prepared the navigational plan and the site architecture.

The team's primary goal was a challenge: to bring designers to the

Client Domtar **Team** James McBeath, producer; Claude Belanger, project manager; Daniel Ste Marie, lead programmer; Genevieve Maltais, art direction **Since** January 2000 **Target** graphic designers **Traffic** Average of one million hits per month

Tools Adobe Photoshop, HTML, Cold Fusion, JavaScript

13 14 **15** 16 17 18 19 20 21 22 23 24

site on a regular basis and display Domtar's products. To do this, they decided on a color scheme that separates Domtar's key corporate and product sections of the site from that of the resource area. The overall design initiative had to appeal to designers who will spend more time browsing the gallery of screens on the site.

Nomex, as always, developed the Web site's navigational plan to ensure that visitors could reach any part of the site from anywhere within the site. This is doubly key for a site where visitors need to be exposed to Domtar's products. Each section was placed in a priority list, and a design brief was developed for the designers ensuring the objectives of the site were met. These objectives were as follows:

- Establish two interfaces linked by design styling
- Develop navigation conventions to be used between the two sections
- Create a graphical similarity and link
- Provide accessibility to all sections from all screens
- Make the site compatible with 4.0 browsers and above
- Presume all plug-ins are available for development including Flash, Shockwave, JavaScript (designers have great access and all the plug-ins you can imagine)
- Keep size to 80k or less

- Design intranet for management of content

The end navigational result is a site with a deep orange with gray detail for Domtar's product and corporate section, and a gray with orange detailed toolkit section. The internal pages used a convention in navigation similar to both; top and to the left is a full menu of principal sections. The menus all have informative, textual mouse-over effects to ensure that visitors are clear about where they are traveling. The team have included significant navigation per product for Domtar, including a variety of tools—such as a paper selector—visiting designers can use to find which product would be of interest to them.

The entire site is database-driven. The client has engaged with a streaming news service for this purpose and their password-protected intranet/supervisor section allows them to manage which content is placed in which section. The intranet itself is an achievement of simplicity, since the client wanted a "no-hassle" way of managing content. The base of the site was developed using Cold Fusion. Nomex has found that most of their sites are easily developed due to the flexibility of this programming platform.

site: **www.creativetoolkit.com**

A key consideration in the design was that visitors be able to reach each individual member rafting company's Web site as quickly and easily as possible.

To the Rafters
Riversearch

http://www.riversearch.com

Riversearch is a map-based site designed so those seeking the thrill of whitewater rafting will find only the best rivers to run and the leading outfitters who run them. It is also an intranet giving the board of directors and members of various companies access to communications tools, such as newsgroups and voting.

The nature of the Web allows any type of rafting company equal billing. When clientele visit rafting company sites on-line, a well-designed site could be representing a company that has a sketchy service record. The outfit could indeed be unsafe, disorganized, and have a less-than-adequate service record. As a result, folks were running rivers and having bad experiences. A group of river-running companies decided to pool resources and develop a members-only site that points adventure enthusiasts towards only the best of whitewater rivers and the highest standard of outfitters.

A key consideration in the design was that visitors be able to reach each individual member rafting company's Web site as quickly and easily as possible. To do this, the designers needed to plan for an easy-to-navigate, map-based interface. This was a challenge since maps tend to make for heavy downloads (the designers also were faced with a difference of opinion among the directors as to the amount of detail they should show per map). The end goal also included the development of a database to allow for continuous marketing.

Nomex decided that, due to the number of outfitters and rivers per region, they would have to bring visitors through three levels: from main-screen map to region, then river, then company. The end result was a site that allowed for a variety of means to get to each rafting company. The team included hyperlinks from a list of regions, a list of companies in the About section, a search function and the maps. Contests, on-line newsletter subscriptions, and a simple e-mail club allow visitors three prominently displayed ways to enter their names into the database.

Client 45 of the top rafting outfitters from around the globe **Team** James McBeath, producer, project manager; David Parenteau, lead programmer; Sonia Girouard, art direction **Since** January 1999 **Target** Adventure tourists

Tools Adobe Photoshop, HTML, Cold Fusion, JavaScript **Traffic** Average of 500,000 hits per month

>>

Simplicity realized.

ORGANIC

Organic

[San Francisco, California]

>>

A pioneer in the field of on-line business development, Organic was one of the first full-service agencies to cater exclusively to on-line clients with strategic analysis, engineering, design, marketing, logistics, interactive media, and integrated e-commerce.

Organic says it "builds businesses on-line." Clients include companies large and small, from brand-name retailers wanting to add new sales channels to their mix to aspiring start-ups looking to develop an on-line business from scratch. The agency pledges that its user-centric, integrated services ensure that site development always put the needs and desires of the end-user first. Whatever the case, Organic has one overriding goal: to create compelling on-line businesses that help clients attract and retain loyal customers. To achieve that, they have adopted what they maintain is a unique, total customer-management approach. This method is designed to streamline what is an inherently complex process to ensure a seamless flow of function, identity, and communication. Working together, Organic strategists, creative teams, technologists, media planners, communications, and logistics experts strive to address every contingency to deliver more than a simple commerce site but rather, "deliver a business."

site: www.organic.com

Home Depot

http://www.homedepot.com

>>

The Home Depot Web site is designed to provide an information-rich experience that will continually engage, inspire, and motivate users. It offers a wealth of step-by-step home-improvement projects, helpful tips, store services details, financials, company background and corporate news, various on-line calculators, and personalized home-improvement information. These project sections feature step-by-step instructions, colorful illustrations, and helpful tips specifically adapted for the Web medium.

While the client was very interested in providing helpful home-improvement information and ideas to its customers, the site had to meet some specific business objectives. The strategy was to attract and educate customers in order to use the Web to build one-to-one relationships with them. The Home Depot also saw the site as a great opportunity to attract and recruit the employees that are so essential to their off-line success. And finally, the site had to meet baseline expectations for corporations on-line: it had to disseminate corporate communications and provide investors with appropriate and timely information.

To meet these objectives, the development team realized the site had to provide first-rate content and make on-line customers feel as if they were getting the personal attention and help they receive at their local Home Depot store. A robust, step-by-step How-To section actually improves on the store experience; customers can browse through project instructions at their leisure and can prepare for their store visit in the comfortable, relaxed atmosphere of their home. To reproduce the experience of a Home Depot store, the site had to be personalized and invite interactivity that transforms The Home Depot site from a static "view site" into an engaging "do site."

First and foremost, The Home Depot site needed to be built on a robust template system to meet both client objectives and user goals. From a business perspective, the site needed to be extensible and flexible to accommodate additional content, new functionality, and, eventually, commerce capabilities. For the users, the site had to be predictable, easy-to-navigate, and consistently meet expectations.

Client The Home Depot (Jeff Cohen, Ellen Dracos) **Team** Marusa Debrini, creative director; Vincent Jurgens, lead information architect; Laurie Bell & Doug Muise, lead designers; Keith Cucuzza, editorial lead; Sasha Panasik, lead production artist; Michelle Haynie, strategic lead; Jared Rhine & Brad Lucas, lead engineers; Cecilia Eloy & Damon Anderson, producers **Since** June 1999 **Target** Residential home-improvement customers

Tools Adobe Photoshop, BBEdit, GifBuilder, DeBabelizer, QuickTime, HTML, JavaScript, Frontier, Macromedia Dreamweaver, FreeHand

To enable easy navigation and orientation, the site architecture is broad rather than deep. It's easy for users to "drill down" into projects for details, but most relevant information is available from a top level and is accessible with a minimum number of clicks. More importantly, the user is always oriented via a number of user-interface cues. Each project section is color-coded to make it easy for users to determine in which section they're located. In addition, each page includes a depth path that traces the pages the user visited to get to their current location. One click on any segment of the depth path returns the user to that particular page.

On many sites, the barrier to personalized content is a cumbersome registration process. The Organic team carefully designed registration that returns control where it belongs—into the hands of the user. The specificity and amount of personalized content users receive is directly related to how deeply they commit to the registration process. At any point in the flow, users can opt to complete their registration, thus ensuring that they receive the benefits of the service on terms that are comfortable to them.

Each content section on the site is introduced via an overview page that orients users to what they will find in each section. Embedded links and local navigation provide easy access to content, and the depth path and global navigation ensure that users can easily travel throughout the entire Home Depot site quickly and easily—something that cannot be done in an off-line Home Depot store.

site: www.homedepot.com

> The site needed to be extensible and flexible to accommodate additional content, new functionality, and, eventually, commerce capabilities.

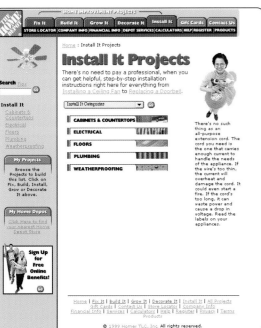

Organic's formula for successful Web development:

- Immerse yourself in the brand and know the target audience.

- Define strategic objectives.

- Balance business needs with user needs.

- Establish a core concept for the site experience that embodies both business and user needs.

- Practice the principles of user-centric design.

- Aggregate assets, both graphical and copy, at the beginning of the project and plan for the production of anticipated assets before you get into production.

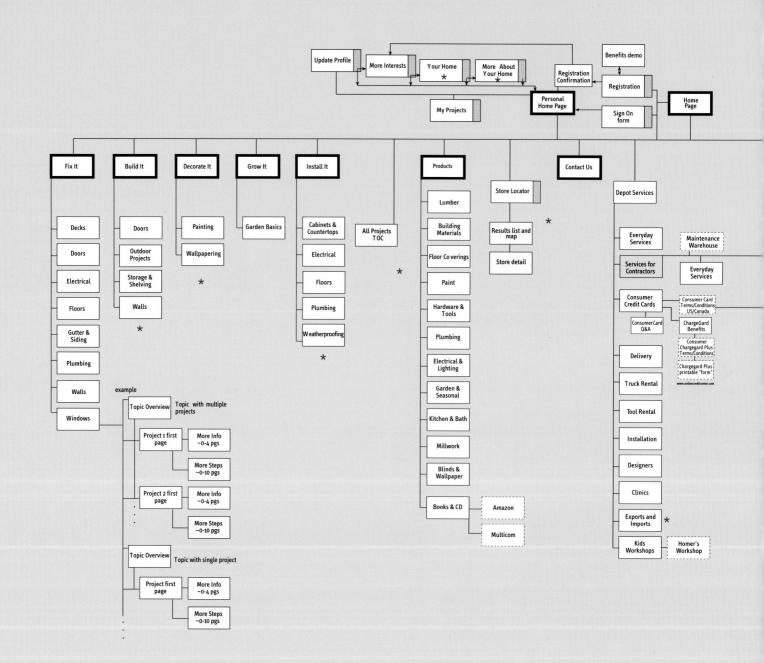

Update Profile

More Interests

Your Home ∗

More About Your Home ∗

Benefits demo

Registration Confirmation

Registration

Personal Home Page

Sign On form

Home Page

My Projects

Fix It
- Decks
- Doors
- Electrical
- Floors
- Gutter & Siding
- Plumbing
- Walls
- Windows

∗

Build It
- Doors
- Outdoor Projects
- Storage & Shelving
- Walls

∗

Decorate It
- Painting
- Wallpapering

∗

Grow It
- Garden Basics

Install It
- Cabinets & Countertops
- Electrical
- Floors
- Plumbing
- Weatherproofing

∗

All Projects TOC

∗

Products
- Lumber
- Building Materials
- Floor Coverings
- Paint
- Hardware & Tools
- Plumbing
- Electrical & Lighting
- Garden & Seasonal
- Kitchen & Bath
- Millwork
- Blinds & Wallpaper
- Books & CD
 - Amazon
 - Multicom

Store Locator
- Results list and map
- Store detail

∗

Contact Us

Depot Services
- Everyday Services
 - Maintenance Warehouse
- Services for Contractors
 - Everyday Services
- Consumer Credit Cards
 - Consumer Card Terms/Conditions US/Canada
 - ConsumerCard Q&A
 - ChargeGard Benefits
 - Consumer Chargegard Plus Terms/Conditions
 - Chargegard Plus printable "form"
 - www.onlinecreditcenter.com
- Delivery
- Truck Rental
- Tool Rental
- Installation
- Designers
- Clinics
- Exports and Imports ∗
- Kids Workshops
 - Homer's Workshop

example

Topic Overview — Topic with multiple projects
- Project 1 first page
 - More Info ~0-4 pgs
 - More Steps ~0-10 pgs
- Project 2 first page
 - More Info ~0-4 pgs
 - More Steps ~0-10 pgs

Topic Overview — Topic with single project
- Project first page
 - More Info ~0-4 pgs
 - More Steps ~0-10 pgs

site: www.homedepot.com

Key diagram:
- abcd = Form, with error and confirmation pages
- grey background x pg = multiple pages
- abcd = external site
- (bold box) = Primary Nav
- example = only one occurrence detailed.
- "form" = page with fields, buttons, but no form submission to server
- ★ = changed since last major version

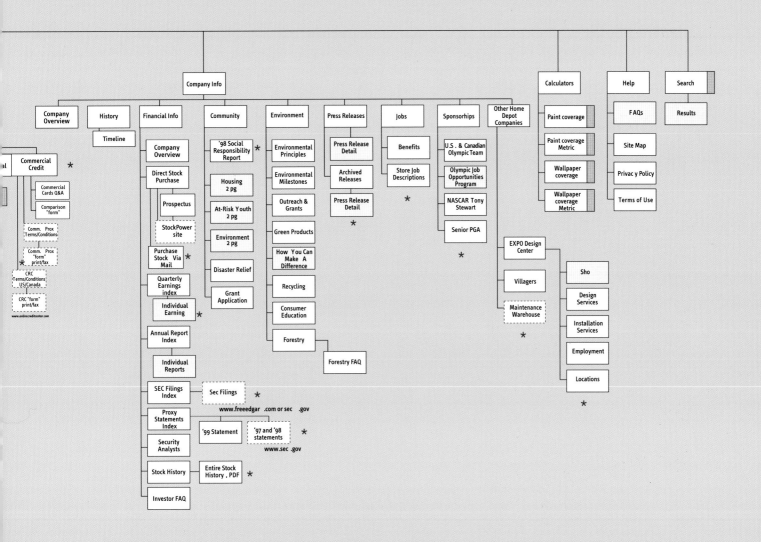

Company Info

Company Overview | History | Financial Info | Community | Environment | Press Releases | Jobs | Sponsorhips | Other Home Depot Companies

Calculators | Help | Search

History → Timeline

Commercial Credit ★
- Commercial Cards Q&A
- Comparison "form"
- Comm. Prox Terms/Conditions
- Comm. Prox "form" print/fax ★
- CRC Terms/Conditions US/Canada
- CRC "form" print/fax

www.onlinecreditcenter.com

Financial Info:
- Company Overview
- Direct Stock Purchase
 - Prospectus
 - StockPower site
- Purchase Stock Via Mail ★
- Quarterly Earnings Index
- Individual Earning ★
- Annual Report Index
 - Individual Reports
- SEC Filings Index
- Proxy Statements Index
- Security Analysts
- Stock History
- Investor FAQ

Sec Filings ★
www.freeedgar.com or sec.gov

'99 Statement | '97 and '98 statements ★
www.sec.gov

Entire Stock History, PDF ★

Community:
- '98 Social Responsibility Report ★
- Housing 2 pg
- At-Risk Youth 2 pg
- Environment 2 pg
- Disaster Relief
- Grant Application

Environment:
- Environmental Principles
- Environmental Milestones
- Outreach & Grants
- Green Products
- How You Can Make A Difference
- Recycling
- Consumer Education
- Forestry

Forestry FAQ

Press Releases:
- Press Release Detail
- Archived Releases
- Press Release Detail ★

Jobs:
- Benefits
- Store Job Descriptions ★

Sponsorhips:
- U.S. & Canadian Olympic Team
- Olympic Job Opportunities Program
- NASCAR Tony Stewart
- Senior PGA ★

Other Home Depot Companies:
- EXPO Design Center
- Villagers
- Maintenance Warehouse ★

- Sho
- Design Services
- Installation Services
- Employment
- Locations ★

Calculators:
- Paint coverage
- Paint coverage Metric
- Wallpaper coverage
- Wallpaper coverage Metric

Help:
- FAQs
- Site Map
- Privacy Policy
- Terms of Use

Search:
- Results

Fix It | **Build It** | **Grow It** | **Decorate It** | **Install It** | **Gift Cards** | **Contact Us**

STORE LOCATOR | COMPANY INFO | FINANCIAL INFO | DEPOT SERVICES | CALCULATORS | HELP | REGISTER | PRODUCTS

Home : Decorate It Projects

Decorate It Projects

From Patching Peeling Paint to Hanging Wallpaper Borders, here's where you'll get step-by-step guidance to beautifully decorate every area in your home like a seasoned interior designer.

For more decorating inspiration and solutions, pick-up a complimentary copy of our new magazine, *The Home Depot Style Ideas*, at your local Home Depot store.

Matte finishes or textured materials with surface irregularities you can see and feel make a room seem cozier and more contained. Examples? Wall-to-wall carpeting, a rice paper hanging, a brick fireplace—or check out the new textured paints. These offer linen, denim, and stone textures for almost any surface.

Search Tips
[] GO

Decorate It
Painting
Wallpapering

My Projects
Browse the Projects to build this list. Click on Fix, Build, Install, Grow or Decorate It above.

My Home Depot
Click Here to find your nearest Home Depot Store

Charge It!
APPLY ONLINE
GO

SIGN OFF

Decorate It Categories [▼] GO

| PAINTING |
| WALLPAPERING |

Home | Fix It | Build It | Grow It | Decorate It | Install It | All Projects
Gift Cards | Contact Us | Store Locator | Company Info
Financial Info | Services | Calculators | Help | Register | Privacy | Terms
Products

Fix It | **Build It** | **Grow It** | **Decorate It** | **Install It** | **Gift Cards** | **Contact Us**

STORE LOCATOR | COMPANY INFO | FINANCIAL INFO | DEPOT SERVICES | CALCULATORS | HELP | REGISTER | PRODUCTS

Home : Decorate It : Wallpapering : Borders : Hanging Borders

WALLPAPERING

Hanging Borders

Like any wallpapering project, you're most likely to be successful if the surfaces are clean and smooth. If you're installing a wallpaper border over an existing paper, you'll get the best results using a vinyl-to-vinyl adhesive.

Stuff You'll Need

Tools
- Flat plastic ruler
- Pencil
- Smoothing brush/Tool
- Wallboard knife
- Utility knife
- Level
- Brush for primer
- Drop cloth

Materials
- Wallpaper border
- Adhesive (if needed)
- Wallpaper primer

Print this List

Step-by-Step
There are 5 steps in this project.

1 Using the width of your border as a guide, prime the wall or surface area where you plan to install your border. Plan your starting point so that if there is a mismatched seam, it'll fall in an inconspicuous place. If you're going to be hanging a border as a chair rail, use a level and draw a light pencil line around the room at the right height.

2 You'll begin hanging your first strip at a corner, and overlap the border onto the adjacent wall about 1/4 inch. Have a helper hold the border while you hang it and smooth it with the smoothing brush.

1 | 2 | Next

Search Tips
[] GO

Decorate It
Painting
Wallpapering
 Borders
 Hanging Borders
 Mitering Border Corners
 Removing Wallpaper

My Projects
You can add How-To projects to your Personal Project File if you Register Now

My Home Depot
Store Locator

Charge It!
APPLY ONLINE
GO

SIGN ON

Add to My Projects

Print This Project

Skill Level
Hanging a border requires basic wallpapering skills.

How Long?
A beginner and a helper can hang a border around an average room in an hour and a half.

Related Topics
Repairing Wallboard
Wallpaper Calculator
Mitering Border Corners

Home | Fix It | Build It | Grow It | Decorate It | Install It | All Projects
Gift Cards | Contact Us | Store Locator | Company Info
Financial Info | Services | Calculators | Help | Register | Privacy | Terms
Products

site: www.homedepot.com

Design Advice from Parisfrance

- Always design for the audience.
- Be consistent.
- Navigation straddles visual, information, and interactive design—cover these areas and navigation is easy.
- The better the content architecture, the less navigation needed.
- Layer the content and the experience.
- Regardless of what the usability experts say, it's not necessary to do the same thing every other site does to provide a great user experience.

Parisfrance
[Portland, Oregon]

>>

Parisfrance is a boutique Web-design studio whose mission statement can be summed up in a single sentence: "We invent places where people love to go." Companies want to interact with people. More and more, this interaction takes place via the Internet. The agency is dedicated to help these companies, or their ad agencies and design firms, by creating Web sites that allow people to interact with brands. The reasons companies seek such interactions are various, ranging from simply saying hello to selling a ton of stuff.

The problem is, people do not always want to interact. In fact, they spend a lot of time avoiding certain interactions. They want to minimize the bad experiences in their lives and maximize the good. The better the Web experience, the more people choose to interact with a company. That's why cofounder Jeff Faulkner uses "love" as the studio's ultimate measure of success. The studio creates these experiences by fusing the skills of advertising and interactive.

While the studio doesn't generally create ads, the designers do apply their advertising background to the Web. (Two of the four founders have spent at least a decade each in ad agencies.) Most Web-design companies are either design driven or technology driven. The studio prefers to think of itself as idea driven. This comes from the understanding that everything they do must communicate the brand. Design and technology, as far as they are concerned, are handmaidens to the idea, which in turn serves the brand.

In its first year of operation, the studio has created Web sites for an eclectic mix of clients, including Gravis Footwear, eVineyard, MLY Snowboards, Millennium Three Snowboards, BOORA Architects, Nerve Advertising, and others. The studio's projects have been recognized by *Communication Arts* Site of the Week, Macromedia Flash Site of the Day, and Searchbots.net's Best Bot, and Cool Home Pages.com.

01 02 03 04 05 06 07 08 09 10 11 12

site: www.parisfranceinc.com

January skin for Paris.

November skin for Paris.

Free Ride
Gravis Footwear

http://www.gravisfootwear.com

>>

Gravis is a footwear company based in Burlington, Vermont. The client needed a Web site that introduced their shoes and supported their brand message. The designers planned the site to complement the advertising and brand image for Gravis developed by Cinco Design Office. They chose to focus the site on the Gravis lifestyle, which is dedicated to the pursuit of surfing, snowboarding, and skateboarding. The Gravis lifestyle is embodied by the members of the Gravis team of riders who view riding not as sports, but as lifestyles.

The Web site gives viewers a chance to read about Gravis shoes and about other riders, with statistics, colors, and sizes for every shoe, as well as photography. Also, every month Gravis sends their team disposable cameras, asks them to show what they're up to and asks them to give a brief written dispatch. Music is also a big part of the Gravis lifestyle, so the designers worked with Om Records, an independent label in San Francisco and a leader in experimental hip-hop sound, to provide visitor-selectable soundtracks for the site.

The studio typically begins its process by exploring the depths and boundaries of the brand, and getting to know the audience and the competitive environment. For Gravis, the Parisfrance team read a lot, hung out in skate shops, took photos, listened to a lot of experimental hip-hop and trance music, wore the shoes, and got to know the riders. Knowing the audience up front is one of the imperatives—not only what kind of connectivity they have, but who they were as people and what their environments looked like. Project creative director Jeff Faulkner says, "Once we had an understanding of all this, clearly understood Gravis' marketing objectives, and

Client Gravis Footwear **Team** Chuck Nobles, account director; Doug Lowell, Jeff Faulkner, creative directors; Jeff Faulkner, visual design; Dave Loverink, Jeff Faulkner, interaction design; Aaron Anderson, technology design; Doug Lowell, Dave Loverink, information design; Jeff Faulkner, sound design; Phillip Kerman, Flash consultant; Dave Loverink, producer.
Brand Agency Cinco Design, Dan Sharp, designer; Desiree East, producer **Since** August 1999
Target Trendsetters in the surf, skate, snow, and music arenas; 15 to 25 years old

Tools Adobe Photoshop, Macromedia Freehand, Macromedia Flash, SoundEdit, Bbedit, Ultra Edit, MS IIS Traffic 4,000–8,000 visitors per week, depending on ads and promotions
Awards *Communication Arts* Site of the Week

First screen, navigation posed but unrevealed.

felt the overall vibe, we began concepting and designing. We comped about twenty passes, whittled it down to ten ideas, and from there, firmed up three and had the client choose one."

The entire user experience had to be true to the Gravis brand. The creative team had to design an experience that engaged the audience without marketing to them. One hint of marketing or a sales pitch and Gravis would lose the brand mystique. The navigation supports the overall experience with sliding menus, layered content, and interactive visuals. The visitor's use of the navigation had to expand on the feeling created by the visuals. In most sites, the navigation produces a completely different feel from the visuals. The goal was to make the visitor switch mental modes

between experiencing the content and navigation.

In addition to looking good within the visual design of the site, the operation of the navigation had to feel right. The designers chose simple interface elements and spent a lot of time tweaking their behaviors, especially the sliding menus. Lots of time was spent on the technical hurdles of getting the JavaScript, CSS, and DHTML to work cross browser and cross platform. ASP and VBScript can make cross-browser and cross-platform development easier if you plan it out. Programmers wrote a lot of JavaScript and VBScript to make it work smoothly for all visitors.

P R DL C

roster

team

While the members of the Gravis Design Team are off surfing reef breaks in Fiji, carving big steeps in British Columbia, or riding skateparks in Tokyo, they're sending back reports. Which tread patterns work best in snow. How our ventilation holds up in the tropics. What feels good on both dirt roads and airport concourses. And in between competitions and pure play, they join up with the rest of the Gravis product development team and design shoes.

TONE

P R DL C

japan

Hokkaido
Honshu
Kyushu
Shikoku

TONE

P R DL C

roster

sascha meyenberg
GERMANY BMX

Age: 21

Homebase: Munich, Germany

Big Accomplishments: '96 World Cup BMX Champ

A day in the life:
I get up at 9:00, eat, eat some more and brush my teeth. Around 10:00 I grab my bike, check the air in the tires and hit some trails. After 2 hours I take a short brake. At 13:00 I , sometimes, can be seen in the gym and afterwards I am back on the trails turning my legs like a sprinter. Nighttime I usually go to a party.

PRODUCT
CENTURY
CUE
DUNE
FACTOR
INDEX
KONA
MERC
RIVAL
TARMAC
SOCKS
METRO PACK

TONE 1 2 3 4 credits | off |

Rider shot. Menus fully extended.

site: www.gravisfootwear.com

>> The interface reveals itself as the visitor uses it, and new layers of content unfold as the site is explored.

Team Brand
Millennium Three

http://www.m-three.com

>>

The Millennium Three site reflects the simple truth that, for this company, the team is the brand. The designers had to spotlight the riders who make up the audience with a site that reflected the inventiveness of their snowboarding style and then let the audience discover the boards on their own. The site, created in Flash 4, rewards an inquisitive mouse with an almost subconscious navigation system, plus tools like a board magnifier and an action video viewer. The creative team also paired up with Om Records, an experimental hip-hop label in San Francisco, to put music on the site.

Throughout, the primary purpose was to showcase the M3 team. Millennium Three was born when a few other pro snowboarders decided to create the ideal snowboard company. In the first year of M3's existence, a stellar crew of pro riders helped design a line of freestyle boards that found immediate acceptance. Each member of the M3 team is a hero to the target audience. The audience knows these riders' standings, they follow them in the magazines, and if these guys designed the boards and ride the boards, then the boards must be cool.

As with every project the designers do, they didn't move a pixel until they had internalized the Millennium Three brand. Given the complexity and underground nature of M3, that took some digging and mind-melding with the client, their branding agency Cinco Design, and their audience.

Client Millennium Three; brand agency, Cinco Design/John Phemister **Team** Chuck Nobles, account director; Jeff Faulkner, Doug Lowell, creative directors; Jeff Faulkner, art director, Flash animator; Doug Lowell, writer; Jeff Faulkner, Dave Loverink, Phillip Kerman, interaction designers; Jeff Faulkner, sound designer; Phillip Kerman, Flash engineering; Dave Loverink, producer; Aaron Anderson, technology designer **Since** November 1999 **Target** 14 to 24 year olds

Tools Adobe Photoshop, Macromedia Freehand, Macromedia Flash, SoundEdit **Traffic** 3,000 to 5,000 visitors per week **Awards** *Communication Arts* Interactive Design, Macromedia Flash Site of the Day

>>

OVERALL LENGTH		160.0 CM		SPECS
EFFECTIVE EDGE LENGTH	124.0 CM	NOSE LENGTH	21.5 CM	
CONTACT LENGTH	120.0 CM	NOSE HEIGHT	56.0 MM	
NOSE WIDTH	29.7 CM	NOSE RADIUS	40.0 CM	
WAIST WIDTH	25.24 CM	TAIL LENGTH	18.0 CM	
TAIL WIDTH	29.7 CM	TAIL HEIGHT	45.0 MM	
SIDECUT RADIUS	8.31 M	TAIL RADIUS	35.0 CM	
SIDECUT DEPTH	22.30 MM	STANCE WIDTH	17-26 IN	
TOP GREY	BASE BLACK	STANCE CENTERING	25 MM BACK	

BOARDS

51
54
56
57
60

STILLS

STORY

Brandon Bybee
Mikey LeBlanc
Mitch Nelson
Chad Otterstrom
Blaise Rosenthal
Risto Scott
Gabe Taylor
Kendall Whelpton
Scotty Wittlake

ACTION

Like any rich experience, the M3 interface involves exploration, something the target audience was very much at ease with. The interface reveals itself as the visitor uses it, and new layers of content unfold as the site is explored.

Navigation is addressed with a single-interface design that relies heavily on a kind of hide-and-reveal aesthetic. The pace of the menus, the pace of the sound, the slide of the horizontal scrolls—everything follows a particular aesthetic, a single vibe.

With the main-level navigation design, the creative team relied on the oldest software convention next to the command line: the drop-down menu. They also designed the inner navigation in the spirit of the overall design, but considered each path on a case-by-case basis. By keeping them simple, almost toylike, the designers felt comfortable mixing the interaction up a bit. As they went into story boards, the horizontal sliding images began to feel really good. "We had the hide-and-reveal thing going on," Faulkner recalls, "and that seemed a smart way to carry it forward. Again, this supported our single interface theory too."

site: www.m-three.com

The Parisfrance
navigation philosophy:

- Design for people—getting
 hit with a lot of information
 at once is no good.

- Be consistent unless doing
 so will bore the audience.

- Navigation is an aesthetic
 and should be treated as
 an element of an overall
 and singular composition.

- Layer the content and
 the experience.

- Usability is important but
 people really can handle
 good and innovative design.

- Iterate until it feels right.

M3 was represented by some groundbreaking print work. Cinco had created a look and vibe that really stood out from the "agro" aesthetic apparent in every corner of the snowboarding media. The designers had to accomplish the same thing on the Web. Their strategy was to break through the confines and clichés of Web design in the same way that the brand and its advertising had broken through other clichés. Though they didn't adapt their look directly from the print campaign, the vibe was consistent from ads to snowboards to riders to the site.

A large amount of information is layered into a deceptively simple interface. The designers spent a lot of time working with the content before the design and interaction came together. There's no substitute for iterations—they kept refining until the experience felt complete. The site was repeatedly comped until the team had a good spectrum of work to show the client. The team then chose the direction that felt "the most M3." From there the designers expanded the concept into story boards and started working on proof-of-concept pieces in Flash.

The designers were very conscious about presenting the M3 company and the M3 riders as a unity. This ethic worked its way into the navigation. You really can't detach the navigation from the content. The navigation *is* the content—just as the company is the riders. There isn't anything standard about the interface. But that doesn't mean throwing out the things that make an interface good, such as consistent behaviors, visual cues, and layering. For the audience, the designers were able to make the cues more subtle, but the tenets of good UI design still applied.

The site has first and foremost to extend the brand experience. In this case, the brand is all about the pro riders on the team. The riders created the company and the boards—no overt marketing or sales messages here. The designers wanted to showcase the riders and provide a great way to learn more about the line of boards. M3 uses exploratory navigation throughout. While the interface elements are unique, their simple nature and consistent behaviors make them intuitive to the young, Web-savvy audience.

>>

"Pardon the analogy," Faulkner writes, "but this one is currently working well for us: navigation is to the interactive designer what plot is to the novelist. Just as a character or a story commands a particular narrative, a brand deserves an interface and navigation unique and inherent to it. To serve our clients' needs best, to serve our users best, we have to take this approach.

"We look upon an interactive piece as a gesture of pop culture, as a statement inserted into the discourse of communication and commerce. The monolithic template-based thing just isn't something we believe in. Our methodology isn't an ostensible one by any means. We create from scratch and test based on our own instincts and how our test users react. Our instincts have a lot to do with where interactive is at any given time. For instance, in February of this year we all felt it was finally acceptable to use a drop down without an in-your-face prompt. Six months earlier that would have been downright arcane. You gotta put this stuff on a timeline otherwise you loose ground and miss opportunities.

"Users have been trained on bad interface over the last few years, but they're beginning to be trained on better interface. The larger point is the public is getting exposed to a variety of navigation strategies and that's becoming more and more acceptable. The OS people and software people probably view the whole thing as the plague. We view it as an opportunity to advance the art, and to create better, more useful interfaces without being tied to the old bad ones.

"As much as people talk about interactive conventions, the fact is there really aren't many—and even fewer still that are worth repeating. Also analogies to other media and 'placey-thingy' metaphors are taboo around here. We just like inventing new ways to get at information. There are a million stories out there, and a million stories deserve a million plots. And audiences are into that."

Phoenix Pop
[San Francisco, California]

>>

Located in the heart of San Francisco's SOMA district, Phoenix Pop Productions is an Internet professional-services provider that helps its clients build start-up Web companies. The agency is set up to help with everything from business strategy to branding to hardware acquisition to site development. In short, Phoenix Pop shepherds big ideas from the cocktail-napkin stage through site launch.

Phoenix Pop specializes in creating "best-to-market" Web solutions that aim for both success and sustainability. It does this by dedicating an "A" team of experts from every discipline—strategy, design, production, project management, user experience, and engineering—to each project it undertakes. The agency's portfolio includes successful launches of Wineshopper.com, Epylon.com, Productopia.com, Sparks.com, iTheo.com, and Spinner.com.

Phoenix Pop has grown to more than one hundred employees since its founding in 1996. It has earned a reputation for design excellence and has won nearly every major design award in the industry, including two Interactive Design Communication Arts Awards of Excellence in 1999 and a One Show Interactive Silver Pencil.

"There is nothing more fascinating than taking a great idea and making it reality. That's what I'm passionate about," says Phoenix Pop CEO Bruce Falck. Falck, who founded the company along with creative director Simon Smith, says what sets Phoenix Pop apart is a business model that doesn't answer to shareholders and thus allows the company to choose clients with the best business models and most interesting design challenges. "A lot of our clients walk in and all they have is a great idea. They walk out with a fully operational company," Falck says. "We want every single CEO that works with us to say, 'I couldn't have done it without them.' "

| 01 | 02 | 03 | 04 | 05 | 06 | 07 | 08 | 09 | 10 | 11 | 12 |

site: www.phoenix-pop.com

Do It Yourself
SpotLife

http://www.spotlife.com

>>

SpotLife offers users a personal broadcasting network with its own distinctive channels, covering everything from sci-fi to music to religion. Now, anyone can easily broadcast digital images and videos. You have your own studio, where you control how your shows are presented and promoted. Viewers can personalize their pages with their favorite shows and channels. Shows with live content and live chat are always featured and easy to find, and a top-ten list highlights viewer favorites. To empower a broader audience to use Webcasting as broadband begins to take hold, SpotLife offers the next phase of Webcast capability and accessibility.

The site is aimed at anyone with an interest in Webcasting, whether as a viewer or a producer, particularly those who were daunted by the technical challenges of configuring and setting up high-tech gear. It was the designers' goal to make Webcasting so easy and engaging that it would take the technology beyond the realm of early adopters to a much broader audience—everyone from serious visual artists to everyday exhibitionists who just want to be seen, even if all they are doing is sitting at their computer.

Phoenix Pop's initial goal was to figure out if it was possible, given the Internet and bandwidth today, for personal broadcasting to be feasible. The only way to personalize Webcasting is to create an environment in which anyone can broadcast at anytime to a potentially narrow audience.

"The greatest technical hurdle was to figure out how to guarantee the quality of service for live streaming over the public Internet," says SpotLife's technical project manager Mija Lee. "We had to guarantee a particular number of available streams for each show, to be able to set up those shows in real-time and on the fly, and ensure that the viewer experience would be compelling."

Since the Real Server architecture was designed to broadcast only specific events at a scheduled time to a broad audience, the trick became working with Real Server to allow a more personal viewer-to-streamer relationship. Phoenix Pop engineers designed a system that served dynamic pages through an application server that pointed to live streams on a Real Server based upon authentication by a database server. The integration of these three systems was the major innovation that gave life to SpotLife.

On the front end, the designers wanted users to determine the content of the site, but they also needed to establish a framework that would inspire creativity and allow for easy navigation for viewers.

The solution was to create a "network" of provocatively named channels, such as Groove, Warp, and Wire, that give users inspiration on what types of content to create, while simultaneously giving viewers access to content they want without having to sift through an enormous "miscellaneous" section. It makes it

Client Spotlife **Team** Nicholas Wittenberg, creative director; Nicholas Wittenberg, Patrick Kalyanapu, Guthrie Dolin, Matthew Carlson, designers; Quentin George, Amy Taylor, Mija Lee, producers; Michelle Lepovic, Nathan Williams, Guy Eldredge, Toby Boyd, programmers **Since** February 2000 **Target** Anyone interested in Webcasting

Tools Adobe Photoshop, Adobe Illustrator, Adobe After Effects, HTML, ATG (Java), JavaScript, Real Server, Logitech Client Software

>> The site is aimed at anyone with an interest in
 webcasting, whether as a viewer or a producer.

easier for people to categorize their own content and easier for SpotLife to manage the site. Using the network analogy also allows for SpotLife to do things like create a localized branch off the main site.

Because SpotLife contains everything from streaming video to static photo albums, nine specialized icons had to be created to help users make decisions.

"Creating icons is a very difficult process to get right," says SpotLife's creative director Nicholas Wittenberg. "Icons should be as self-explanatory and intuitive as you can possibly make them. They must also bear some relation to each other, and must stay in harmony with the overall visual design."

At the end of the day, SpotLife's language of icons meets all of those objectives. Combined, the channel directory and the icons create a fun and novel experience for users that nonetheless provides swift, clear direction.

The complexities didn't end there, however. There were also issues to resolve over content. For example, who decides what is appropriate? The answer in this case was to create a Yikes button, which allows viewers to alert each other to inappropriate content. The site is not moderated by SpotLife but by the users.

site: www.spotlife.com

>> On the front end, the designers wanted users to
determine the content of the site, but they also
needed to establish a framework that would
inspire creativity and allow for easy navigation for
viewers.

Quantum Leap

[Chicago, Illinois]

>> Quantum Leap Communications, Inc., the Internet-development and advertising
subsidiary of Leapnet, Inc., is dedicated to inventing outstanding experiences for consumers on the
Internet. A leading end-to-end creative-solutions provider, Quantum Leap combines award-winning
design, technical expertise, and a heritage of marketing disciplines to build large-scale, personalized
Web sites and advertisements.

Initially established as the digital services unit of The Leap Partnership, a creative-focused traditional adver-
tising agency founded in September 1993, Quantum Leap was spun off in January 1997 as a freestanding sub-
sidiary. Since then, the company has grown swiftly. From its inception, Quantum Leap has had two distinct
business units: large-scale Web site development and Internet marketing. As the Internet continues to con-
tribute to its clients' successes, Quantum Leap has expanded its services to include strategic consulting,
research, account planning, and customer development.

"We are thought leaders; we are brand strategists; we are creative engineers," remarked chief creative
officer and cofounder Richard Giuliani. "By leveraging the communications capabilities of new media,
Quantum Leap creates comprehensive, brand-driven consumer marketing solutions. This synergistic
approach brings the best of all worlds to our clients and their customers under one roof." Today, with
offices in Chicago and San Francisco, marquee clients include American Airlines, Wal-Mart, Sam's Club,
Microsoft (MSNBC.com, Slate, Encarta, Internet Access), Ernst & Young, Morningstar, and The University
of Chicago Graduate School of Business.

| 01 | 02 | 03 | 04 | 05 | 06 | 07 | 08 | 09 | 10 | 11 | 12 |

site: **www.quantum.leapnet.com**

American Airlines

http://www.aa.com

>>

This full-service Web site allows American Airlines customers to book travel, manage AAdvantage (frequent flier) accounts, learn about special offers, and receive comprehensive information on American Airlines' programs and services. The site is intended to serve as a customer-care center for AAdvantage members, as well as enable customers to book flights.

In order to maintain a true partnership between Quantum Leap and American Airlines, each phase of the design process included a great deal of client participation. This not only kept the project on strategy, it also kept it on time and on budget.

To facilitate interaction between Quantum Leap team members and American Airlines, the agency deployed an extensive password-pro-

tected extranet system. This extranet archived all designs and prototypes, allowing completed work to be reviewed at any time. Allowing Quantum Leap and American Airlines to develop a comprehensive definition of the project's costs, technology, timelines, and tasks, a preliminary scoping phase resulted in a detailed analysis of the site's requirements. Translating American Airlines' business objectives into a detailed project plan that satisfied customers' needs, Quantum Leap analyzed the client's current and future requirements, company history, products and services, customer base, competitive environments, brand position and marketing programs, as well as existing on-line activity. Through a series of sessions with American Airlines, Quantum Leap developed the

Client American Airlines **Team** Richard Giuliani, chief creative officer; Matt Hanson, chief technology officer; Mark Hines, senior information architect; Margo Johnson, creative director; Michael Forsythe, art director; Mike Oltman, lead programmer **Since** Summer 1997 **Target** Frequent business travelers and AAdvantage members **Traffic** 1,475,000 unique visitors with 1.9 days of average viewing per month and 11.8 minute average duration period; 706,000 unique visitors from businesses versus 874,000 unique visitors from homes. In addition, aa.com experienced a 500 percent increase in gross e-commerce booking from 1998 to 1999, as well as a total on-line sales revenue of approximately $500 million in 1999 **Awards** Media Metrix, *Wall Street Journal* Interactive, *PC* magazine, ZDTV

Tools Adobe Illustrator, BroadVision One-To-One, Cold Fusion Server, Cold Fusion Studio, HomeSite, Informix, Oracle, QuarkXpress, Sun JDK, SQL Server, Visual Interdev

13 14 15 16 17 18 **19** 20 21 22 23 24

concepts and functionality for the proposed Web site and organized the site's content into a detailed map of features and applications.

To make sure that the visual design, navigation, and site architecture created a compelling consumer experience appropriate for American Airlines' brand, Quantum Leap performed the following five steps: look-and-feel investigation; inspiration boards; Web site designs; HTML design prototype; and, finally, a design document. Concurrent with the design phase, this phase accomplished a great deal of initial preparation, such as content analysis and functionality testing. During the final steps in site creation, a working "gold" beta of aa.com was released internally during the soft launch, a full working version that enabled Quantum Leap and American Airlines to test the site in conditions identical to what the end-user will experience.

Once the necessary testing was completed, the site went live to the public. During the initial public launch, close attention was paid to the system's performance as well as feedback from the site's users. Quantum Leap continues site maintenance, performance review, and additional feature deployment on behalf of aa.com. For instance, Quantum Leap developed American Airlines' Pick Your Prize Promotion. Once the site was officially launched, Quantum Leap utilized its extensive marketing experience to help educate consumers on aa.com's features and benefits, drive traffic to the site and build brand awareness.

At the advent of the Internet, first-generation Web sites were specifically designed to satisfy the demands of the represented organization, often losing the end-user in the navigation process. Recognizing this problem, Quantum Leap brought to life the concept of placing the individual customer within the epicenter of every transaction. The success of the aa.com site, which was one of the Web's first attempts at customer personalization, immediately proved its validity. While American Airlines' primary messages certainly deserve acknowledgment, they alone do not amount to much if the customer logs off due to navigational disarray.

Breaking down the usability of aa.com into four fundamental needs, the Web site gets to the root of customer personalization. For one, it allows the end-user to plan and book travel plans. Two, it enables the user to manage his or her AAdvantage account. Three, it serves as a solitary source for locating special offers and deals. Finally, the site groups together all reference material for quick and easy searches. By performing all of these functions, aa.com offers scalable versatility, in which one can painlessly add new content to the existing site without continuously reinventing the wheel and forcing the user to renavigate the site.

By combining visual appeal with multifaceted functionality, this Web site achieves much more than simply an application. For instance, aa.com assisted a very large company in leveraging detailed information on each user, allowing for the specialized delivery of relevant information to the customer based on information stored in the highly specific database for the very first time.

The most significant technical challenge related to coordinating and facilitating the integration of the site with its existing 33-million-person Aadvantage member database. This entailed compressing all three thousand pages of static HTML content into a dynamic publishing system that is centrally managed.

AAdvantage®

GO Contents

⚠ SPECIAL ALERT

The traffic to our new site has been extraordinary. We apologize for any inconvenience as we continue to upgrade system capacity and improve response time.

TODAY'S NEWS ON AA.com

AAdvantage Net SAAver Awards
Get away to select destinations this weekend for fewer miles.

American Airlines Double Bonus Mile Offers
Earn double miles system wide on American Airlines—SEE HOW!

Discover the Online Privileges of Membership
The All New AA.com is built to work for AAdvantage members.

SPECIAL FEATURE

Here's a Smart Way to Earn More Miles!

Apply for a Citibank AAdvantage Card today—and earn up to 4,000 bonus miles! And you'll earn even more miles when you use the card!

• AAdvantage Program Information

 AAdvantage Member Services - Check your miles, claim awards, request mileage credits...and more.

Instant AAdvantage Enrollment - Become a member (it's free) and get the most out of your travel.

PIN Request and Replacement - Get your PIN for full access to AA.com.

Special Offers - Check here often for current AAdvantage specials.

Participants Index - Who's offering AAdvantage benefits? Find out here.

Earning Miles - Flying on American Airlines is just one of many ways to earn miles.

Using Miles - Redeem your miles for flights and other partner benefits.

AAdvantage Elite Status - Recognition and benefits for our most loyal customers.

Awarding Miles - AAIM - Boost your business or reward your employees through AAIM.

Claiming Awards - Learn how to claim your AAdvantage award certificates.

Newsletter Online - Find recent editions of the AAdvantage newsletter here.

⬆ RETURN TO TOP

AmericanAirlines

A word about your Privacy.
Send comments or suggestions to: webmaster@aa.com

Contents

⚠ SPECIAL ALERT
The traffic to our new site has been extraordinary. We
any inconvenience as we continue to upgrade syster
improve response time.

 TODAY'S NEWS ON A'A.com

AAdvantage Net SAAver Awards
Get away to select destinations this weekend for fewe

American Airlines Double Bonus Mile Offers
Earn double miles system wide on American Airlines–

Discover the Online Privileges of Membersh
The All New AA.com is built to work for AAdvantage mi

. AAdvantage Program Informatio

SPECIAL
FEATURE

**Here's a Smart Way to
Earn More Miles!**

Apply for a Citibank
AAdvantage Card
today—and earn up to
4,000 bonus miles! And
you'll earn even more
miles when you use the
card!

(¥) <u>AAdvantage Member Services</u> - Check your mi'
awards, request mileage credits...and more.

<u>Instant AAdvantage Enrollment</u> - Become a member (
and get the most out of your travel.

<u>PIN Request and Replacement</u> - Get your PIN for full a
AA.com.

<u>Special Offers</u> - Check here often for current AAdvant
specials.

<u>Participants Index</u> - Who's offering AAdvantage benef
out here.

<u>Earning Miles</u> - Flying on American Airlines is just one
ways to earn miles.

<u>Using Miles</u> - Redeem your miles for flights and other p
benefits.

<u>AAdvantage Elite Status</u> - Recognition and benefits fo
most loyal customers.

<u>Awarding Miles - AAIM</u> - Boost your business or rewar
employees through AAIM.

<u>Claiming Awards</u> - Learn how to claim your AAdvantag
certificates.

<u>Newsletter Online</u> - Find recent editions of the AAdva
newsletter here.

⊕ RETURN TO TOP

AmericanAirlines
A word about your <u>Privacy</u>.
Send comments or suggestions to: <u>webmaster@aa.com</u>

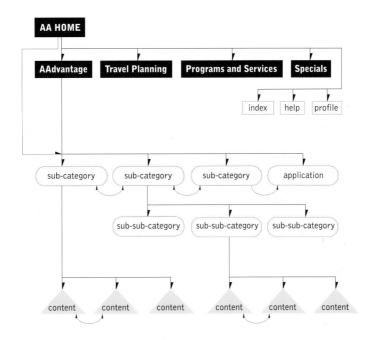

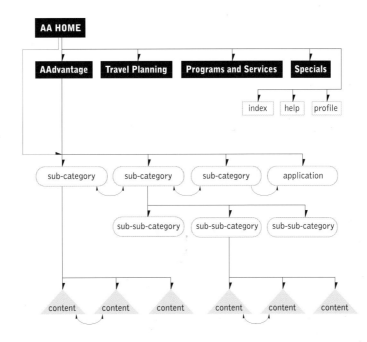

Red Sky (Nuforia)

[New York, New York]

>> Red Sky Interactive, formed by a merger of Nuforia, an Internet professional-services company—itself resulting from the 1999 merger of communications design firm Belk Mignogna Associates Ltd.—and technology company Net Explorer, Inc. Red Sky applies strategy, technology, and creativity to building business in a changing economy. The agency help clients see, meet, and exceed the needs and expectations of their customers, thereby enabling them to define, lead, and even dominate the markets they occupy.

Red Sky offers its integrated e-business and strategic branding services to corporate clients ranging from *Fortune* 500 companies to e-commerce pioneers. From offices in Atlanta, Boston, Chicago, Houston, Irvine, and New York, Red Sky's teams of experts design and implement programs that fulfill the diverse objectives of strategic management, information technology, and relationship marketing.

The following areas of expertise are integrated, as appropriate, to the interests of the corporate client and its customers: strategic consulting, branding, e-commerce, customer-relationship management, knowledge-management systems, custom application development, portal creation and management, solutions integration, object architecture, and new-media and print communications design.

01 02 03 04 05 06 07 08 09 10 11 12

site: www.nuforia.com

view by industry
view by case study
view alphabetically

nuforia | about | solutions | clients | news | careers | contact | sitemap

a global who's who

Altoids	Earthweb	Lithographix	Reebok
American Express	Electronic Data Systems (EDS)	Logix	Regeneron
Anheuser-Busch, Inc.	El Paso Energy Marketing	Lone Eagle Publishing	Saga Software
BMC Software, Inc.	EnergyPortal.com	Mead Corporation	Scripps
Boyd Communications	Enron Corporation	MetLife	Seagram Corporation
Browning-Ferris Industries	EXE Technologies	Mirage Resorts	Sematech
Cameron Corporation	Exxon Production Research	Morgan Stanley	Shell Gas Pipeline
CBS	FreeAgent.com	N2K	Sony
Chase Manhattan Bank	Geophysical Development	Nabisco	Sunkyong
Columbia University	Corporation	Neiman Marcus	TechniLogix
Cooper Cameron Corporation	Harcourt General	Nickelodeon	Texaco
Copelco	Intec Engineering, Inc.	nonstock	Timothy Childs Productions
Children's Scholarship Fund	Investcorp	NYCE	Travelogix
Dow Jones	Kraft Foods	NYNEX	Tricon
Dunbar Productions	Landmark Graphics	Oakley, Inc.	Ultramar Diamond Shamrock, Inc.
	Lehman Brothers	PaineWebber	Weatherford
			W.B. Mason

- **Altoids:** Creating a Curiously Strong Web Presence.
- **Chase:** Leveraging the Web to Recruit Rising Stars.
- **Cooper Cameron:** Creating a Model for B2B E-Commerce.
- **Dow Jones:** Restoring the Luster of a Blue-Chip Bellwether.
- **EXE Technologies:** Forging a New Global Identity.
- **Neiman Marcus:** Promoting a World-Class Brand.
- **nonstock:** Breaking Through to a Tough Audience.
- **Oakley:** Launching the "O Store" Online.
- **Travelogix:** Making Electronic Travel Take Off.

solutions | clients | news | careers | contact | sitemap

what can we do for you?

"We need to launch a new product." "We need to develop a Web strategy." "We need a more dominant presence on the Internet." "We need to do it yesterday." Companies come to us with all sorts of challenges. Here are a few case studies to illustrate our broad problem-solving capabilities and dynamic work style.

nuforia

about | solutions | clients | news | careers | contact | sitemap

Our mission is to help our clients increase their presence, potential and profitability through integrated e-business and strategic branding solutions.

solutions | clients | news | careers | contact | sitemap

an integrated state of mind

Nuforia is a leading provider of integrated e-business and strategic branding solutions. We have more than 200 professionals in six offices nationwide. We have a proven track record of repeat business with prominent global companies. Our teams of experienced business strategists, designers and technology experts combine to help companies build businesses without boundaries.

13 14 15 16 17 18 19 **20** 21 22 23 24

>>

Luxury Goods On-line
BestSelections

http://www.bestselections.com

>>

The BestSelections site was designed to provide a new, fresh retailing concept, showcasing select items from boutique stores around the world. The site presents a diverse range of luxury items and unique merchandise—from couture to caviar, candles to candelabra, antiques to toys—selected from the world's finest retailers, artisans, and gallery owners. It is positioned as the premier destination for the discriminating shopper and distinguishes itself from other e-commerce and luxury sites by providing customers with exceptional selection, high-quality merchandise, and unparalleled customer service.

Red Sky was retained to solve several key business issues for BestSelections. First, they were asked to redesign the existing Web site. BestSelections wanted a site that would provide a unique user experience for its customers and merchants. The new site had to become more upscale, showcasing their "best selections" from merchants across the globe. In addition, they wanted their customers to have a user experience that supported customer expectations

as indicated by repeat shopping, customer referrals, increased sales, and increased number of represented merchants. To support their site's redesign, BestSelections also asked Red Sky to redesign their brand. The new logo is a kaleidoscope of color that represents the company's concept, that is, the metaphorical "intersection" where the discriminating shopper can find the best of the best chosen from many different worlds. To support the design of a new site, BestSelections then asked Red Sky to build a custom, e-commerce application that would support their business goals and objectives of increased traffic and increased sales.

While the client was receiving regular press attention, it was clear their site required a total rebuild in order to support a brand-enhancing, customer-centric user experience. In addition, the technical sophistication and capability of their Web site was in question. As pre holiday advertising and marketing efforts were expected to increase traffic and drive up sales, they were uncertain that the current site would be able to support a proportionate increase in transactions.

Client BestSelections.com **Team** Hans Neubert, senior vice president, national creative director; Alberta M. Jarane, client partner; Philip Rackin, producer; Jost Lunstroth, project director; Chris Jarzombek, producer; Carol Boyd, project manager; Group Teams Design (New York), Object Modeling (Houston), Engineering and Programming (Houston), Customer Support (Houston), Senior Management (all locations) **Since** November, 1999 **Target** The discriminating shopper

Tools Adobe Illustrator, Adobe Photoshop, Adobe Imageready, Macromedia Flash, HTML, JavaScript, Client Side Java, Weblogix Virtual Source Safe, and others.

site: www.bestselections.com

Furthermore, the business model of BestSelections required a robust customer-relationship management strategy. The current site lacked this and many other features and functionality.

BestSelections was growing. Their business model suggested that the time was right for an on-line retail experience that focused on upscale, hard-to-find luxury goods. BestSelections recognized this niche and made business commitments to capitalize on this opportunity.

Red Sky's strategy was centered around three very interrelated approaches. From a branding perspective, Red Sky strategized that the client retain its business name. Their analysis revealed that there was sufficient brand equity in the name to recommend keeping it and that a redesign would help reposition the company and enable greater brand recognition.

From a creative perspective, Red Sky analyzed and recommended a user experience that would focus on several key attributes. They recommended that the areas of Categories, Cities, and Shops be the primary ways in which customers could enter the

site. In addition, customers would have the opportunity to customize their experience at www.bestselections.com by providing certain information on a voluntary basis.

From a technical perspective, many weeks were spent analyzing the business rules of BestSelections.com, Inc. Several joint application-development sessions were performed with the client, which served as the basis for constructing an object model by Red Sky's team of expert object modelers. The OM team designed an object model that allowed them to author a system specification document that incorporated all the business rules of BestSelections as well as the user experience model constructed by Red Sky's creative team.

BestSelections and Red Sky have created a brand-enhancing, customer-focused site that is recognizable from two essential perspectives: the look-and-feel of the site is unlike any other, and the robust e-commerce engine is scalable, robust, and constructed to accommodate the growth of BestSelections' business.

Second Story

>> Since 1994, Second Story has created interactive experiences delivered on the Web and through disk-based media. Principals Brad Johnson and Julie Beeler work with teams of artists, writers, illustrators, and programmers to produce an inventive blend of technology and storytelling on topics ranging from adventure travel, architecture, and natural history to corporate merchandising and promotions. Clients include DreamWorks Records, Kyocera, NASA, *National Geographic*, Nike, Universal/MCA, Kodak, and PBS.

Second Story's projects have been recognized by major interactive design competitions, and published in dozens of books and magazines. The company's work has also been inducted into the Smithsonian National Museum of American History's permanent research collection on information technology.

"We don't have a rigid design philosophy we apply to every site," Julie Beeler says. "Our approach is to create a unique, custom experience for every project that is derived from the content and not only through the visual design but through the experience of navigating through the site as well. We're reinventing the wheel every time."

"When I first got into this industry, there was no graphical Web as we know it today, only CD-ROMs, and there were two different directions I could go," Brad Johnson adds. "I could make entertainment-based games or design for businesses." Producing editorially-based work for the Web, however, has allowed Second Story to do both. "What's exciting now is that there's a real niche for us to make sites that fulfill corporate needs by developing entertainment-based content," Johnson concludes, "and doing it in a media-rich way that gets us back to our roots in multimedia.

01 02 03 04 05 06 07 08 09 10 11 12

site: www.secondstory.com

A Snake is the Key

National Geographic, King Cobra

http://www.nationalgeographic.com/king cobra/index-n.html

This companion site to the 1997 Explorer television season premiere of "King Cobra" was created to provide an educational and entertaining accessory to the television show. With the purpose of educating visitors about the facts behind king cobra folklore, the Web site's full-size depiction of the snake reveals the story behind the serpent throughout the course of a narrative inspired by medieval Indian court painting.

The snake itself serves as both a navigation and content device, allowing users to access the content either randomly or according to the narrative. Using the "snake key," visitors instantly access the serpent's eleven segments and learn more about the particular nature of the snake within each distinct section. JavaScript rollovers activate the different sections of the snake and highlight the content titles. After visiting different areas of the snake, the key automatically updates itself with a line drawing that fills in to display fully rendered art indicating where the user has been.

Users' capabilities posed the biggest hurdle in creating the site. It was very important that users on low-end machines didn't receive a "dumbed-down" version of the site and that the nuts and bolts were still available to them. The designers had to forget about incorporating nifty navigational elements in order to develop a viable user interface. After many hours of writing and testing code, the team came up with a variety of options.

Their final decision was to have each segment in a frame, so users could click on arrows to load other segments of the snake. This meant they had to split users off at the root level based on the browser. Doing so involved some minor browser "sniffer" code, while avoiding the necessity to build two completely different sites. Although some pages needed to be duplicated, for the most part, both versions of the site could share the same Web site files. This fall-back format wasn't nearly as engaging as the fully functioning JavaScript version, but it was enough to satisfy the client.

Client National Geographic **Team** Julie Beeler, designer and programmer; Brad Johnson, designer; John Beezer, programmer; Paul Krater, illustrator; Laura Carter, producer for *National Geographic* **Since** August 1997 **Target** *National Geographic* readers **Awards** High Five Award, Yahoo Daily Pick, Project Cool "Cool Sighting," *USA Today* Hot Site

Tools Adobe Photoshop, Adobe AfterEffects, JavaScript, Adobe Premiere, GIFBuilder, Adobe Illustrator, BBEdit, HTML, RealAudio

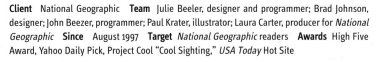

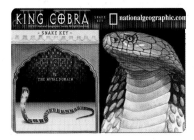

An introductory GIF animation of the king cobra's tongue sets the stage for the site. The playful homepage states, "Beware, Enter if you Dare. This Web site contains a life-size King Cobra." Upon entering, users are presented with a depiction of the snake that serves as both a navigation and content device, allowing them to access the content either randomly or according to the narrative. Using the "snake key," visitors can instantly access the serpent's eleven segments and learn more about the particular nature of the snake within each distinct section. JavaScript rollovers

activate the different sections of the snake and highlight the content titles. After visiting different areas of the snake, the key automatically updates itself with colorized artwork indicating where the user has been.

The metaphor for the snake key was derived from traditional "You Are Here" maps. Using this idea as a springboard, the designers were able to transform the life-size king cobra into a miniature version allowing instant access for users and a small download, since the segments were broken up into eleven specific sections.

13 14 15 16 17 18 19 20 **21** 22 23 24

>>

The site has to provide users with multiple ways to reveal and explore the snake. Delivering a life-size serpent to users without making them download a huge graphic was the greatest technical challenge for the designers. Dividing the snake into segments and providing a line-art outline allows the user to download the fully rendered art and content sections on demand. Getting a perfect representation of the king cobra was another challenge. Photographs wouldn't suffice, because no image was available that would perfectly fill the small-screen real estate (640 x 480). An illustration, however, could be controlled to fit the environment, yet had to appear realistic. The illustrator worked very closely with herpetologists to make sure every detail was accounted for, right down to the individual scales.

site: // http://www.nationalgeographic.com/king cobra/index-n.html

I. THE KING'S ARMORY

It has a head as big as a man's hand and can stand tall enough to look you straight in the eye.

Its venom can stun your nervous system and stop your breathing.

ENTER

II. SOVEREIGN SENSES

The king can't see the royal purple—or any other color. Still, its eyesight is better than most snakes'. It's good enough to see a moving person almost half a mile (100 meters) away.

The snake focuses by moving the lens in and out, and can sleep with eyes open, seemingly alert.

Image from "King Cobra," National Geographic EXPLORER

III. THE IMPERIAL POSE

The king's hiss is much lower than most snakes', more like a dog's growl. It's produced by tiny holes in the trachea and is resonated by the lung.

Hear a king cobra hiss, you'll need RealAudio

Image from "King Cobra," National Geographic EXPLORER

IV. A NOBLE MEAL?

With no limbs or cutting teeth, the king is unable to tear its food. However undignified, the king gulps down every meal whole.

Its digestive tract is like a long straight tube. Blunt teeth puncture the food and the venom's enzymes start the digestive process. From the long stomach, food travels through the small intestine, the large intestine, and then out the cloaca.

—V. Myths and Legends

Image from "King Cobra," National Geographic EXPLORER

V. MYTHS AND LEGENDS

Snake charmers do not really hypnotize cobras with their flute music. It's often a sad con game in which an exhausted cobra is put on the defensive, yet conditioned (with pain) not to strike the flutist.

Snake charmers don't necessarily catch their own cobras—they may buy them and have them defanged. Some charmers may know little about snakes, while others know as much about them as experts do.

Photograph by Alexandra L. Middendorf © NGT, Inc.

VI. THE ROYAL DOMAIN

The king's natural realm stretches from India eastward to Vietnam, southern China, and the Philippines, and southeast through Malaysia and Indonesia. Yet throughout its vast range the king cobra is not common anywhere, and in India it has become rare from habitat loss.

Once users decide to view a section of the snake they are presented with content-rich information about one aspect of the king cobra. A subnavigation allows them to explore the informative content or load other snake segments. Balancing a narrative path with random accessibility is a navigational principle Second Story builds into every site. That means having a compelling sequential path users can experience, while at the same time having the ability to jump around anywhere they want. This strategy presented an interesting challenge in the case of "King Cobra": If visitors could jump anywhere in the site, the designers had to keep track of where they had been so the programming would only download graphics users selected.

By allowing visitors to select their own navigation path the site can appear to be shallow to some, yet deep to others, while still being fulfilling. It is critical not to overwhelm the user with choices, but at the same time a "thin" site must be apparent to the user from the start. By delicately balancing a narrative, linear path with random accessibility the designers were able to satisfy a wide variety of users. Since users' capabilities determine the site's shallowness or depth, they need to be immersed in the material so that when they leave the site, they realize the depth and scope of all the content.

site: // http://www.nationalgeographic.com/king cobra/index-n.html

The technical requirements to realize this site are outdated now, although they were a huge consideration at the time of its launch. Most of what the designers were trying to achieve at the time had to do with downloading segments on demand without having to reload pages and graphics. Using very complicated JavaScript they achieved their goals. The idea they explored with this site has become a reality over time with the notion of layers and streaming technology. With the use of Flash, QuickTime, RealMedia, DHTML, etc., users only have to download the specific segment they want and they are delivered a very smart back-end browser experience hooked up to databases. At the time this site was created, none of these technologies were available, yet the site can still be considered up-to-date and technically savvy.

Before the advent of compact discs, designers for record publishers enjoyed the luxury of vinyl formats in which a lot of visual real estate could be used to promote an album. When CDs displaced vinyl, some retailers offset the smaller packages with "listening booths" where consumers could browse albums by listening to the tracks. The DreamWorks Web site strives to revitalize the browsing experience by developing a new interactive paradigm that rewards customers' curiosity about the music.

Design and technology together create a compelling end-user experience. Without one or the other, the site would be flat, boring, and vacuous. This site goes beyond the norm and breaks through into the next generation of immersive motion, sound and interaction. A "thin" metastructure was important for the label branding and global navigation but it couldn't be prominent or overdesigned because it would then compete with the artists' contributions that appear on the Web site's "stage." The stage takes over the site and transforms it so as to be particularized to the specific artist.

Listening Booth
DreamWorks Records

http://www.dreamworksrecords.com

>>

Client DreamWorks Records **Team** Brad Johnson, creative director, designer; Julie Beeler, producer and designer; Sam Ward, designer; Kim Markegard, programmer; Ken Mitsumoto, programmer **Since** July 1998 **Target** Music consumers

Tools Macromedia Flash, Adobe Photoshop, Adobe Illustrator, BBEdit, HTML, MediaCleaner, SoundEdit, RealMedia **Awards** 1999 *Communications Arts* Interactive Design Annual; IPPA Design Excellence Award; Netscape's What's Cool; *Communication Arts* Site of the Week; Macromedia Flash 3.0 Gallery; Shocked Site of the Day; Netscape's Studio On

In developing the navigation for this site, the designers applied the same rationale and ideology behind many of their projects: The site must have random access and a linear path. The path is clearly defined in the "album bin," where titles are put on display for sampling. Simple, clean pull-down menus allow instant access to the entire DreamWorks catalog. The basic structure is simple: three frame-sets, with the center frame serving as the stage. Both top and bottom frames relate to the stage itself, and users can easily participate in a unique experience depending on the artist selection. A number of different visual artists are involved in the ongoing realization of this site—a critical consideration in keeping the content fresh and diversified.

Second Story's goal was to create a site as diverse as the Dreamworks Records' label itself. It was critical that the site be diverse enough to cover all genres of music, ranging from urban to pop, rock, to country. There was no better way to do this than to let each artist and related album define the look and feel of the site. Users browse the album covers displayed in a features frame to see what's new, or search the complete discography of the label. When they have made a selection, visitors immediately experience full-screen visuals, copy, animation and sound related to the album. (Code has already detected each user's browser type, plug-in possession and monitor resolution, and created a new window with an interface that fills the screen.) These "interactive covers" were created in Flash animation by many different artists inspired by the music, each of them as unique as the album they promote. Many of the tracks on each album are available in three different audio formats, and every music video is streamed on-demand. Going deeper, users can link directly to an on-line retailer of their choice, and get in-depth biographical information, tour dates, and links to artists' sites.

>> In developing the navigation for this site, the designers applied the same rationale and ideology behind many of their projects: The site must have random access and a linear path.

>>

The Venice Dream Team Web site tells the story of a group of young photographers in Venice, California, and their mentor, named Bagwa. The team is continually in motion, traveling to various cities and countries, photographing events and celebrities, and then selling their work to fund travel expenses for their next destination.

Venice Dream Team

http://www.kodak.com/US/en/corp/features/veniceDreamTeam/frame.

Client Internet Marketing Group of Eastman Kodak Company **Team** Brad Johnson, creative director, designer; Julie Beeler, designer and programmer; Sam Ward, designer; Tom Allen, writer; Suzanne Mattson, assistant. Kodak: Cindy McCombe, editor; S. Blaine Martin, design director; Jennifer Cisney, visual interaction designer; human factors: Jack J. Yu **Since** August 1999 **Target** Kodak clients to promote brand awareness via a human-interest story about picture taking

Tools Macromedia Flash, Adobe Photoshop, Adobe Illustrator, BBEdit, HTML **Awards** *Communication Arts* Site of the Week, Shocked Site of the Day, *USA Today* Hot Site

The site showcases the team's photos and captures the spirit of their creative cycle by using a unique circular architecture that reflects the structure of the team experience. The hub or center of the site profiles the man who keeps the team in motion. From there, users jump into the cycle and follow the team through its creative rhythm, learning about photography, taking pictures, going on assignment, printing pictures, and selling them. Viewers can randomly navigate through the cycle using a circular Flash tool or click through the HTML zone.

>> Any site that needs a site map to define the navigation route has not succeeded in presenting an intuitive navigation foundation.

site: www.kodak.com/US/en/corp/features/veniceDreamTeam/frame

>>

If navigation is overwhelming and confusing it is very easy for users to become frustrated and not get an intuitive "lock" on the site's structure.

To showcase the Venice Dream Team's photographs and capture their creative energy, Flash was used to enable a full-screen, scalable interface. The interface presents a grid that displays an interactive photo gallery, which places the photos in thematic context without depending on the accompanying narrative. The gallery displays the photographers' range of work, and mousing over thumbnails calls up new galleries and quotes from the photographers, their parents, and mentor. Additionally, Flash allowed Second Story to time the presentation of their work through animated transitions and interactivity. Building a hybrid site enabled the designers to bridge the gap between Flash and HTML, using both languages to create the Web site. Flash has its strengths for certain types of content, but not all, nor is it the appropriate medium for text-based information. Using DHTML on the back-end allowed the designers to create seamless environments.

Creating a sound site structure is as important as determining how best to tell the story. If navigation is overwhelming and confusing it is very easy for users to become frustrated and not get an intuitive "lock" on the site's structure. A simple circular device told the complete story of the Venice Dream Team and made for intuitive navigation. Color coding allowed the sections to be easily distinguishable, and text rollovers provided feedback about what to expect in each section.

Users following the story links could easily continue throughout the site without ever having to interact with the circular device. Dual navigation applies to a diverse audience and lets them select their path and determine what content they wish to view. However, too many navigation paths or too many buttons linking to the same content can become very confusing and frustrating. Any site that needs a site map to define the navigation route has not succeeded in presenting an intuitive navigation foundation.

site: www.kodak.com/US/en/corp/features/veniceDreamTeam/frame

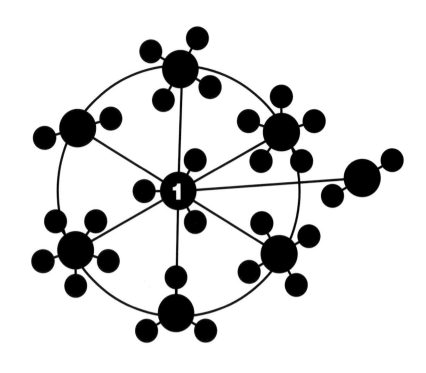

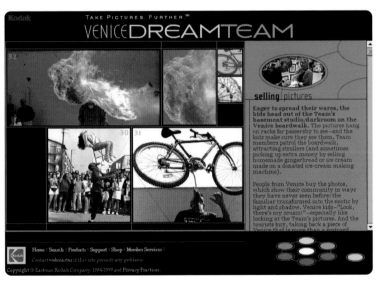

TAKE PICTURES. FURTHER.™

VENICE DREAMTEAM

selling pictures

Eager to spread their wares, the kids head out of the Team's basement studio/darkroom on the Venice boardwalk. The pictures hang on racks for passersby to see—and the kids make sure they see them. Team members patrol the boardwalk, attracting strollers (and sometimes picking up extra money by selling homemade gingerbread or ice cream made on a donated ice-cream making machine).

People from Venice buy the photos, which show their community in ways they have never seen before: the familiar transformed into the exotic by light and shadow. Venice kids—"Look, there's my cousin!"—especially like looking at the Team's pictures. And the tourists buy, taking back a piece of Venice that is more than a postcard.

Home | Search | Products | Support | Shop | Member Services |

Contact webmaster if this site presents any problems.

Copyright © Eastman Kodak Company, 1994–1999 and Privacy Practices.

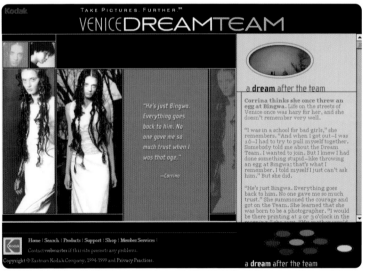

a dream after the team

Corrina thinks she once threw an egg at Bingwa. Life on the streets of Venice once was hazy for her, and she doesn't remember very well.

"I was in a school for bad girls," she remembers. "And when I got out—I was 16—I had to try to pull myself together. Somebody told me about the Dream Team. I wanted to join. But I knew I had done something stupid—like throwing an egg at Bingwa; that's what I remember. I told myself I just can't ask him." But she did.

"He's just Bingwa. Everything goes back to him. No one gave me so much trust." She summoned the courage and got on the Team. She learned that she was born to be a photographer. "I would be there printing at 2 or 3 o'clock in the

> "He's just Bingwa. Everything goes back to him. No one gave me so much trust when I was that age."
>
> —Corrina

Home | Search | Products | Support | Shop | Member Services |

Contact webmaster if this site presents any problems.

Copyright © Eastman Kodak Company, 1994–1999 and Privacy Practices.

a **dream** after the team

Tanagram
[New York, New York]

>> Tanagram opened its doors in 1992 with the singular goal of providing design excellence for a select group of clients. It quickly adopted a media-agnostic approach to communication design services, and by 1995, Tanagram was building interactive sales and marketing tools for clients such as Niketown, Spiegel, Motorola, and U.S. Robotics. Today, Tanagram is frequently selected by start-up companies in the technology sector as a resource for the design and implementation of their powerful brands. It is Tanagram's belief that creativity and humanity must be applied to any process methodology, information should lead to the envisioning of new ideas, creative insights differentiate companies, new technology should be embraced as opportunity, and fear should never compromise a great idea.

Tanagram's Eric Wagner says, "Due to our design methodology, our answer to most philosophical questions is often the unsexy, 'It depends.' For all design problems, including the design of a Web site's navigation, there is never one constant way to approach it. It is our duty to understand our client's business goals and then apply it into a form that is appropriate, effective, and true."

01 02 03 04 05 06 07 08 09 10 11 12

site: www.tanagram.com

Rite of Passage
Greaves India

http://www.greavesindia.com

Greaves India is an interactive presentation of India Tours offered by Greaves Travel, along with tips on traveling in India and background information on the company. The purpose of the site is to communicate Greaves' superior tour services and provide visitors with the resources to make well-informed tour purchases. Greaves wanted a Web site that would deliver a more dynamic experience than the static brochureware in use by the competition. With this in mind, the designers looked for ways to make the site come alive without adding animation for the sake of animation.

While many Web sites are designed from the top down, this site was really designed more like a book, from the inside out. After the Tours Showcase was fully conceptualized, the rest of the site was designed around it. Tanagram's goal was to make a site that was inviting—not intimidating or confusing. This goal was addressed in all aspects, especially the navigation. The structure of the navigation on all pages was meant to be as simple as possible to give the user a direct path to any page while conveying a feeling of restraint and elegance. Since the majority of the site's content was encapsulated in the Tours Showcase Flash presentation, the designers were able to keep the site small and the subsequent navigational choices to a minimum. Rollover states for navigation elements—once a novelty item in Web design—are now considered a requirement to cue the user that a graphic item promises to link to a new place or action. For the Greaves navigation, rolling over the buttons causes a subtle yet visible color change.

Client Greaves Travel **Team** Eric Wagner, creative director; Seth Hill, programming; Marina Jovanovic, production and research **Since** December 1999 **Target** Well-heeled travelers

Tools Adobe Photoshop, Macromedia Flash, Macromedia Freehand, BBEdit

A collection of tour packages forms the core of the site. Tanagram decided the best way to present each tour was through a time-based, interactive format. This Macromedia Flash presentation became the Tours Showcase. Inside the Tours Showcase, the user views a short introductory animation and is then given a main menu that includes a list of the tours and a map of India. Rolling over a tour name will illuminate the corresponding region of the map, giving the tour a strong sense of geographical context.

The navigation in the Tours Showcase, which allows the user to toggle from day to day, is presented sequentially in conjunction with the drawing of the tour's path on the map. Since the site is describing events that occur over a period of time, the format immediately puts the days in context with the locations, giving users a better sense of the journey they will be taking.

After the user makes a selection, the chosen tour opens with a map detailing the tour area. Then a tour path draws itself, day by day, city by city. As each of the points of the path appear, a numbered Day button appears at the bottom of the presentation window. When the path is completely drawn, the user is able to randomly access the details of any day by clicking any button. The details include a text description and a photograph. At the top of the window is a button linking back to the main menu, as well as a button linking to the next menu. This gives the user the ability to go anywhere at any time.

site: www.greavesindia.com

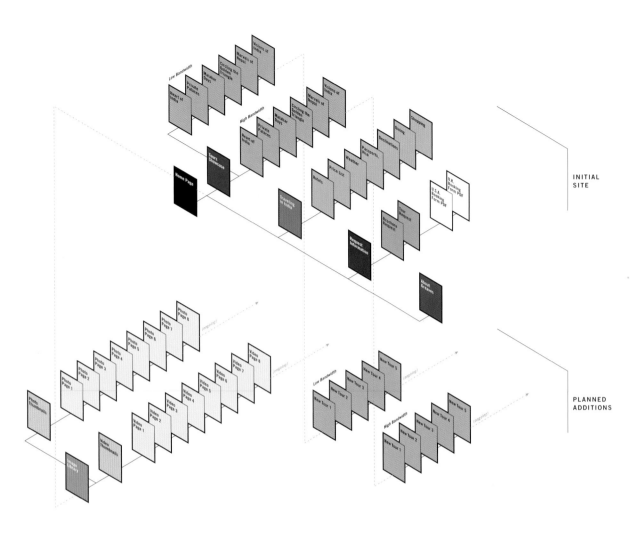

INITIAL
SITE

PLANNED
ADDITIONS

>> Rollover states for navigation elements—once a novelty item in
Web design—are now considered a requirement to cue the user
that a graphic item promises to link to a new place or action.

site: www.greavesindia.com

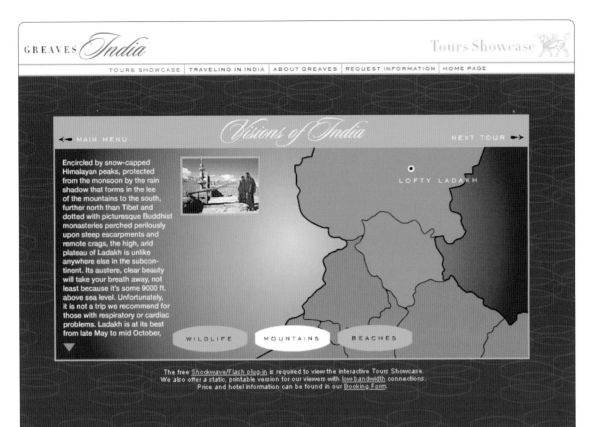

>> After the user makes a selection, the chosen tour opens with a map detailing the tour area. Then a tour path draws itself, day by day, city by city.

Trollbäck & Company

[New York, New York]

>> Trollbäck & Company provides graphic design, special effects, and directorial services for feature films, commercials, broadcast design, Web sites, and music promos. Founded in April of 1999, the company is rapidly establishing itself as a major force in the design community. The quickly growing multinational group consists of designers, art directors, editors, and directors working in a collaborative environment, combining a wide variety of skills. With a unique understanding of motion and space, the group has recently started to apply their skills to a select group of Internet projects.

Founder Jakob Trollbäck affectionately defends computers as "misunderstood." He says too many people think of them as machines for doing things quicker, rather than as artistic tools for doing things differently. "The computer is the birthplace of a new aesthetic," he says. "The biggest challenge in the design world has nothing to do with creativity or artistry but with politics ..."

The company's Web site started while the design team were discussing a film and broadcast countdown during an elevator ride. As always with a firm connection to the world of architecture, they envisioned their company as a creative environment, a building of the mind. Based in the dense city of New York, the designers pictured levels (or floors) of creativity that are interconnected and communicate vertically. The elevator seemed to be a good concept for this vertical navigation between different disciplines. When you are visiting the site you first see a countdown as the navigation is loaded. Once you're there, your cursor controls the car of the elevator and the different sections slides by as you travel up or down. When you see a floor that you want to visit you just have to click for the ride to stop.

Trollbäck & Comp
212/529_1010
212/627_9292
info@trollback.cor

| 01 | 02 | 03 | 04 | 05 | 06 | 07 | 08 | 09 | 10 | 11 | 12 |

site: www. trollback.com

Swiss Neutrality

The City of Geneva

http://www.geneva-portal.ch

The site is a city guide to Geneva that provides the user with information about restaurants, hotels, transportation, entertainment, shopping, and more. The site is meant to be a service to both tourists and locals alike in providing user-friendly access to all of the city's resources.

The purpose of the Geneva Portal is to serve as a quick guide for visiting travelers. To make it as easily accessible and compelling as possible, the navigation is completely dedicated to the map-travel concept. The user is at the center and can follow lines or routes that will unveil additional information at their destinations.

In general, the structure of navigation needs to be tailored to a specific project in regard to the structure of the actual information. The navigation needs to relate to this structure but also to the subject matter of the information. Sometimes, as with the Geneva site, it is fairly literal. Many times, an unexpected navigation actually can help to give a unique understanding and approach to the subject matter. Therefore, it is not usually as simple as preferring a shallow or a deep structure. Designers should not be afraid of multiple clicks. They can be very helpful and logical for accessing complex information since each multiple-choice click drastically reduces the number of options. On the other hand, if a designer utilizes a smart animated interface, he will have a unique opportunity to link groups of information and make it very intuitive.

>> The designers pictured levels of creativity that are interconnected and communicate vertically.

Client The city of Geneva and IBM Lotus **Team** Jakob Trollbäck, creative director; Antoine Tinguely, Nathalie de la Gorce, art directors/designers; Meghan O'Brien, producer **Since** Spring 1999 **Target** Tourists and citizens of Geneva

Tools Adobe Photoshop, Adobe Illustrator, Flash

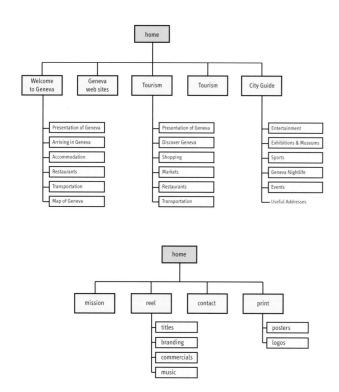

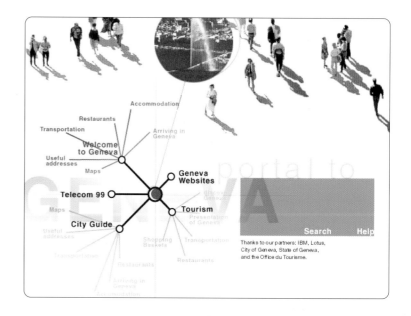

Welcome to Geneva
Geneva web sites
News
Tourism
City Guide

Discover Geneva

History of Geneva
Things to do
Geneva's parks

The history of Geneva
2000 years of history / the Protestant "Rome"

An antique city, Geneva has never stopped, during its long history, to fight for its independance, its freedom and ideas.

In turn Gallic city, Roman city, Burgundy capital city, episcopal principality and important fairs city, Geneva becomes a Republic and adopts the Reformation in 1536. It will become the birthplace of democracy and a place of refuge for the persecuted in the whole of Europe.

Three names personify Geneva: Jean Calvin (1509-1564), the Reformer who changes the city into the "Protestant Rome". Jean-Jacques Rousseau (1712-1778), the "Geneva citizen", helps people become self-aware and prepares the French Revoultion. Henri Dunant (1828-1910) brings the States to sign the Geneva Convention in 1863, limiting the effects of war, and will become the actual International Red-Cross.

Some reference marks:

The strategic situation of Geneva, busy area on the Rhône, has won it the equivocal honnor of being often coveted throughout the centuries:

Julius Caeser went through Geneva in 58 before J-C. During the roman period, Geneva expanded. The Bourg-de-Four square, the oldest of the town, was then a forum.

During the early Middle Ages, the kings of Burgundy made Geneva their capital city.

In the Middle Ages, Geneva became an important commercial center.

The Reformer Jean Calvin established himself in Geneva in 1536.

>> To make it as easily accessible and compelling as possible, the navigation is completely dedicated to the map/travel concept.

Terry Green and Nori-zso Tolson are the design partners of twenty2product (22p), a motion graphics and interactive production company whose internationally recognized client work appears as title design, broadcast identity, motion graphics for commercials, and prototyping for Web sites. 22p serves a technology-, sports- and entertainment-based clientele that includes Nike, NEC, Adobe Systems, IBM, Levi Strauss & Company, MTV, America On-line, Yahoo!, Apple Computer, Sony, and Hewlett-Packard.

Terry Green received a B.A. in graphic design/corporate identity from Rutgers in 1985, and an M.F.A. in computer graphics from the Academy of Art in 1987. 22p is his first (and hopefully last) real job. Nori-zso Tolson learned her craft from her television director parents who worked in Chicago and New York City. 22p began doing interface design in the early nineties in response to their clients' requests to visualize animated "computer of the future" interfaces in commercial and industrial productions, gaining useful experience working in a medium that didn't yet exist.

Terry Green describes the studio's process: "We go into any Web-design project assuming that the client wants to simply and clearly communicate what they're about. So first we have to determine what they believe are the most important parts of their message: who's buying their stuff, and how they use it. As we're sketching things out, we try to remain conscious of how a page will be used. A site should let you get the content you're after with the minimum effort, and even anticipate the content you'll most want to see."

13 14 15 16 17 18 19 20 21 22 23 **24**

>>

Shock Absorber
RockShox2000

http://www.rockshox.com

The RockShox2000 site contains information about RockShox bicycle suspension products, sales contacts, technical support data, editorial content about bicycling, and listings of upcoming bicycle-racing events. The site's purpose is to inform a motivated and technically oriented audience about the company's products and related events and activities.

Client RockShox, Inc. (Chris Adams, Judy Oyama, executive producers) **Team** Terry Green, Nori-zso Tolson, site design, motion graphics, and live-action editorial (Son Heavy Industries, site programming and graphics/Flash production) **Target** Mountain-bike enthusiasts **Traffic** Two million hits over the first seven days

Tools Adobe Photoshop, Adobe AfterEffects

>> Successful navigation is about making content immediately accessible and that can happen outside the site, as a banner, or even in an entirely different media.

site: www.rockshox.com

Successful navigation is about making content immediately accessible, and that can happen outside the site, as a banner or even in an entirely different media. If you familiarize your intended audience with your content and the visual language you use to present it, they'll have a degree of familiarity with a site's content that will make navigation very simple for them. RockShox 2000 is a good example of this approach.

There are three navigational schemes for the site immediately apparent on the home page. The nav bar on the top is color keyed, and when you click on a section heading, it spills down into second-level navigation with the section overview already deployed. This is important because RockShox customers are technically oriented and want advice on how to customize their shocks to the kind of riding they do, either directly through FAQs and tech notes or by example in interviews with pro riders.

On the bottom of each page is a color-keyed site map. Each tick represents a page and lets users know where they are, and any tic mark will take users to that page and rollover the page title in the gray bar above. Though probably not immediately apparent, it's useful for frequent visitors.

The center of the home page contains four changing content areas that take you directly to an illustrated feature within the section overview pages.

Navigation Resources

Books and articles

Patrick Burgoyne, Liz Faber, Lewis Blackwell (Editor). *The Internet Design Project: The Best of Graphic Art on the Web*. St. Martin's Press, 1998.

Jeff Carlson, Glenn Fleishman, Toby Malina. *Web site Graphics: Navigation*. Rockport, 1999.

Ken Coupland (Editor). *Web Design Now*. Graphis Press, 1998.

Ken Coupland, "Caught in the Web: Fishing for Information." *Critique*, Spring 2000.

Ken Coupland, B. Martin Pedersen (Editors). *Interactive Design 1*. Graphis Press, 1999.

Daniel Donnelly, David Carson (Introduction), Florian Brody, Sarah Hahn. *Cutting Edge Web Design: The Next Generation*. Rockport Publishers, 1998.

Noel Douglas (Editor), Geert J. Strengholt, Willem Velthoven. *Website Graphics Now*. Thames & Hudson, 1999.

Vincent Flanders, Michael Willis. *Web Pages That Suck: Learn Good Design by Looking at Bad Design*. Sybex, 1998.

Jennifer Fleming, Richard Koman (Editors). *Web Navigation: Designing the User Experience*. O'Reilly & Associates, 1998.

Patrick J. Lynch and Sara Horton. *Web Style Guide: Basic Design Principles for Creating Web sites*. Yale University Press, 1999.

Jakob Nielsen. *Designing Web Usability: The Practice of Simplicity*. New Riders Publishing, 1999.

Louis Rosenfeld, Peter Morville. *Information Architecture for the World Wide Web*. O'Reilly & Associates, 1998.

On the Web

Yale University Style Guide: Navigation
http://info.med.yale.edu/caim/manual/interface/navigation.html

Tomalak's Realm: Best site for links to web design topics
http://tr.pair.com

Jakob Nielsen, "Is Navigation Useful?"
http://www.useit.com/alertbox/20000109.html

Jakob Nielsen, "Ten Good Deeds in Web Design"
http://www.useit.com/alertbox/991003.html

Also:
http://www.telescapes.com.au/about/webrules.htm

User experience

Mark Hurst, "White Paper on Customer Experience Strategy"
http://www.goodexperience.com/

Jean Kaiser. "Website Navigation Techniques"
http://webdesign.about.com

Other usability articles
http://home.cnet.com/webbuilding/0-7278.html
http://www.builder.com/Graphics/Evaluation/

Web Review ("cross training for Web teams")
http://webreview.com/pub/Navigation

Search

Best all-around metasearcher: http://www.go2net.com

Best site about search engines (includes advanced searching tips):
http://www.searchenginewatch.com

Web Glossary

A

ADSL (asymmetric digital subscriber line) The next-generation Internet-access technology for speeding data over standard copper phone lines. Currently contends with cable modems and wireless delivery for broadband market dominance. Also see DSL.

B

Bandwidth The amount of information transferred by a Web page, determined partly by modem speed and partly by the server's capability.

Bricks and mortar A company's physical plant, usually a retail outlet.

Broadband High-speed Internet access including DSL, using phone lines and cable, using TV.

Browser A program that allows users to access graphics and information on the Web.

Buffer A holding area of the computer's memory where information can be stored by one program or device.

C

Cache A small, but efficient, area of memory where parts of the information in main memory or disc can be copied faster.

CSS (cascading style sheets) Allow content providers and users to attach multiple styles including fonts, colors, etc. to HTML documents

CGI (common gateway interface) A way of making Web pages support interactive interfaces such as forms.

Client/server A program or computer that requests services from a network or server. The client provides the user interface and performs some or most of the application processing.

Compression Manipulation of digital data to omit unnecessary or redundant information in order to store more data with less memory.

Convergence The seamless, trouble-free integration of the computer with television and other media.

D

Database A collection of information organized so that its contents can be easily accessed, managed, and updated. On a Web site, information from a database can be retrieved and presented in a browser by means of templates.

DSL (digital subscriber line) Low-cost dedicated access for small users. See ADSL.

F

Filters Controversial software that screens out Web sites containing questionable material. Also refers to programs that ingest data, transform it, and then spit it out again. Many e-mail programs utilize filters to allow you to sort your mail by date, name, or subject.

Frames Horizontal or vertical division of Web pages, supported by newer browsers, that operate independently to improve or simplify site navigation.

FTP (file transfer protocol) The high-level Internet standard protocol for transferring files from one computer to another.

G

GIF (graphics interchange format) A universal format developed for reading images on the Web.

GUI (graphic user interface) All the visual elements of an interactive Web display.

H

Hits The number of visits to a Web page.

Home page The opening document displayed when viewers access a site. See splash page.

HTML (hypertext markup language) The coding language used to make linking documents on the Web.

I

IP (internet protocol) The standard protocol that defines a unit of information passed across the Internet and provides the basis for connectionless, best-effort delivery service.

ISP (Internet service provider) A company that enables users to access the Internet via local dial-up numbers.

J

JavaScript A popular interpreted programming and scripting language.

JPEG (joint photographic experts group) An image-compression format that substantially reduces the size of the image files with slightly reduced image quality.

L

LAN (local area network) Any physical network technology operating at high speed over a short distance.

Launch Public posting of a Web site.

M

MIME (multipurpose Internet mail extension) High-level protocol that complements older mail infrastructures. MIME defines how to send messages containing formatted text, international character sets, attachments, and multimedia content.

N

Newsgroups Special-interest electronic bulletin boards accessed on a subscription basis as part of a news database, such as USENET.

O

Open source Linux and other codes that provide robust, complex software applications developed by a volunteer force and freely distributed to all.

P

PDF (portable document format)
Enables documents with complex text and graphics to be viewed and printed on various computer platforms and systems with all information imbedded in the file.

Plug-ins Programs that can be easily installed and used as part of Web browsers to enable additional functions.

Portal Any stopping-off point on the Internet that helps users navigate the on-line world. Recently, many major search engines have morphed into portals, offering stocks, sports, and the like in predigested formats.

Pop-up A graphical user interface element, usually a small window, that appears in response to a mouse or cursor click or rollover.

Post Any message submitted to a newsgroup. See newsgroups.

Q

Quicktime Multimedia format for displaying sound, text, animation, and video in a single file.

R

Resolution A measurement of the monitor image's sharpness and clarity.

Rich media Multimedia solutions that allow advertisers to implement e-commerce and lead generation and branding campaigns directly within their on-line banner ads.

Rollover Operation involving rolling a mouse or cursor over a given page element, resulting in a new display or action.

S

Scrollbar Screen feature that provides a means of reaching parts of the Web page that are not already in the window.

Search engine A service that keeps track of millions of Web pages and allows users to search through them by keyword to find topics they are interested in.

Server A computer on a network that is accessed by multiple users.

Shockwave Add-on or plug-in available from Macromedia that allows users to access compressed animations on the Web.

Splash page Opening screen used to present general information such as browser or plug-in requirements.

Streaming media Technology accessed by downloadable plug-ins that allows you to view animations and listen to sound on-line for short periods of time.

Style sheets Allow documents in an XML format to be easily converted into HTML. See cascading style sheets.

T

TCP (transmission control protocol) The Internet transport level protocol that provides reliable, full-duplex stream service

upon which many application protocols rely.

Throughput The rate of data transmission at a given point, related to bandwidth.

U

URL (uniform resource locator) The address used to get to sites on the World Wide Web.

V

VRML (virtual reality markup language) Programming designed for 3-D graphics and rendering.

X

XML (extensible markup language) Language that allows documents to be coded to identify any portion of a document, such as a quote from a specific person. With this coding, search engines can give users a more refined search, finding only those documents for example where the specified person is quoted.

Studio Directory

BBK
5242 Plainfield NE
Grand Rapids MI 49525
616 447-1460
info@bbkstudio.com

CyberSight
220 NW Second Avenue,
Suite 1100
Portland, OR 97209
503 228-4008
info@cybersight.com

Deepend
44-46 Scrutton Street
London
EC2A 4QL
United Kingdom
+44 20 7247 2999
design@deepend.co.uk

Digitas
The Prudential Tower
800 Boylston Street
Boston, MA 02199
617 867-1000
drollert@sig.bsh.com

Fork Unstable Media
Juliussstrasse 25
22769 Hamburg
Germany
+49 40 432 948 0
info@fork.de

Futurefarmers
1201B Howard Street
San Francisco, CA 94103
415 552-2124
ame@sirius.com

Genex
10003 Washington Blvd.
Los Angeles, CA 90232
310 736-2000
info@genex.com

Icon Nicholson
The Puck Building
295 Lafayette Street
New York, NY 10012
212 274-0470
info@icon-nicholson.com

iXL
363 W. Erie
Chicago, IL 60610
312 274-5600
info@ixl.com

LiveArea
75 Maiden Lane
New York, NY 10038
212 402-7868
info@livearea.com

M.A.D.
237 San Carlos Avenue
Sausalito, CA 94965
415 331-1023
mad@madxs.com

MeTV
152 Cross Road
Waterford, CT 06385
1-877-MeTV.com
contact@metv.com

Minneapolis College of
Art and Design
Marketing Department
2501 Stevens Avenue South
Minneapolis, MN 55404
612 874-3700 ext. 817

Nofrontiere
Zinckgasse 20-22
1150 Vienna, Austria
+43-1-98 55 750
info@nofrontiere.com

Nomex Inc.
460 Ste. Catherine West,
Suite 200
Montreal, Quebec
Canada, H3B 1A7
514 282-1888
info@nomex.net

Red Sky (Nuforia)
373 Park Avenue South
New York, NY 10016
212 659-5700
info@nuforia.com

Organic
510 Third Street, 5th Floor
San Francisco, CA 94107
415 831-9986
info@organic.com

Parisfrance
222 NW Davis Street, No. 309
Portland, OR 97202
503 225-1200
info@parisfranceinc.com

Phoenix Pop Productions
1211 Folsom Street
San Francisco, CA 94103
415 934-7700
info@phoenix-pop.com

Quantum Leap
Communications, Inc.
420 W. Huron
Chicago, IL 60610
312 528-2400
info@leapnet.com

Second Story
239 NW 13th Avenue, Suite 214,
Portland, OR 97209
503 827-7155
info@secondstory.com

Tanagram
855 W. Blackhawk Street
Chicago, IL 60622
312 787-6831
info@tanagram.com

Trollbäck & Company
915 Broadway
New York NY 10010
212 529-9540
infor@trollback.com

twenty2product
440 Davis Court No. 509
San Francisco, CA 94111
415 399-9744
info@twenty2.com

American Airlines
AAdvantage Customer Service
P. O. Box 619623
DFW Airport, TX 75261-9623

Best Selections
350 7th Avenue
New York, NY 10001

Cap'n Crunch
The Quaker Oats Company
P. O. Box 049003
Chicago, IL 60604-9003

Creative Toolkit
Domtar
395 De Maisonneuve
Montreal, Quebec
Canada

Discover Card
P. O. Box 29019
Phoenix, AZ 85038-9019

DreamWorks Records
100 Universal Plaza
Bungalow 477
University City, CA 91608

Furniture
Attn: Customer Care
1881 Worcester Road, Suite #2
Framingham, MA 01701-5459

Geneva
The City of Geneva
Switzerland

Gigabuys
Dell Computer Corporation
34375 Viaduct San Juan
Capistrano Beach, CA 92624

Gravis
2855 Campus Drive
San Mateo, CA 94403

GreavesIndia
311 South Wacker Drive,
Suite 950
Chicago, IL 60606

Herman Miller
855 East Main Ave
P. O. Box 302
Zeeland, MI 49464-0302

Home Depot
2455 Paces Ferry Road
Atlanta, GA 30339

Keds
The Stride Rite Corporation
191 Spring Street
Lexington, MA 02420-9191

King Cobra
National Geographic Society
P. O. Box 63002
Tampa, FL 33663-3002

L.L. Bean
Casco Street
Freeport, ME 04033-0001

Limn Co.
290 Townsend Street
San Francisco, CA 94107

Lufthansa Systems Network
Am Weiher 24
65451 Kelsterbach
Germany

Millennium 3
8338 NE Elderwood Road,
Suite 200
Portland, OR 97220

Metropolitan Museum of Art
1000 Fifth Avenue
at 82nd Street
New York, NY 10028-0198

NSXbyAcura.com
American Honda Motor Co., Inc.
P. O. Box 2206 - 700
Van Ness Avenue
Torrance, CA 90509-2206

OXO International
75 Ninth Avenue, 5th Floor
New York, NY 10011

Pictor
Lymehouse Studios
30-31 Lyme Street
London NW1 OEE
United Kingdom

Pontiac and GMC Redesigns
P. O. Box 436008
Pontiac, MI 48343-6008

Restaurant
1040 Avenue of the Americas,
24th floor
New York, NY 10018

Riversearch
460 Sainte Catherine Street
West, Suite 200
Montreal, Quebec H3B 1A7
Canada

Rockshox2000
401 Charcot Avenue
San Jose, CA 95131

Swarovski
A-6112 Wattens
Kristallweltenstraße 1
Austria

Venice Dream Team
A Division of
Eastman Kodak Company
360 West 31st Street
New York, NY 10001